Clin d'œil

PAO & PAWS

BIS

Clin d'œil

PAO & PAWS

BIS

First published in 2004 by
BIS Publishers
Herengracht 370-372
1016 CH Amsterdam
P.O. Box 323
1000 AH Amsterdam
The Netherlands
T +31 (0)20-5247560
F +31 (0)20-5247557
bis@bispublishers.nl
www.bispublishers.nl

ISBN 90-6369-079-7

Printed in China

FOREWORD

The Art [& Design] of Illustration

The evidence is right in front of your eyes, you are holding it in your hands; illustration is back.

It had to happen; finally making a dramatic return to form the discipline has stepped back in from the wilderness, from almost a self-imposed exile, after too long away from the spotlight. Of course, the time was ripe for a radical re-emergence, re-birth, re-invention, or rejuvenation: call it what you will, but who would have dared guess at how this transformation would take place?

Illustration has always existed in a pretty interesting space. It occupies an area that sits some place between art and design. Never truly considered to be an adjunct of art with a capital 'A', nor allowed to wholly exist as a solo design discipline, without the prop that is graphic design, illustration has often been disowned by both artists and designers, whilst continually taking knocks from both sides too.

In the world of art, a blanket refusal to acknowledge the importance of the role that illustration plays and the cross over from art to illustration occasionally being deemed appropriate but visa-versa rarely accepted. Meanwhile, over in the design world, designers plunder freely from the fields of illustration, yet infrequently taking any responsibility for sowing new seeds, little time or space being given to nurture growth in emerging talent.

So, 'despite of' rather than 'because of' its relationship with art and design, illustration's recent dramatic return to form should be seen for what it is; a remarkable self-initiated transformation. Although not before time, I hear you utter, and it is fair to say that illustration, globally, had been in a depressing state of affairs, had begun to look tired, worn-out, run-down, jaded and out of fuel.

'Something' had to happen and happen it did; a new breed of illustrators with something to say, with the ways and means of saying it, started to command control. No longer pandering to the needs of dull business-to-business corporate clients: a savvy, more fashion-conscious, style-aware illustrator started to create images for an audience made up of its own peers. The ever evolving 'style' mags; on the hunt for cutting edge and creative ways of staying visually ahead of the pack as well as record labels eager to promote new independent bands alongside fashion companies tapping into a zeitgeist created away from the glare of the photographer's lens, all took the bait willingly.

A renegade, but global, group of illustrators and image-makers, albeit independently, started to set new standards in illustration, aiming at a new audience. Young, keen, motivated but ultimately talented illustrators bucked trends; creating work that felt good, looked right and had attitude. A raw mix of the digital, the analogue, the traditional, the photographic,

the hand-drawn, the stencil, the... nothing was out of reach to a group that believed that the creative outcome was more interesting than the technical input. This new breed felt empowered by technology, not confused, as had the previous generation, having spent more time avoiding it than embracing it.

Utilizing digital technology, once held captive by designers, and creating images about subjects that they were motivated by, in the same way that artists approach their own work, new illustration, for a short time, was not dictated by client demands. In fact, this quest for creating new forms of image making had meant that much was done outside of the confines of the commission. Illustrators, acting like artists, initiated their own projects; followed their own instincts, set their own parameters and then just like designers sought out new clients, previously unimpressed with the offerings from yesterday's generation of illustrators.

Not all the new work followed the age-old mantra that deemed that the best illustration contains a great 'idea'; much of this new work captured a flavour, a mood, an essence or a moment. For many, it was about the look and feel, more than the communication of that 'clever' idea. Gritty urban backdrops vie for attention with drawings of beautiful, yet often vacant looking people, set against themes that include sex, relationships, music, fashion; sometimes dark and surreal, sometimes humorous and

playful. The strand that holds this range of diverse subjects and picture making skills together, as evidenced in this book, is the belief in the importance of the creation of unique new visual worlds. Those that truly exist in that space where art and design meet have reinvented and rejuvenated illustration, forcing the discipline back out into the light. This time, contemporary illustration is a force to be reckoned with.

And the evidence is right there in your hands.

Lawrence Zeegen
January 2004

THOMAS BARWICK

tom.barwick@virgin.net

What is your nationality & astrological sign? British / Aries. **What schools have you attended?** I studied Fine Art at Trent Polytechnic. **What is the first thing you do in the morning?** Make warm milk. Make toast and marmite. Make tea. Turn on TV. Turn on my computer. **What do you love the most?** My girlfriend and our children. **What does a habit mean to you?** 'Little wheel spin and spin, big wheel turn around and around' – Buffie Saint Marie. So a habit is a small wheel a little routine that supports a bigger routine. The hardest habit to quit is life itself. **Why are you creative?** Who really knows? My father's father was a master joiner(carpenter) and my mother's father was a jeweller (watchmaker). My father collects illustrated books. My mother makes very fine patchwork quilts by hand. So I guess a lot of it's in my nature and a lot of it has been nurtured. **Where is your energy inspired from?** From looking very carefully. From sitting on my bed in the dark and from staring at the sun. I don't look at a lot of other illustration at all because I find that often it has a profound effect on me and disables me completely. Last night, I looked at Egon Schiele in a beautiful book that I got as a gift from Thames & Hudson's head of production. I can't afford books. I was reading it and looking at the pictures – really enjoying myself – when I turned the page and came across a picture called "The Virgin", 1913. Everything stopped. I was transfixed. I followed the line around every contour of the girl's figure and they where all perfectly true. I looked at the whole and could feel the burning glare of the subject as she stared at the artist, imagining this curious state were artist and model are locking horns in a very intense way. Now that would count as looking carefully and that will have of inspired me and given me energy. **What would you say is your contribution to this world?** A very small contribution. I think I have contributed to the history and traditions of my family and I take great pride in that. I hope I have inspired young artists to become illustrators, while worrying that, having done so, I have condemned them to a life of poverty and great hardship. Though, I think that with the right temperament that hardship can produce amazing results. That a young illustrator can sit with no food in their belly and no money in the bank and think about beauty and line and fantastic imaginary things is a transcendent and precious thing. **What is illustration to you?** It is my favorite language and it is how I speak to the most people with the least difficulty. Illustration is like Shamanism, in that it exists in every culture and yet has no formal doctrine or dogma, and is the uninhibited exploration of what cannot be seen by the naked eye or recorded with a camera. There is a universal language that enables illustrators to communicate ideas about style and technique without ever meeting or saying a word to each other. The feeling is that we are all building something that will eventually become a truly global style form and language. No other discipline in the Arts goes through the creative process as fast or in such a harsh, creative environment [>commission>inspiration>execution>next commission] This can have of all happened in two days. Illustration in the 21st century is fast, tough and well informed. Picasso said: 'Great artists don't borrow. They steal; And illustrators survive by stealing without pride or prejudice. **How do you want to be remembered?** By the making of a quilt and the telling of a tale, and as the quilt gets older the tale gets longer and more exaggerated and parts that didn't happen become intertwined with the parts that did. **Explain one of your most difficult drawing experiences?** No competition! Working for Pao! on the Where Chu artwork. The distance between the UK and Taiwan was a challenge, but we did manage to get it all done via E-mail, so that aspect was all fine. I think the interesting thing was my and Pao's influences and how they worked together. It's complicated to explain. My work is influenced by Chinese and Japanese art, the simplicity of the drawing and the flat use of color. However, it is also influenced by Western comic art and artists from the turn of the century, like Van Gogh and Picasso – though, of course, they in turn were influenced by art from the Far East, themselves. So to produce a portrait that was of a Taiwanese person in my style, but with western elements, was a complex task. Then take into account that Pao is clearly influenced by minimalist modernist designers from the West, but also very much working in the Far East market-place, with a 21st century client to satisfy. So it was clear that we had a very globalized project under way. The icing on the cake for me was when Pao produced the posters for the campaign and used the same design that was used in ancient portraits in Japan and China. And so he had brought the whole thing back around full circle to were it had originally begun: with that innovative sense of simplicity of design that you see in almost all Oriental art. Sometimes the most difficult jobs are the most rewarding ones. **If you weren't an illustrator, what would you be?** A stone carver. **What is your dream job?** 'Six months in a brothel smoking pot with a model – John Glashan, 1968.

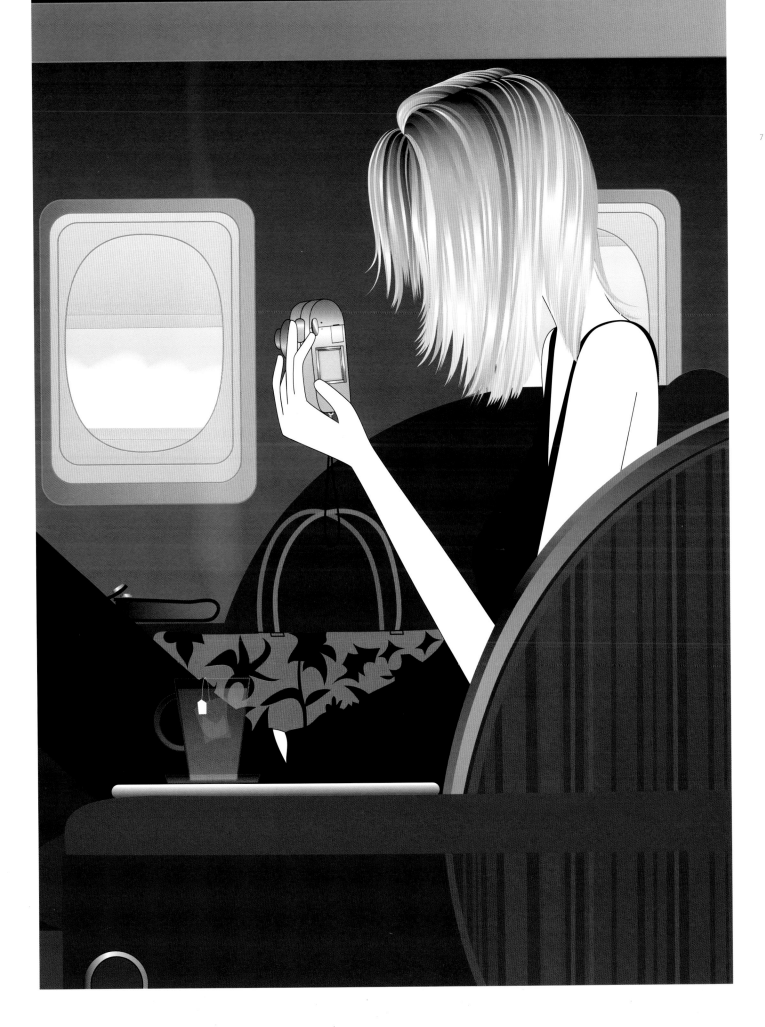

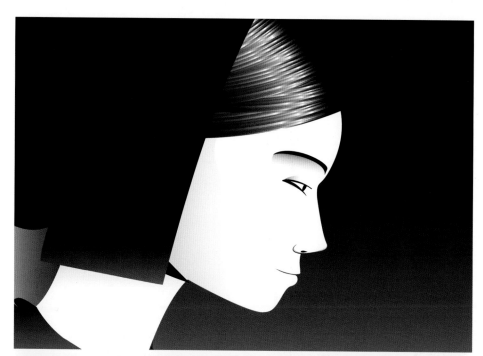

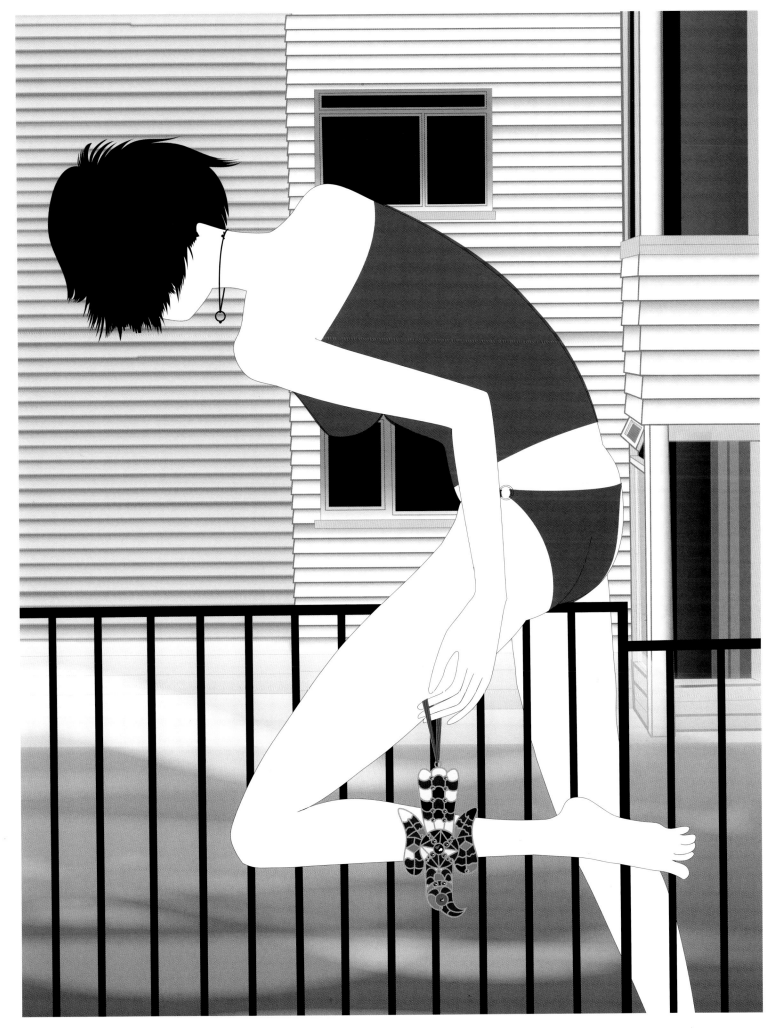

POLLY BECKER

pollybecker@yahoo.com

14

What is your nationality & astrological sign? American / Gemini. **What schools have you attended?** Presidio Hill, Inverness School, Point Reyes. Elementary School, Marin Academy (all in California), and Rhode Island School of Design. **What is the first thing you do in the morning?** I go to my two-year-old son in his crib who is bellowing imperiously, "MAAAAAMA!" to let me know he is awake. **What do you love the most?** The mystery, depth and complexity of the real. Emotion. Interrelationships. Reading and eating at the same time. **What does a habit mean to you?** I think of a nun's habit. Austerity is good. I am drawn to the austere, myself. I consider both senses of the word "uniform." The assumption of an identity based on the regular repetition of a choice. There is a value to not having to decide everything all over again every time. This is how you build style and, to speak of psychology, how you establish who you are. Having something one would typically do is a necessary covering to the nakedness of the open question. **Why are you creative?** That is a difficult question.

Wouldn't anyone want to be creative? It seems like something to be desired the way one might desire to be beautiful, or interesting, or important, or lovable, or articulate. To pursue creativity strikes me as having a value which is self-evident. **Where is your energy inspired from?** Caffe ine, fear of failure, and the desire for praise. **What would you say is your contribution to this world?** Nobody should have to ever answer that question. It invites a sort of self-indulgent pomposity. I hope it will have been my "contribution" will have been to have avoided. **What is illustration to you?** If handled right, a wonderful job. **How do you want to be remembered?** To be remembered at all would be a good thing. **Explain one of your most difficult drawing experiences?** In art school, in a classroom context, I found "life drawing" to be an ordeal. **If you weren't an illustrator, what would you be?** If I could be good at it – a writer. **What is your dream job?** My dream job would be an actual job with ten times the pay.

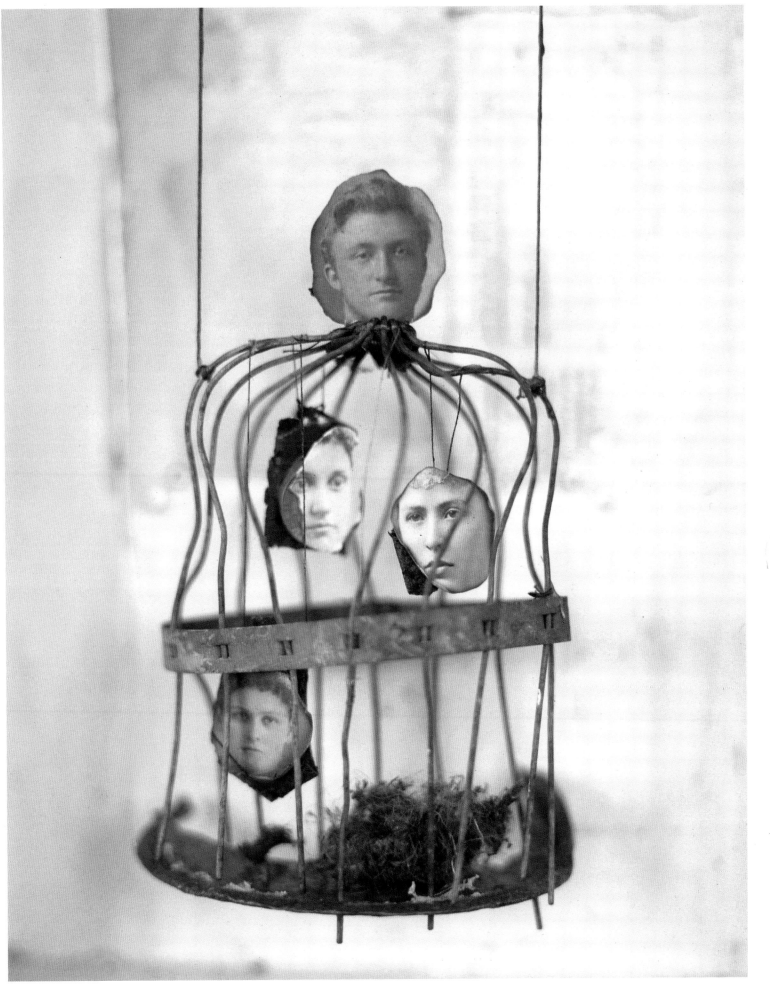

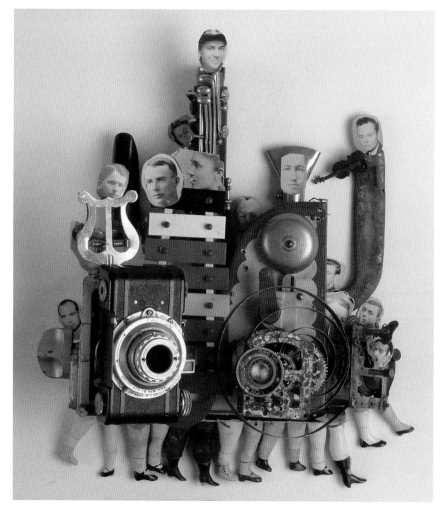

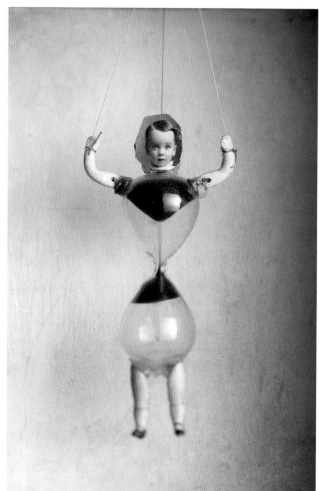

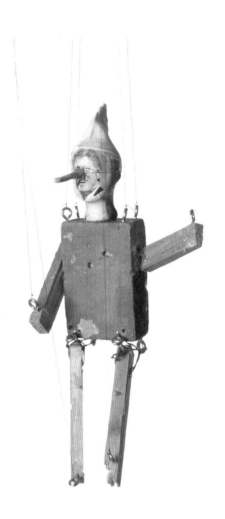

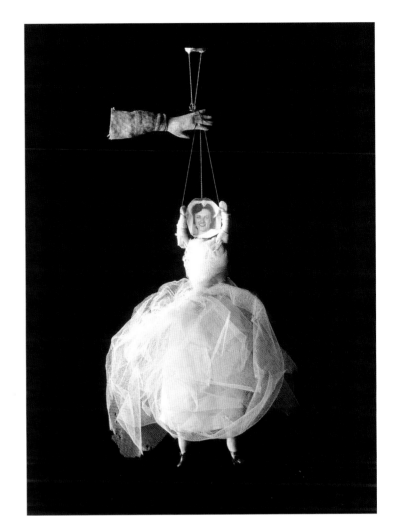

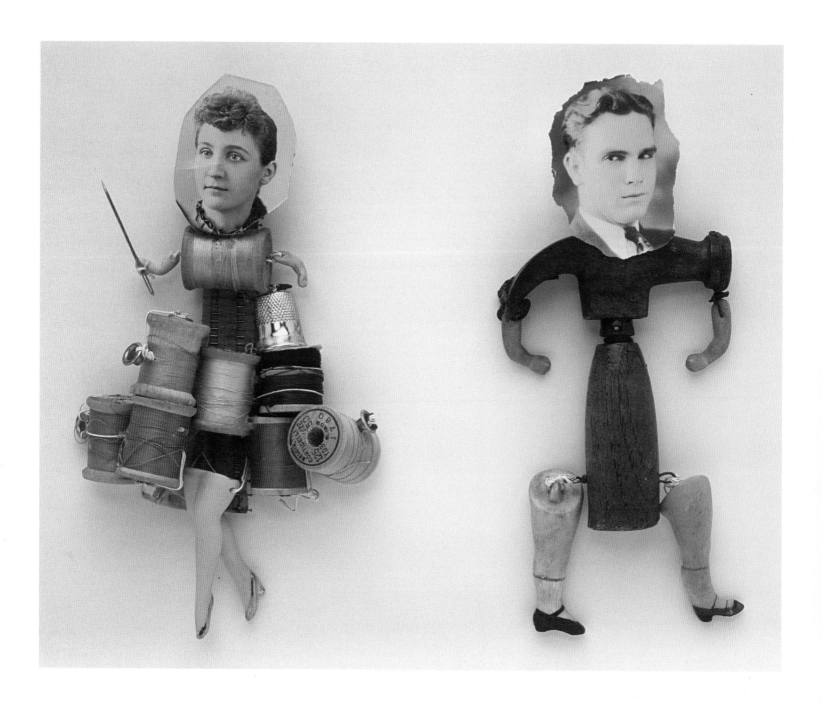

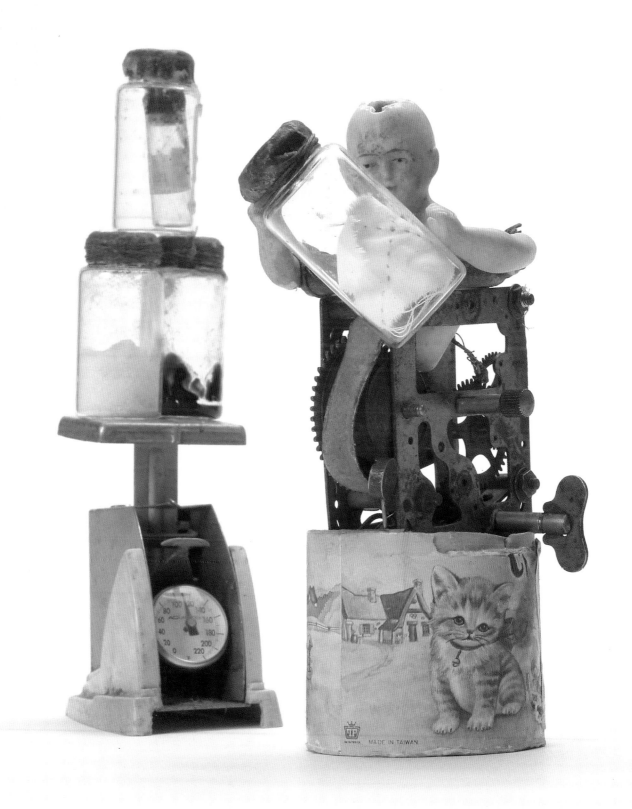

JULIETTE BORDA

julietteb@earthlink.net

What is your nationality & astrological sign? I'm 4th-generation Italian-American. I'm a Virgo. With Scorpio rising. **What schools have you attended?** Carnegie Mellon University, BFA in Fine Art. **What is the first thing you do in the morning?** Pee. **What do you love the most?** 1.My son 2.Sensual pleasures – all of them. **What does a habit mean to you?** Unexampled behavior. **Why are you creative?** I get bored if I'm not doing things. If I don't keep busy, I get into my head, a dangerous place. A big part of my identity is a maker of things. Also, I love beauty and I have a compulsion to beautify the space around me. **Where is your energy inspired from?** I've always been a high-energy person. I jump first and think later. **What would you say is your contribution to this world?** The love I share. And also I would say a unique vision. **What is illustration to you?** A way to explain things. **How do you want to be remembered?** Not just for my work, but for my spirit: I'd want to be remembered as an artist, but also as a solid woman of uncommon qualities. **Explain one of your most difficult drawing experiences?** In 4th grade, trying to fit the arm of the Statue of Liberty at the top of the paper – I had worked from the ground up. **If you weren't an illustrator, what would you be?** A microbiologist or a cupcake baker. **What is your dream job?** I'm living it.

Borda

BORda

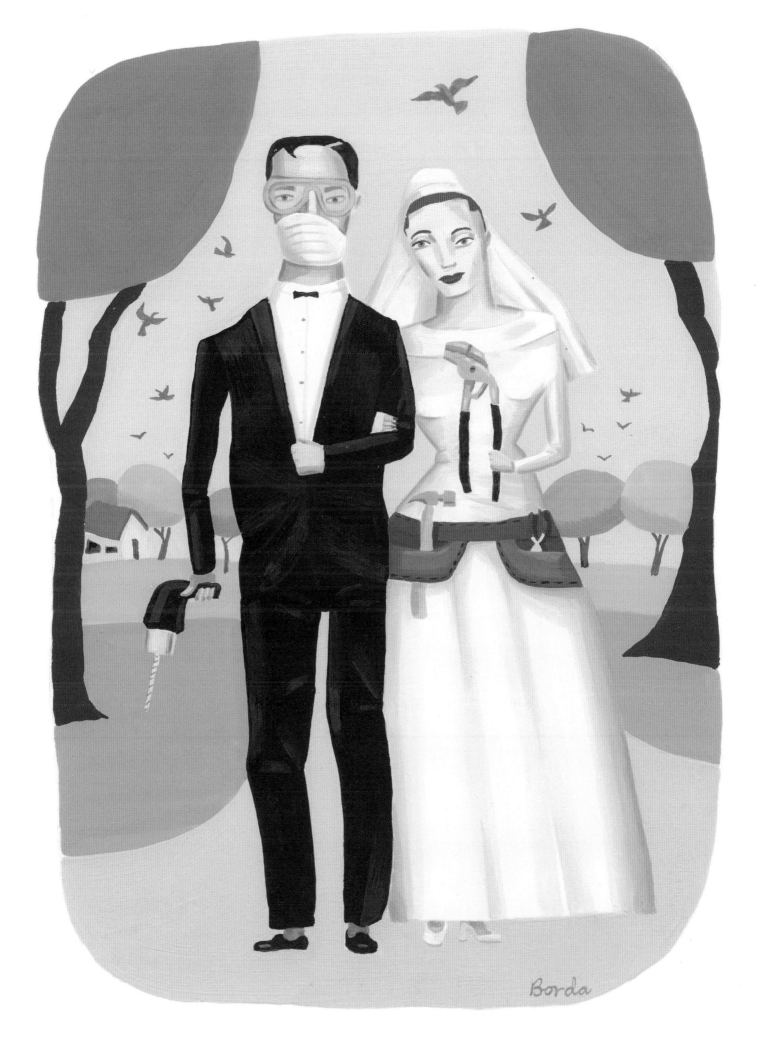

CALEF BROWN

calefbrown@earthlink.net

What is your nationality & astrological sign? USA / Capricorn. **What schools have you attended?** Pratt Institute and Art Center College of Design. **What is the first thing you do in the morning?** Drink green tea. **What do you love the most?** Answering questions. **What does a habit mean to you?** At best, a discipline. At worst, an addiction. **Why are you creative?** I have no idea. **Where is your energy inspired from?** My friends, family and peers.

What would you say is your contribution to this world? I make people laugh from time to time. **What is illustration to you?** Art that illuminates an idea. **How do you want to be remembered?** As a b-list genius. **Explain one of your most difficult drawing experiences?** I had to do a portrait of Kurt Cobain – a very difficult person to draw. **If you weren't an illustrator, what would you be?** A mediocre writer or musician. **What is your dream job?** Governor of California.

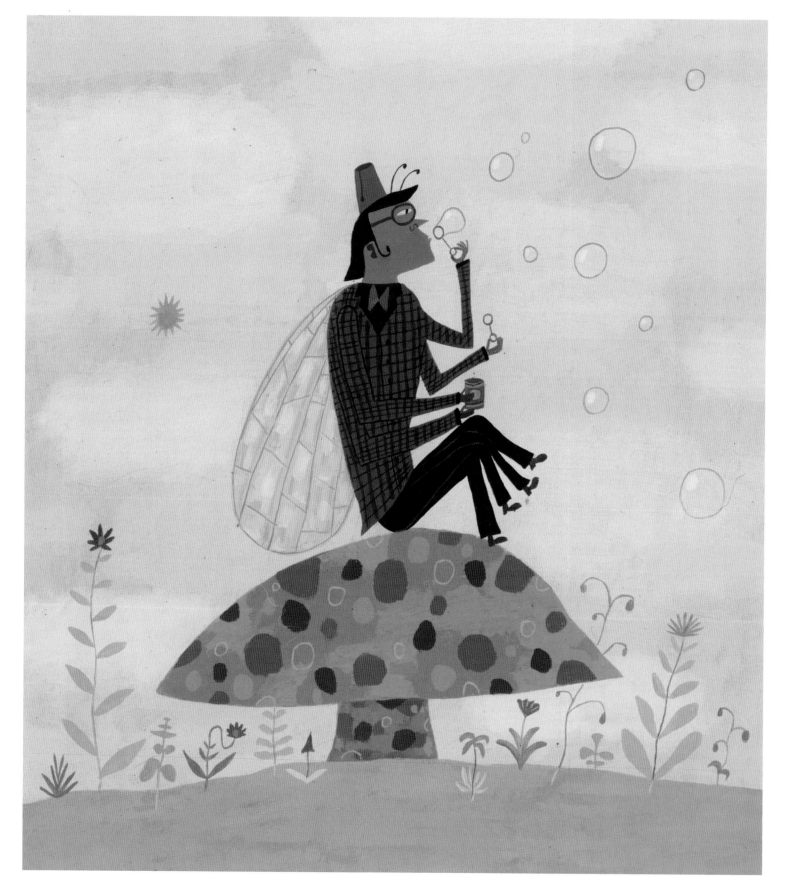

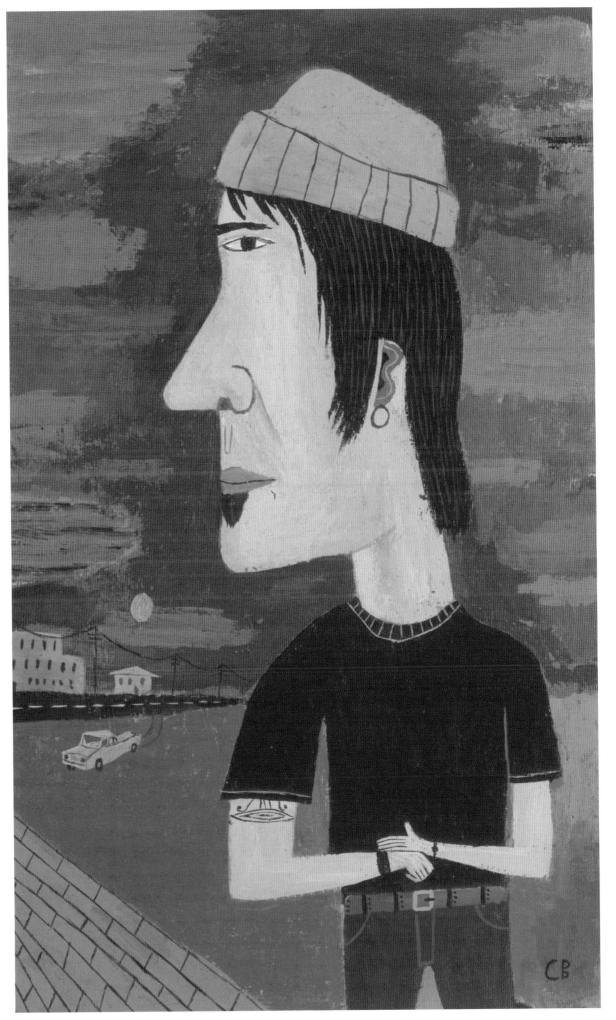

BRIAN CAIRNS

brian@briancairns.com

What is your nationality & astrological sign? I am Scottish. I do not believe astrology dictates my future. I make my own decisions, but my birth date is 21st, April, 1965. **Which schools have you attended?** I attended the Glasgow School of Art and studied Graphic Design. I had friends in Fine Arts, so I spent a fair amount of time in the painting and print-making departments, as well as daily-life drawing classes. During my post-graduate studies, I had a studio space in both the Graphic Design and Painting departments. **What is the first thing you do in the morning?** My day begins at 6:30 a.m. with a visit to the gym. I start work around 8:30 a.m. and usually work till 10:00 p.m. or 11:00 p.m. taking a break between 6:00-9:00 p.m. If I am not down at the gym I will check my emails and put on the kettle for tea. **What do you love the most?** In terms of priority, it is definitely my family. I love my work but I am careful not to let it consume me – both my time and resources – which it can easily do. I love hot days, which we get very few of in Scotland. I love being near the sea. I love to travel, especially to hot climates which I am very comfortable in. I love Spain and it's culture and I would love to be able to speak Spanish. I am in the process of learning it since I have some Spanish speaking friends. I love many things in nature that make you think this is being alive. **What does habit mean to you?** Habit is destiny. I have seen the following quote attributed to various sources but believe it holds true whoever said it first. In summary, 'You reap what you sow'. If you sow a thought, you reap an act. If you sow an act, you reap a habit. If you sow a habit, you reap a character, If you sow a character, you reap a destiny. Habits can also be almost ceremonial routines that help you to get your mind thinking in a certain way or help you switch into a specific mode. I do have my own habits for making work. One is having my own studio space. I used to be able to chat to studio friends while I worked but, since moving my studio and working alone over the last 3 years, I have found I need a lot of peace to produce my work. **Why are you creative?** I do not think I had a choice. It is how my brain is wired. Drawing and building things was a part of play in my family from an early age, so there was never a point of discovery at which I realized I was creative. It was always simply there and a part of my life. So I would say it is part nature and part nurture. My thought processes tend to be intuitive rather than analytic. Usually the intuitive approach leads to the same conclusion in a less obvious and quicker route. I really enjoy my work and the creative process, but it is good to keep it in perspective. No one is going to live or die because I do a good piece of work, though potentially it can enrich those lives. **Where is your energy inspired from?** My 'energy' and 'inspiration' comes from God and my Christian faith. I see my art very much as a gift. My responsibility is to fully realize its potential. To be the best I can possibly be and produce the best work I am capable of. In doing this, I do not operate in a vacuum. All around me are influences and inspirations from simple printed materials like logos on matchboxes and graffiti, to artists I admire and all the great artists and designers whose shoulders you stand on and whose work we benefit from. In everyday life I find lots of things that make me think and spark off ideas – from badly painted road markings, or old power switches on railway carriages. It is more an attitude of mind, being prepared to look at things abstractly and appreciate an object's values and qualities and then think how you can use those qualities. **What would you say is your contribution to the world?** My contribution in a professional context as an artist is that I hope I produce images that will enrich people's lives, by giving them ideas to think about and images which resonate a chord of truth. **What is illustration to you?** Illustration is art. For myself, the terms "low art", "high art", and "commercial art" have little significance. I believe art is about communication and truth. Whether in the context of the printed page, online or a gallery space. "Illustration" is a term which attempts to define the creative process of illuminating a text or idea. I believe "Illustration" is now wider than this and the term "communication art" probably more appropriate. Communicating visually through the most appropriate medium for the message. **How do you want to be remembered?** I doubt history will remember me, though I would like to leave work that my children and grandchildren will be proud of and that stands the test of time. Illustration moves incredibly quickly and is not documented as well as the fine arts so I have no false illusions about my inclusion in design history. I do my best for the now and hope history will take care of itself, though I do believe in being fully aware of the history of design and art in order to gain a perspective on my own contribution. **Explain one of your most difficult drawing experiences?** My most difficult drawing experiences are when I am asked to provide a 'style' to a job. My ideas and images are linked to finding an appropriate solution. Sometimes the concept is derived from the shape of an object or its color, so it is hard to separate the two. To separate the aesthetic and content can simply provide a hollow solution lacking depth or sophistication. **If you weren't an illustrator, what would you be?** If I was not an illustrator, I would be another form of artist, possibly involved in film or new media. If not an artist in any form, then I would be an entrepreneur. I have always enjoyed having ideas and then realizing them. It would need to involve travelling and meeting different people and cultures, seeing how they think and express their culture. **What is your dream job?** My dream job is probably one where someone finances me to come up with ideas and make them happen. Where I would have scope to experiment and learn about different media. It would involve travelling to different countries and cultures around the world, as well as being well paid... . Sorry, I am dreaming.

YOU
REAP
WHAT
YOU SOW

SERVICIO

LOST
OR POSSIBLY
STOLEN
1 RIB
IF FOUND
TELEPHONE
+44 (0)1239
61 41 22
ASK FOR ADAM

eve

howies
WEAR WHY

8/06/02 CAIRNS

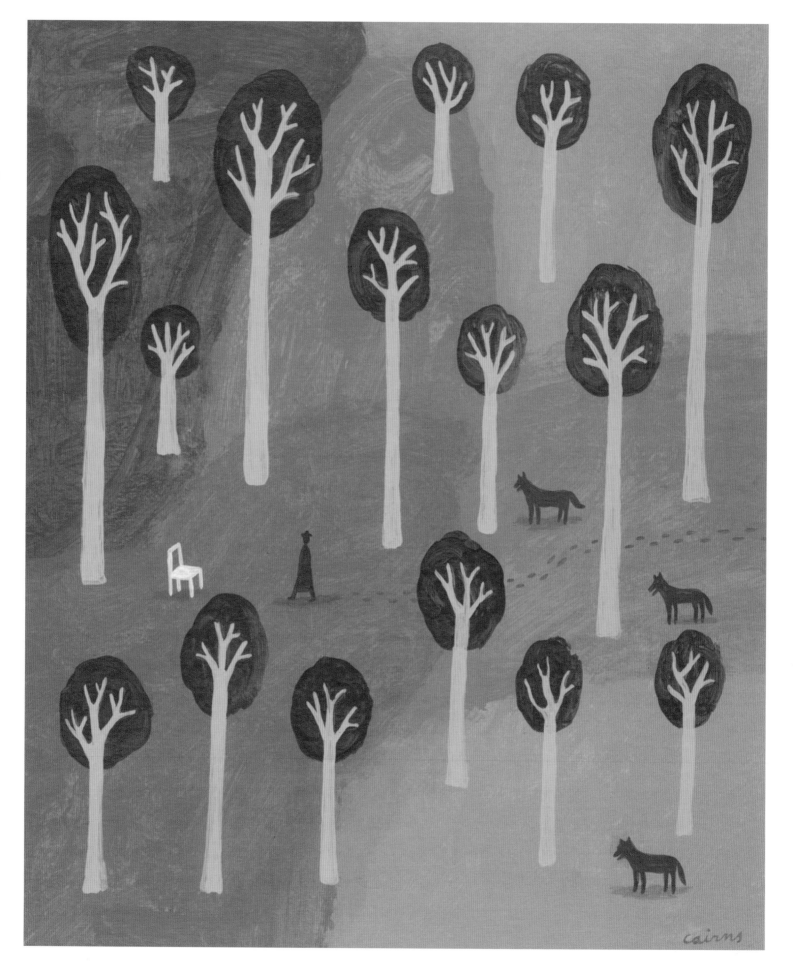

CHENNA

h.obasi@btopenworld.com

What is your nationality & astrological sign? UK. Goat. What schools have you attended? Chelsea College of Art. What is the first thing you do in the morning? Five press ups. What do you love the most? Pictures. What does a habit mean to you? A repetitive problem that is noticed by others. Why are you creative? The question should be why am I not creative. Everyone is creative in some way. Where is your energy inspired from? Melancholic music like Tricky.

What would you say is your contribution to this world? My children. What is illustration to you? A perfect way of making a living. How do you want to be remembered? I don't. Explain one of your most difficult drawing experiences? Having to draw something that means nothing to me. If you weren't an illustrator, what would you be? An illustrator. What is your dream job? I'm doing it.

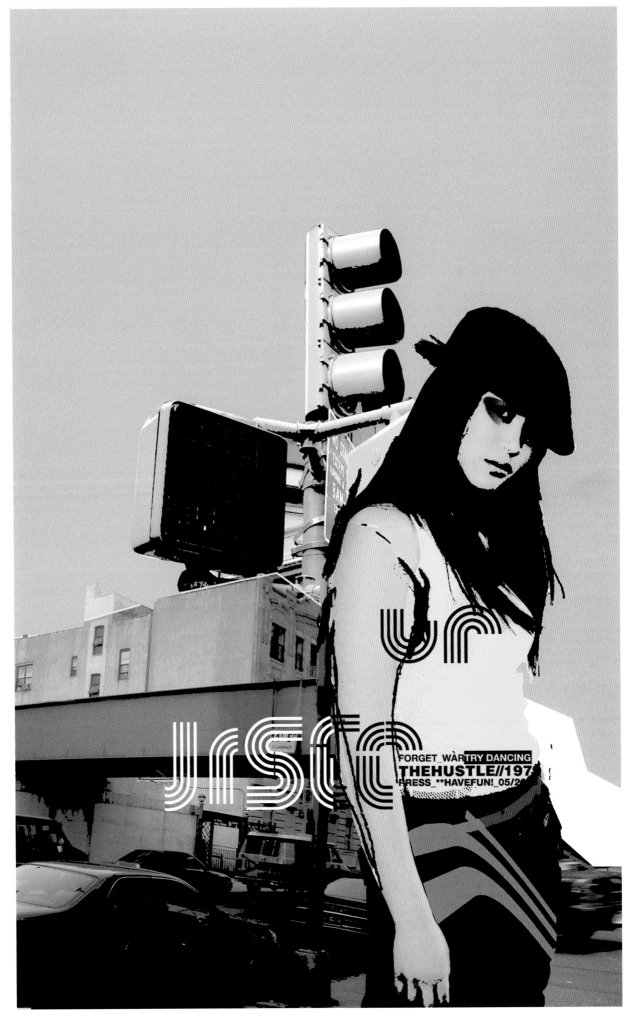

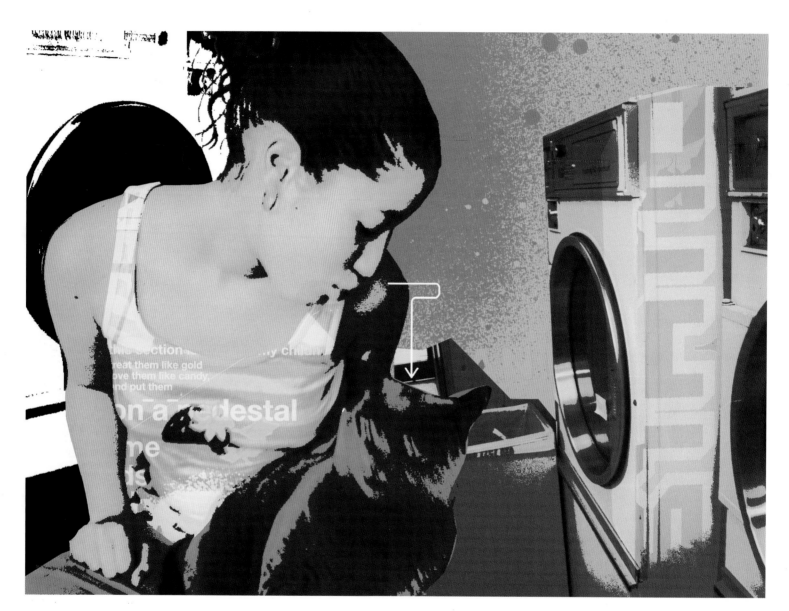

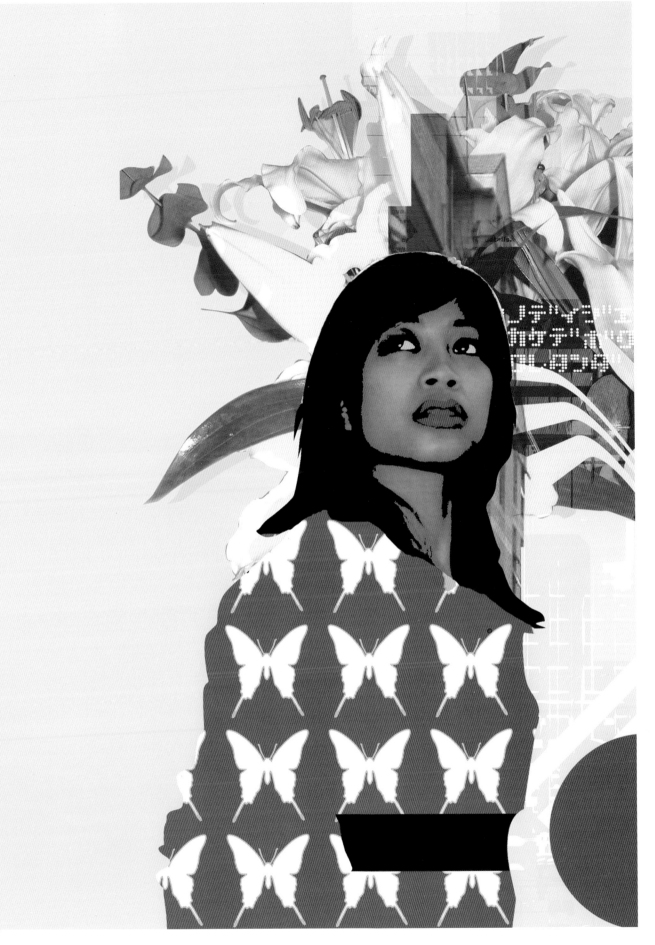

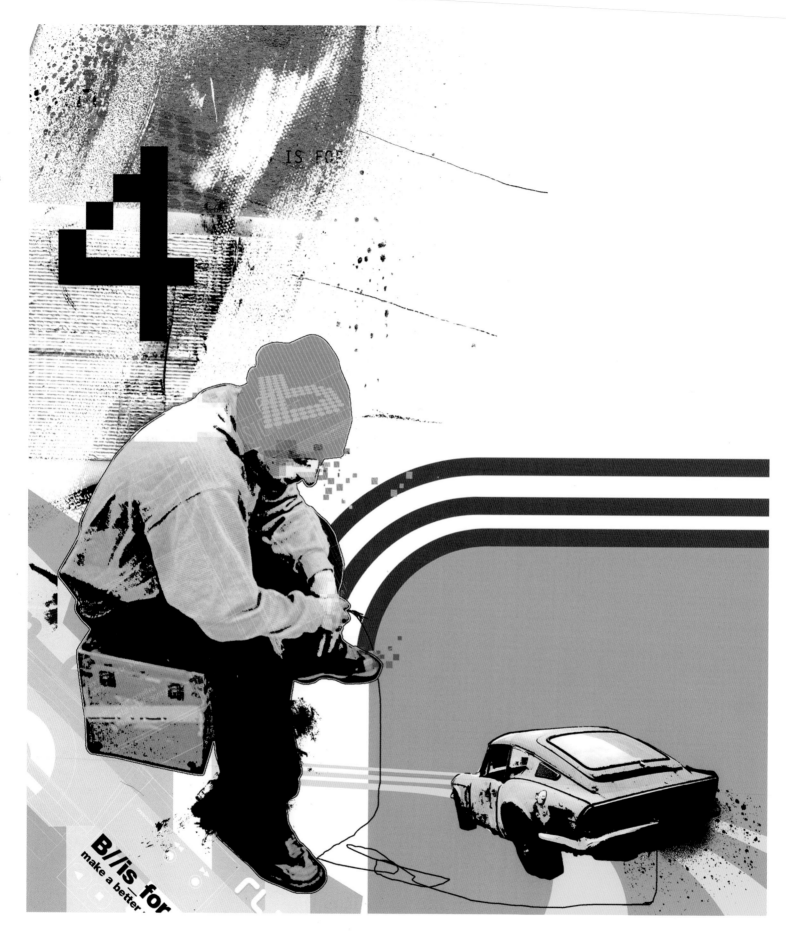

IS FOR

B//is_for
make a better

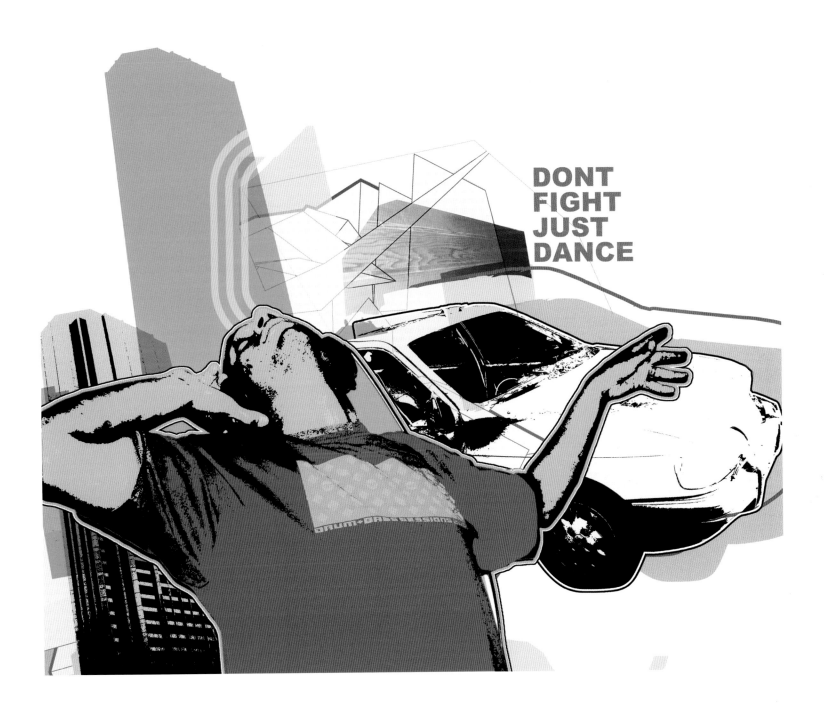

DONT
FIGHT
JUST
DANCE

D.A.D.D.Y.

daddy@teamdaddy.com

What is your nationality & astrological sign? There are three of us. We are called Mike, Chris and Enda. We are all Irish. Our astrological signs are Gemini, Scorpio and Aries. **What schools have you attended?** We all attended DLIADT, an art college in Dublin, Ireland. **What is the first thing you do in the morning?** We all live together and work from home. Usually we all shower together, dress Enda and eat breakfast from a tin. **What do you love the most?** Attention. **What does a habit mean to you?** An addictive behavior – not always in a bad way. Habits we own include: Cursing. Wind. Annoying each other. Late going to bed. Late getting upping. Drinking too much. Smoking cigarettes when drinking. Looking at girls too much. **Why are you creative?** We feel the more creative we are the more valid our existence becomes on this green earth. We like when other people like what we do. We like opening a book or magazine or turning on TV and seeing something we did. We want to make our parents proud. We really want to be very, very rich from doing something we love. **Where is your energy inspired from?** Creative messing, practical jokes, jealousy of other people's work, and secretly thinking we are amazing. **What would you say is your contribution to this world?** If we work really hard, make loads and loads of pictures and animations and print them all out, we can build a paper stairs to heaven. Then everyone who was bold during their life can sneak up our stairs and get in – plus, have a laugh on the climb looking at all the funny pictures. **What is illustration to you?** We work together under the name D.A.D.D.Y., which stands for Design Animation Design Design Yay. As you may well have noticed, illustration is not a word featured in our dodgy acronym. But in fact, illustration is the link, the silent partner, the glue that sticks all our feelings, ideas and styles together. We are constantly drawing and sketching and using illustrations to explain ideas to each other, Perhaps because illustration is such a normal part of our everyday lives together we forget how much it is the reason we exist as D.A.D.D.Y. So, Yay! We love illustration. **How do you want to be remembered?** A beautiful painting of us dying tragically, saving our families from a sinking battleship. **Explain one of your most difficult drawing experiences?** One time we were all sitting around the kitchen trying to draw portraits of each others' spirit guides. We were all just becoming enlightened when the phone rang and broke our concentration. **If you weren't an illustrator, what would you be?** Evil Zillionaire Space Rockers. **What is your dream job?** Evil Zillionaire Space Rockers on tour.

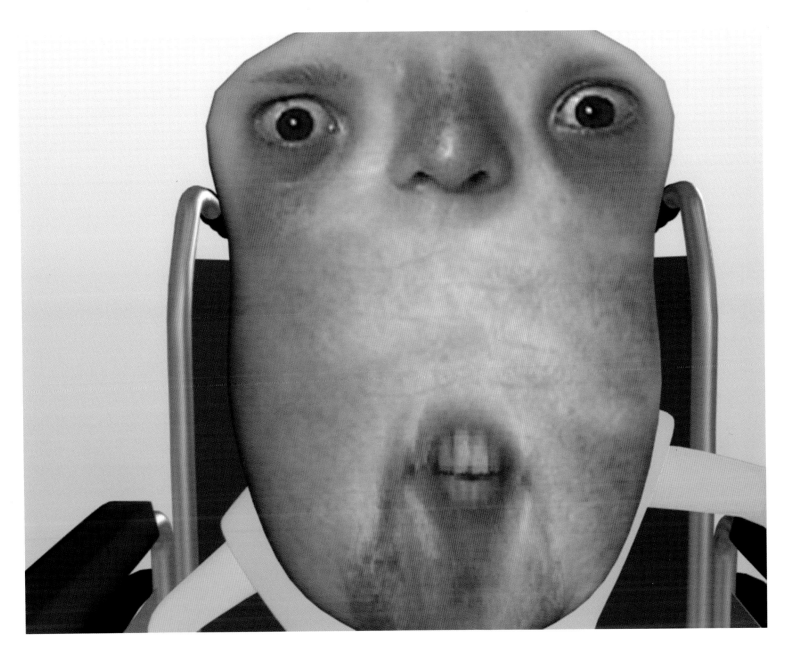

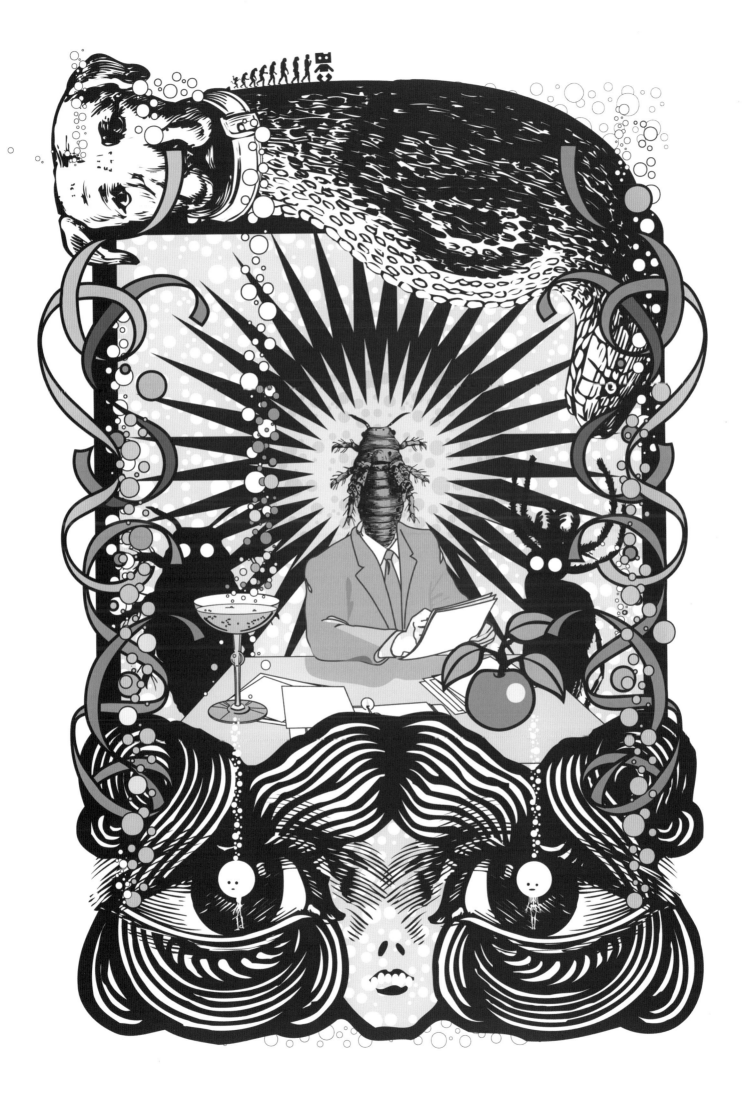

PAUL DAVIS

bigorange@btclick.com

What is your nationality & astrological sign? English. Born under the sign of The Unbeliever. **What schools have you attended?** Exeter College of Art and Design. **What is the first thing you do in the morning?** Wonder 'why?'. Then attempt to find the answer, then go to the bathroom and forget the question. **What do you love the most?** Really, really good sex. Money for nothing. Laughing uncontrollably. **What does a habit mean to you?** Drinking and smoking too much. **Why are you creative?** God knows and there isn't one. **Where is your energy inspired from?** Fear of boredom. **What would you say is your contribution to this world?** Laughter. Lining the pockets of drinks and tobacco companies. **What is Illustration to you?** Visual illumination of (normally) someone else's idea. **How do you want to be remembered?** As somebody who's worth remembering. Takes a while.

Explain one of your most difficult drawing experiences? Clients continually changing the creative director's mind (due to 'focus group' or 'research') therefore wasting everyone's time so the project always turns out half-baked and not worth remembering. It's very difficult to keep inspired in those long, tedious, irrational situations because what you are drawing doesn't necessarily mean anything until the whim of the client is satisfied. I feel physically upset when there's an inkling of that miserable, pointless confusion. **If you weren't an illustrator, what would you be?** Working in McDonalds. **What is your dream job?** Here you are – unlimited funds to produce the most beautiful book in the world – do what you want. You can use a fantastic studio (with all the mod-cons) for free in the South of France. And take your time. Everyone will love you so don't worry.

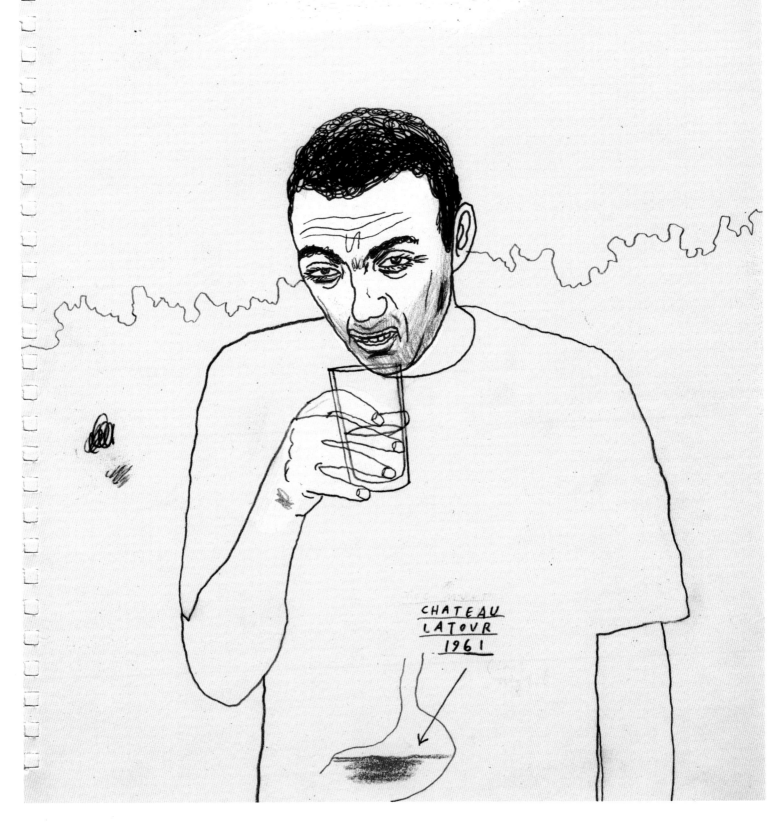

コクヨ ケ-35 20×20

A SURFER EXPLAINS:

I'M SO FAR OUTSIDE NORMAL SOCIETY

FREUD, EINSTEIN, DOSTOYEVSKY, HEGEL, WHATEVER, ALL SHOULD HAVE SURFED, MAN.

⑦

GOT CAUGHT INTERACTING
WITH HIMSELF WHILST
IMAGINING INTERACTING
WITH LADYBOYS HE'D
SEEN INTERACTING
WITH THEMSELVES
● FROM SHEMALE.COM.
BY HIS WIFE

HERMÈS

DEHARA YOKINORI

dehara@air.linkclub.or.jp

What is your nationality & astrological sign? Japan. I was born May 6, 1974. What schools have you attended? Osaka, University of Arts. What is the first thing you do in the morning? I look at the outside of the room. What do you love the most? It gets drunk. What does a habit mean to you? Imagines, draws and makes. Why are you creative? It is believed that it is my own work.

Where is your energy inspired from? Movie. What would you say is your contribution to this world? Leave me alone. What is illustration to you? The illustration excites me rather than arts. How do you want to be remembered? Form and color. Explain one of your most difficult drawing experiences? Politician. If you weren't an illustrator, what would you be? Actor. What is your dream job? Film director.

MARION DEUCHARS

mariondeuchars@lineone.net

What is your nationality & astrological sign? British / capricorn. **What schools have you attended?** Duncan of Jordanstone college of art, Dundee, Scotland / Royal college of art, London. **What is the first thing you do in the morning?** Wee. **What do you love the most?** Friends, love, humour. **What does a habit mean to you?** Depends if it is an endearing one or a bad one. I have an annoying one at Present which is licking my lips until they hurt. **Why are you creative?** Everyone is creative. **Where is your energy inspired from?** Fear.

What would you say is your contribution to this world? When i've made someone smile. **What is illustration to you?** Commercial art. **How do you want to be remembered?** With love. **Explain one of your most difficult drawing experiences?** Trying to do an early illustration commission where the client wanted it to be inspired by leonardo de vinci. (Help). **If you weren't an illustrator, what would you be?** A nun or a long-distant runner. **What is your dream job?** London olympics posters.

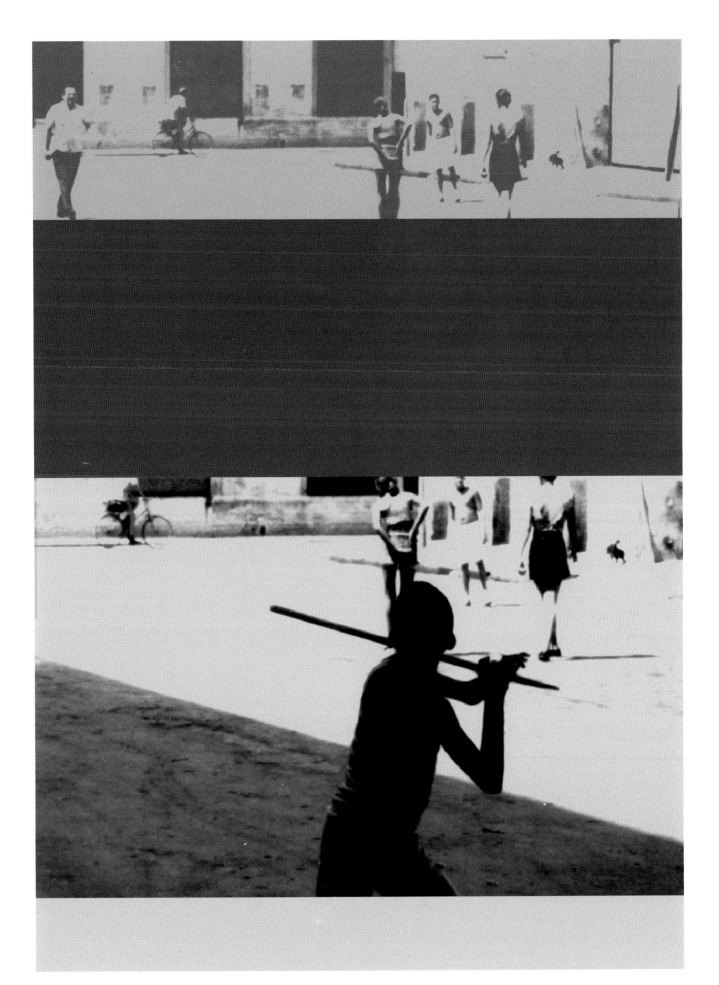

1 2 3 4 4

5 6 7 6 8 9

1 3 5 7 2 4

WE MADE OUR WAY TO THE FOOT OF THE Majestic DARBAND MOUNTAIN, NORTHERN TEHRAN IN A *PEYKAN (*The original British Hillman) HUNDREDS OF IRANIANS HAD HONKED AND SQUEEZED THEIR WAY TO THE CITIES FAVOURITE EATING PLACE. DRIVING IS MAD MAD MAD AND DANGEROUS IN TEHRAN, NO SIGNALS, OVERTAKING ON BOTH SIDES, THE HORN MEANS 'NOT STOPPING') WE PARKED ONLY JUST AND WALKED THE REMAINDER OF THE WAY UP A WET NARROW COBBLED PATH. THERE WAS THE DEAFENING SOUND OF GUSHING WATER COMING FROM TWO RIVERS ON EITHER SIDE OF THE PATH. SNOW MELTING FROM THE TOP OF THE MOUNTAIN. LINING THE PATH WERE STALLS AND SHOPS SELLING FOOD STUFFS AND TRINKETS SWEET TOBACCO, DISTINCTIVE SOUR BERRIES CRUSHED INTO A SET RED JELLY SAFFRON-FLOWERS (THE SIZE OF HANDS) SPICES OF CARDOMEN AND TURMERIC BRIGHT GREEN PISTACIOS, PEELED WALNUTS (In water resembling jars of miniature brains) POMEGRANIT PILED UP AND CANDY FLOSS STALLS BY THE DOZEN CONJURING UP THE ATMOSPHERE OF A FAIR) AS WE GET NEARER, THE inticing SMELL OF BREAD FROM THE CLAY OVENS AND BARBECUED MEATS DRIFT TOWARDS US. TOUTS ARE DOING THEIR BEST ACT TO GET THE LOCALS TO EAT IN THEIR RESTAURANTS - MOST OF WHICH ARE OPEN-AIR AND PACKED FULL WE CHOOSE ONE WHICH HAS WAITERS RUNNING FRENETICALLY AROUND AND SIT CROSS-LEGGED ON A PERSIAN RUG RAISED FROM THE GROUND ON PLATFORMS. IT IS A BIT chilly ON THE MOUNTAIN AND OUR WAITER BRINGS US TWO PORTABLE STOVES AND PLACES THEM IN THE CENTRE OF THE RUG. WE ORDER WHAT EVERYONE ELSE IS ORDERING - BARLEY SOUP Which is as close as I can remember to my mothers SCOTCH BROTH - EXACTLY THE SAME! FOLLOWED BY GRILLED LAMB, FRESH HERBS AND FLAT THIN ROUND BREAD straight from the oven that we fear and devour. THE FOOD IS SIMPLE, AND DELICIOUS. ALCOHOL IS NOT ALLOWED AND So WE DRINK A TASTY YOGHURT DRINK a bit like lassi BUT CARBONATED. IT FEELS LIKE BEING ON A FANCY PICNIC, THE MOUNTAIN IS DARK, THE OVENS AND PORTABLE STOVES ARE THE MAIN SOURCES OF LIGHT HIGHLIGHTING DARK SHAPES OF PEOPLE. ITS LIKE A FAMILY OCCASION, EVERYONE CHATTING, ANIMATED, CHILDREN, GRANDPARENTS MOTHERS, FATHERS AND FRIENDS. AFTER DINNER WE JOIN OUR FELLOW DINERS IN THE TRADITIONAL CUSTOM OF CHAY (Iranian Tea) AND HUBBLE BUBBLE (A WATER-FILLED SMOKING PIPE) THERE ARE DIFFERENT FRUIT-FLAVOURED TOBACCO ALL WITH DISTINCTIVE COLOURFUL WRAPPING. WE CHOOSE APPLE AND OUR WAITER PLACES A FEW HOT CHARCOALS ON TOP OF OUR PIPE. WE PUFF AWAY TAKING TURNS, IT GIVES A MILD BUZZ AND MAKES A GURGLING SOUND. (relaxing) HOT TEA IS BROUGHT ON SMALL SILVER TRAYS AND IS SERVED IN SMALL GLASSES, THE COMBINATION IS PERFECT. AFTERWARDS WE MAKE OUR WAY BACK DOWN THE WET MOUNTAIN AND BUY SOME SWEET ALMOND STICKY CAKES TO EAT IN THE BACK OF THE PEYKAN.

CARACAS
EXPOSICIÓN
7 JUNIO - 28 JULIO
MUSEO DE ARTE CONTEMPORÁNEO
DE CARACAS SOFÍA IMBER

BOGOTÁ
EXPOSICIÓN
15 AGOSTO - 7 SEPTIEMBRE
SALA DE INFORMACIÓN,
BIBLIOTECA LUIS ANGEL ARANGO
BANCO DE LA REPÚBLICA

SANTIAGO DE CHILE
EXPOSICIÓN
25 SEPTIEMBRE -10 OCTUBRE
GALERÍA DE ARTE CENTRO DE
EXTENSIÓN DE LA PONTIFICIA
UNIVERSIDAD CATÓLICA DE CHILE

PICTURE THIS

EN LATINOAMÉRICA

ILUSTRACIÓN CONTEMPORÁNEA BRITÁNICA

137 Clapham Common Battersea Park
Sloane Square Knightsbridge
Hyde Park Corner
Marble Arch Oxford Street

OXFORD CIRCUS

ARRIVA

DIZZY

dizzy@seed.net.tw

What is your nationality & astrological sign? Republic of China / Libra. **What schools have you attended?** Everyday life. **What is the first thing you do in the morning?** Trying to wake up. **What do you love the most?** Dream. **What does a habit mean to you?** It is an attitude. **Why are you creative?** I like to observe and watch people. **Where is your energy inspired from?** I am inspired by emotion, encouragement, and resistance. **What would you say is your contribution to this world?** I hope I am doing something positive to this world. **What is illustration to you?** It is expression of my life in many levels. **How do you want to be remembered?** Someone who has touched their feelings. **Explain one of your most difficult drawing experiences?** To be forced to compromised in the content and style of my work. **If you weren't an illustrator, what would you be?** Photographer, art Director or drug dealer. **What is your dream job?** To start my own magazine with financial resources.

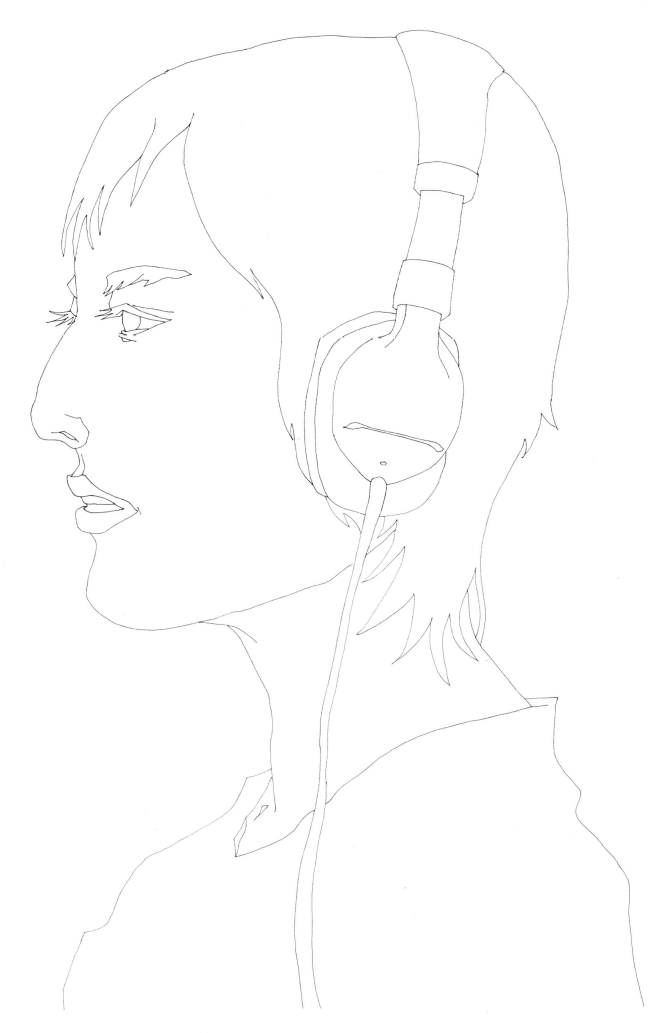

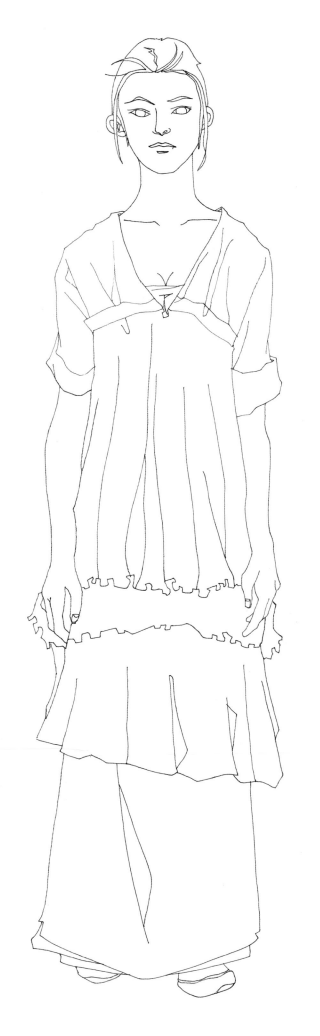
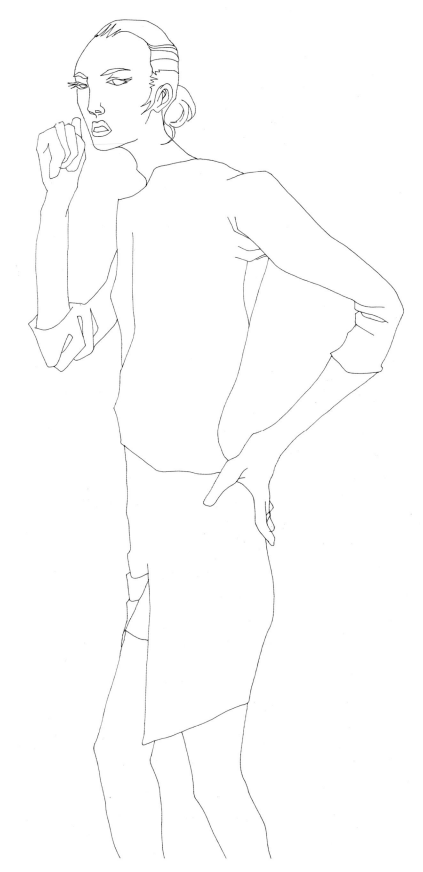

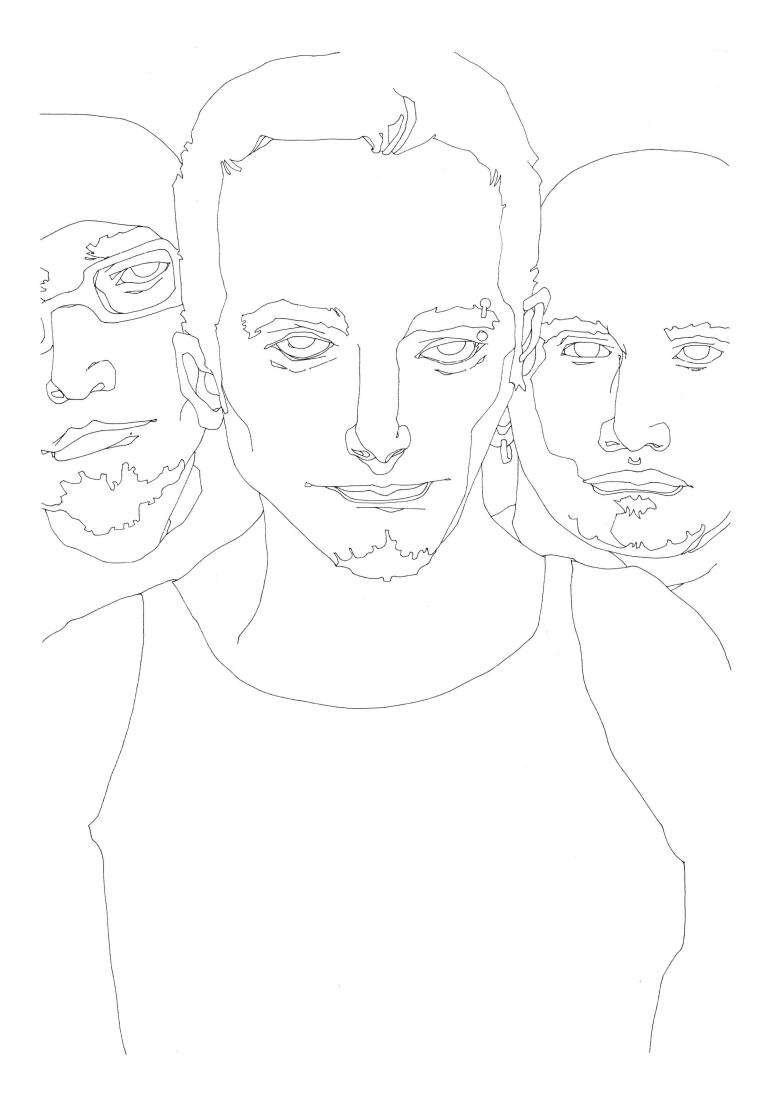

MIA DORA

tom.barwick@virgin.net

What is your nationality & astrological sign? U.K. / Aries. What schools have you attended? Falmouth School of Art. Cornwall. What is the first thing you do in the morning? Blink 20 times. What do you love the most? Heavy rain, grey sky. Flat fields stretching out to no where. Brown sea. Cold wind whipping my face. What does a habit mean to you? Habits that are motivated from within are good habits. All other habits are bad. Why are you creative? To make dreams into reality. To stop clocks. To be in a different place for a short time. Where is your energy inspired from? From the subconscious mind. What would you say is your contribution to this world? Through drawing, I am leaving a trail like a snail. What is illustration to you? Thousands of men and women all obsessively creating all over the world at the same time. These are vital times for illustration. Just as long as their are editors out there who understand the visual richness that illustrators can add to a culture that's obsession with photography has blinded itself to the power of drawing to stimulate the deepest seas of the mind even in the most mundane commercial setting. There are only a few of these editors in the world. They are individuals who treasure individuality and without them illustrators would be in big trouble right now. How do you want to be remembered? By my smile. Explain one of your most difficult drawing experiences? Well, I recently did some work for an Italian newspaper that involved 30 illustrators from all over the world and was edited in New York. You would think that would be difficult. But thanks to Fed EX and E-mail, it really wasn't. If you weren't an illustrator, what would you be? I would wind down like a clockwork watch, and with a lot of free space in my brain that I wouldn't really know what to do with I would soon get rusty like the Tin Man . What is your dream job? Pond monitor. That's the person who looked after the frogs and newts and fish in our school pond . But I already achieved this at age 8 , been drifting ever since .

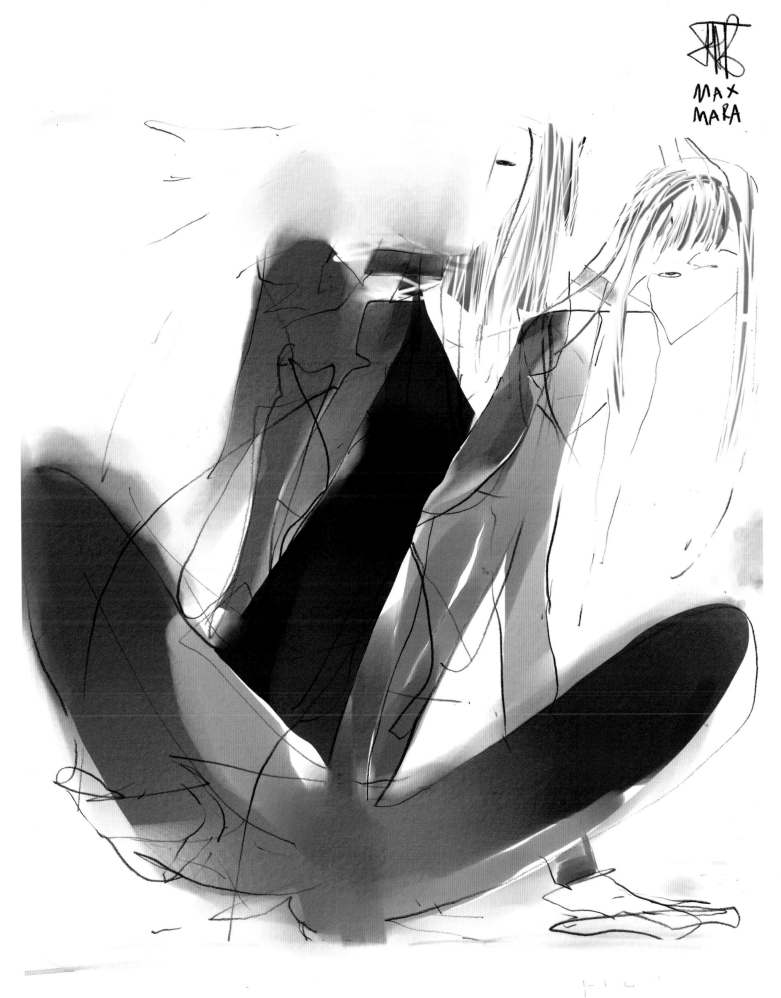

MAX
MARA

83

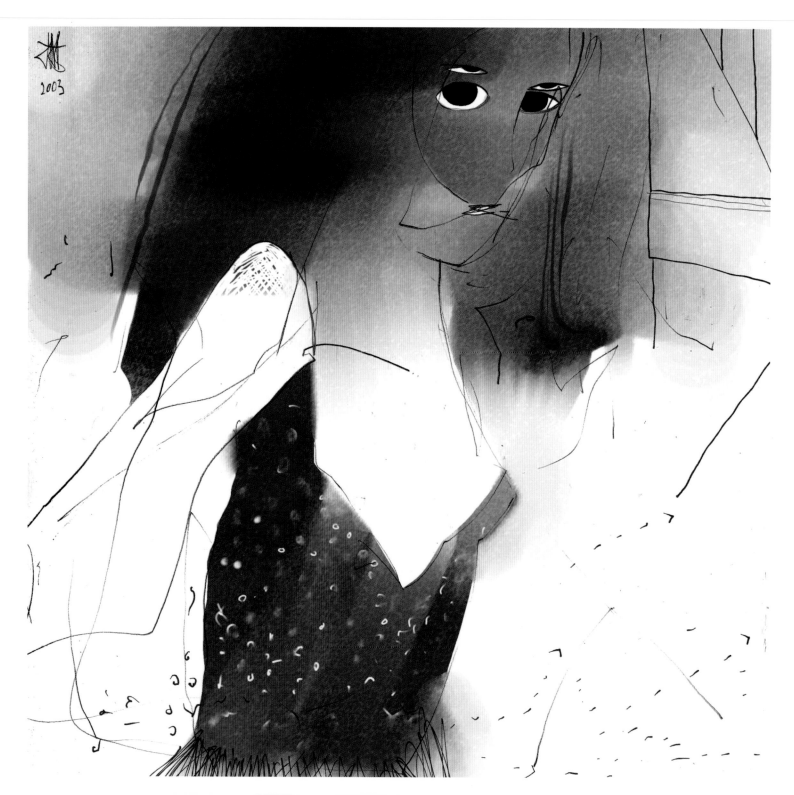

2003

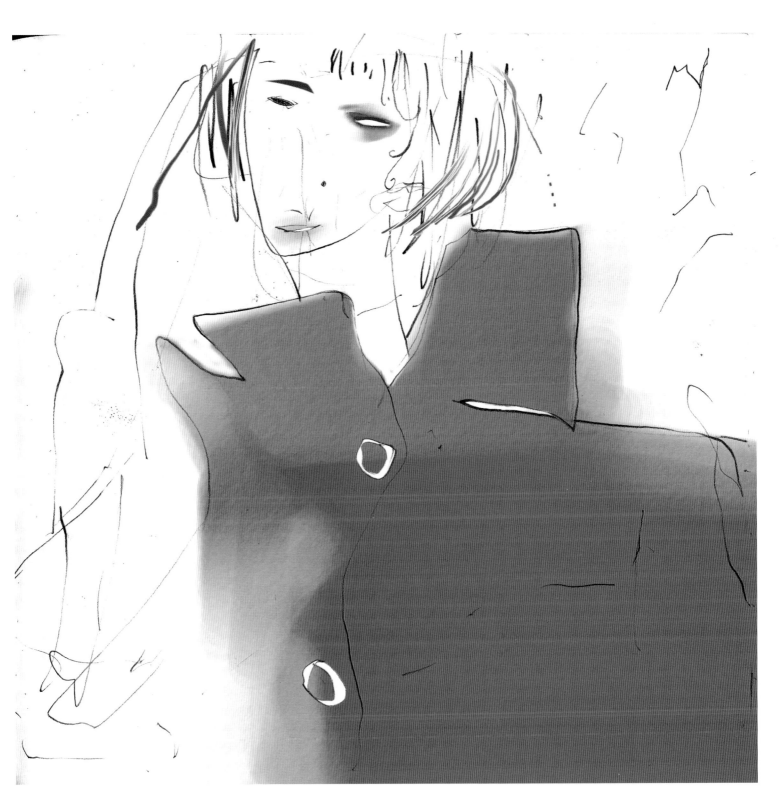

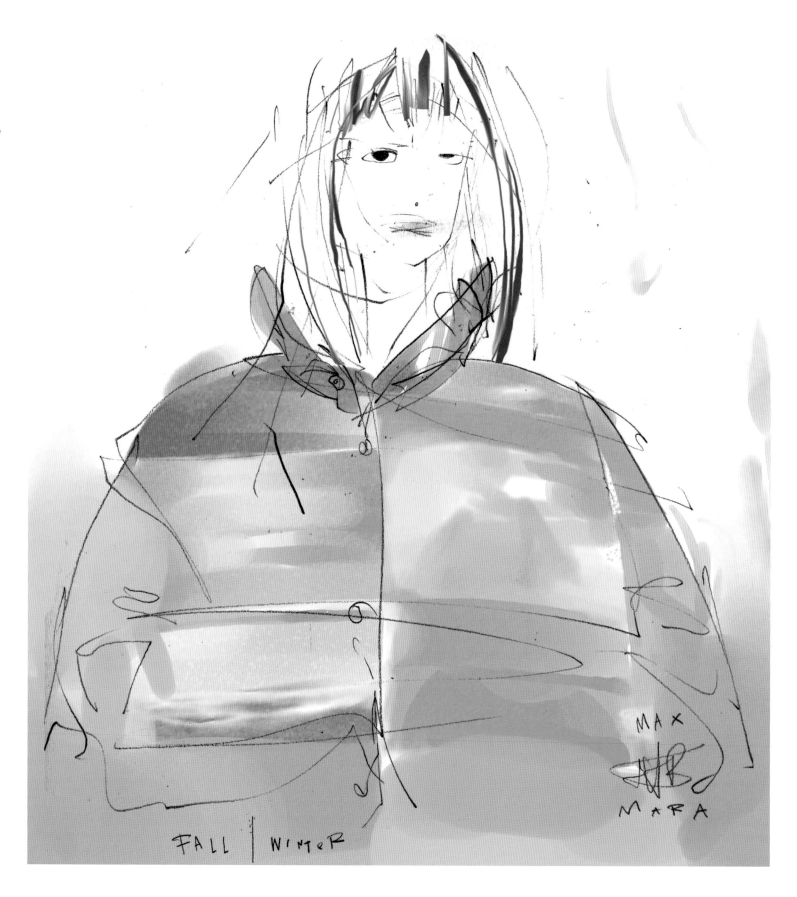

FALL | WINTER

MAX
MARA

DAVID DOWNTON

daviddownton@btinternet.com

What is your nationality & astrological sign? British / Aquarius. What schools have you attended? Tonbridge Grammar School / Wolverhampton School of Art. What is the first thing you do in the morning? Make coffee. What do you love the most? Drawing for a living. What does a habit mean to you? I try to avoid forming habits. They kill spontanteity. Why are you creative? I have no choice! Where is your energy inspired from? The world as I see it. What would you say is your contribution to this world? That's not for me to say. What is Illustration to you? Ideally it's a perfect fusion of commerce and creativity.

How do you want to be remembered? With affection. Explain one of your most difficult drawing experiences? I recently drew Erin O'Connor's fitting for John Galliano's "Egyptian" Dior Couture show in Paris. The dress was so extravagant and complicated; there were dozens of people in the room and all the usual tensions that go with putting on a show. In addition, the drawing had to be in The New York Times the following day. If you weren't an illustrator, what would you be? Thank God, I've never had to think about it. What is your dream job? I already have my dream job. As long as I can keep on doing it I'm happy.

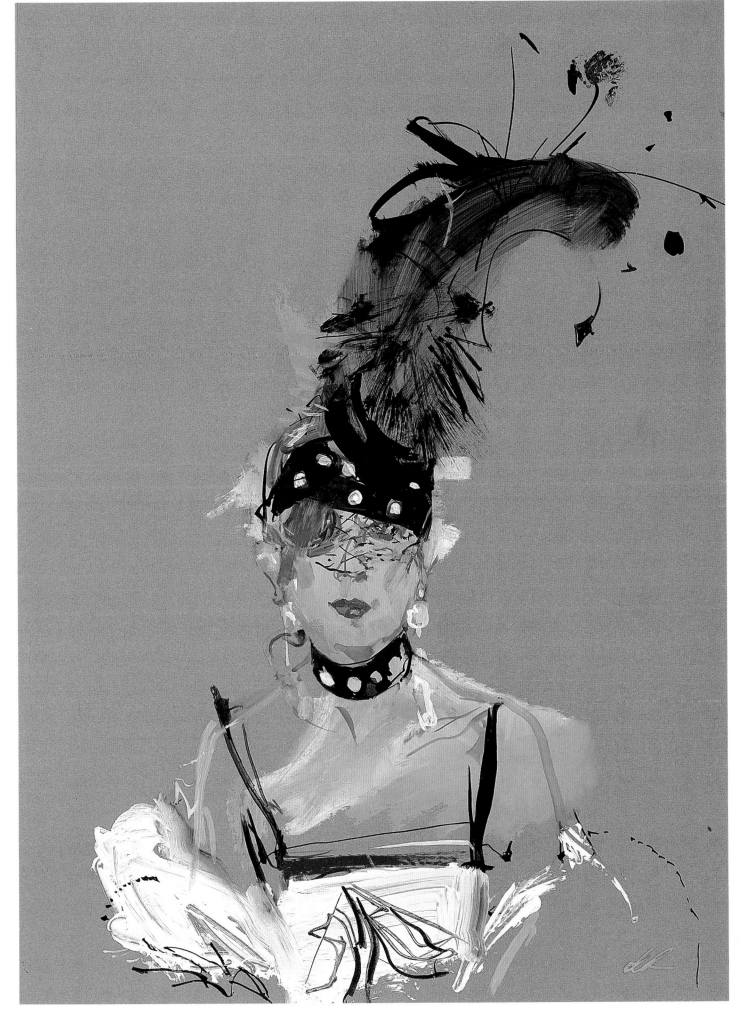

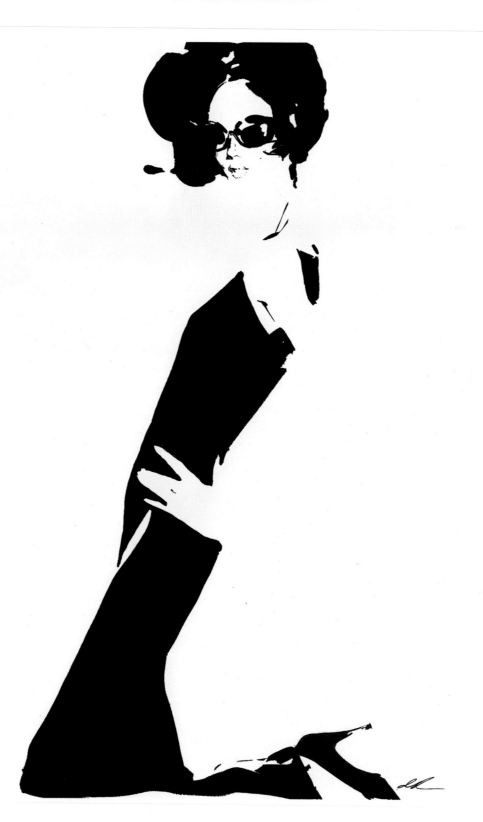

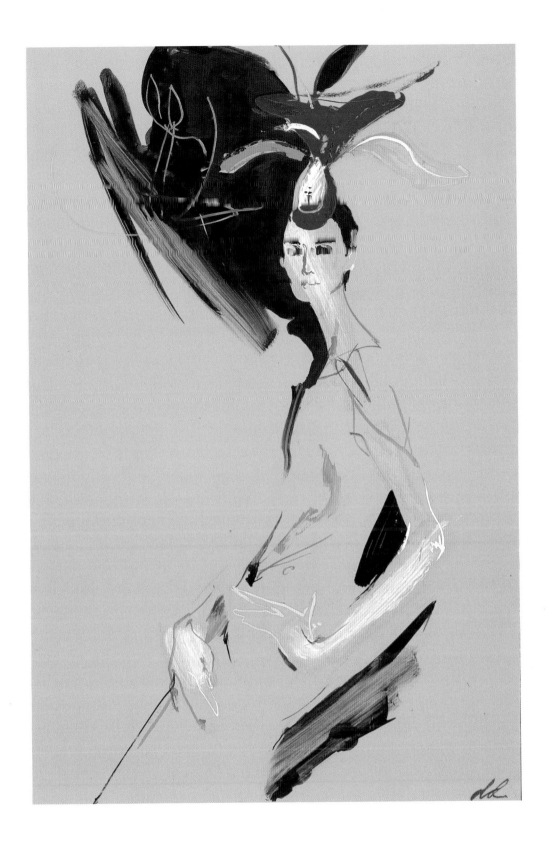

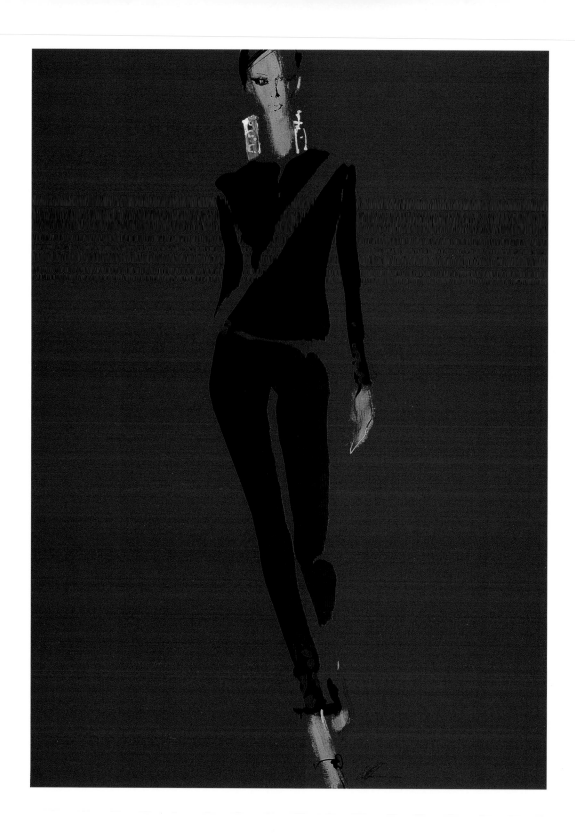

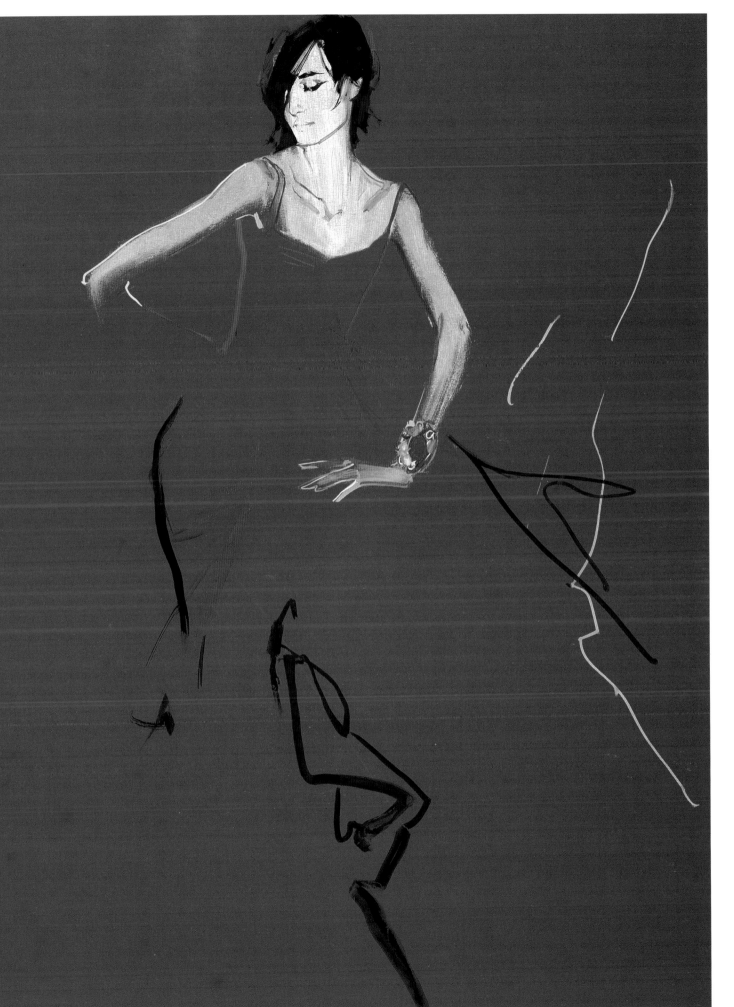

EBOY

jobs@eboy.com

What is your nationality & astrological sign? Scorpion / Gemini. What schools have you attended? Cool schools in Germany. What is the first thing you do in the morning? Checking on my erection. What do you love the most? Kids. What does a habit mean to you? Nothing. Why are you creative? Because I'm alive. Where is your energy inspired from? Pop culture in general. Coffee and cookies and white wine spritzers. What would you say is your contribution to this world? Kids, pictures, bones...interviews :) What is illustration to you? Nothing but financing our life style. How do you want to be remembered? Don't care.Frauenheld und partylier.

Explain one of your most difficult drawing experiences? Can't remember. Trying to kiss my girlfriend's name in the snow around 1994. If you weren't an illustrator, what would you be? We are squirrels in the tree of contemporary design. What is your dream job? President of the USA... Note: eBoy is Steffen Sauerteig, Svend Smital, Peter Stemmler and Kai Vermehr. All questions have been answered together by all of us four. For this reason, we insist that answers are marked with 'eBoy' and not with our individual names. Apart from this, it is OK if our individual names are used in a general context. Thanks!

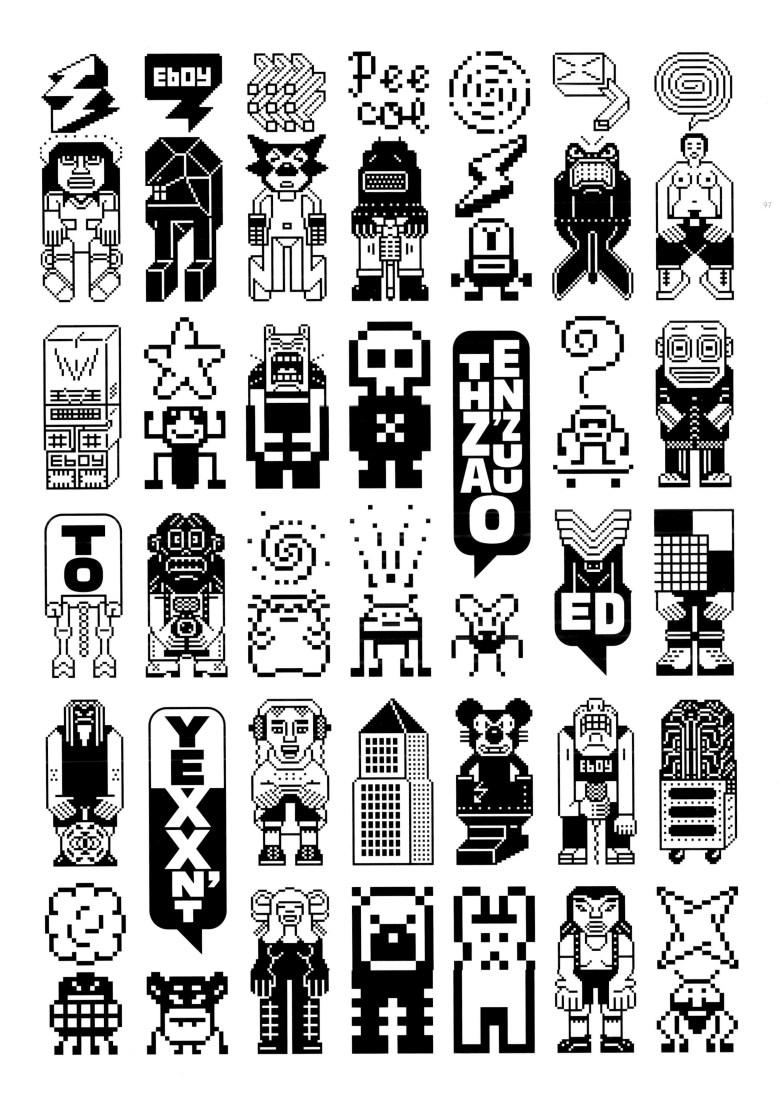

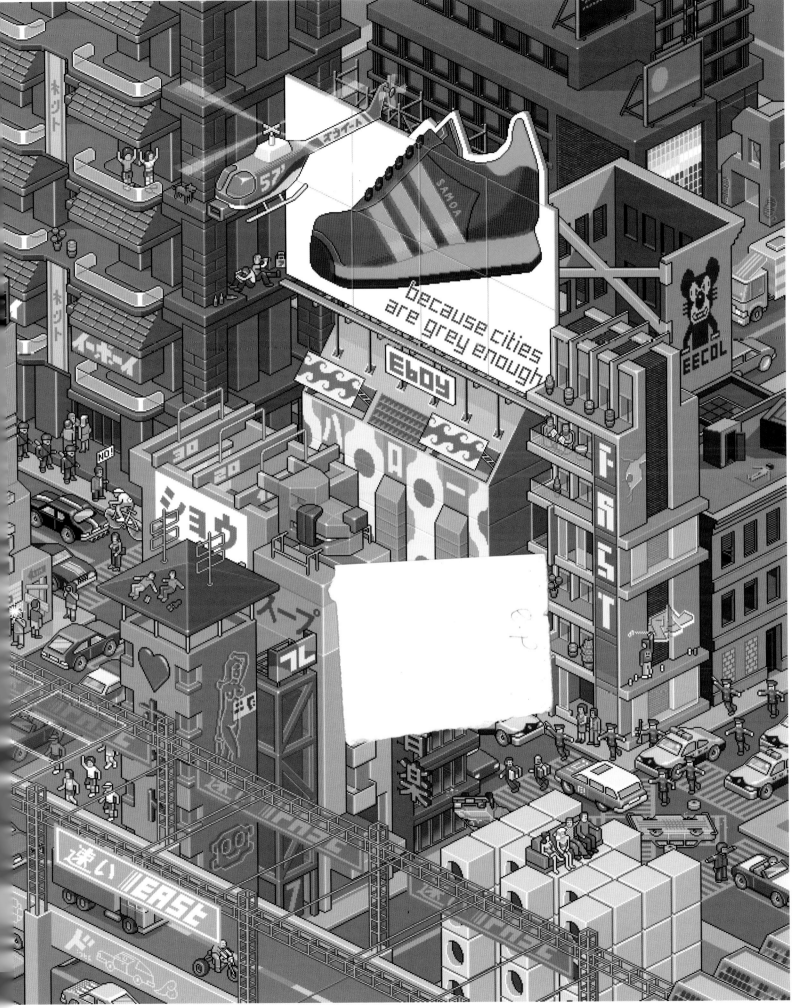

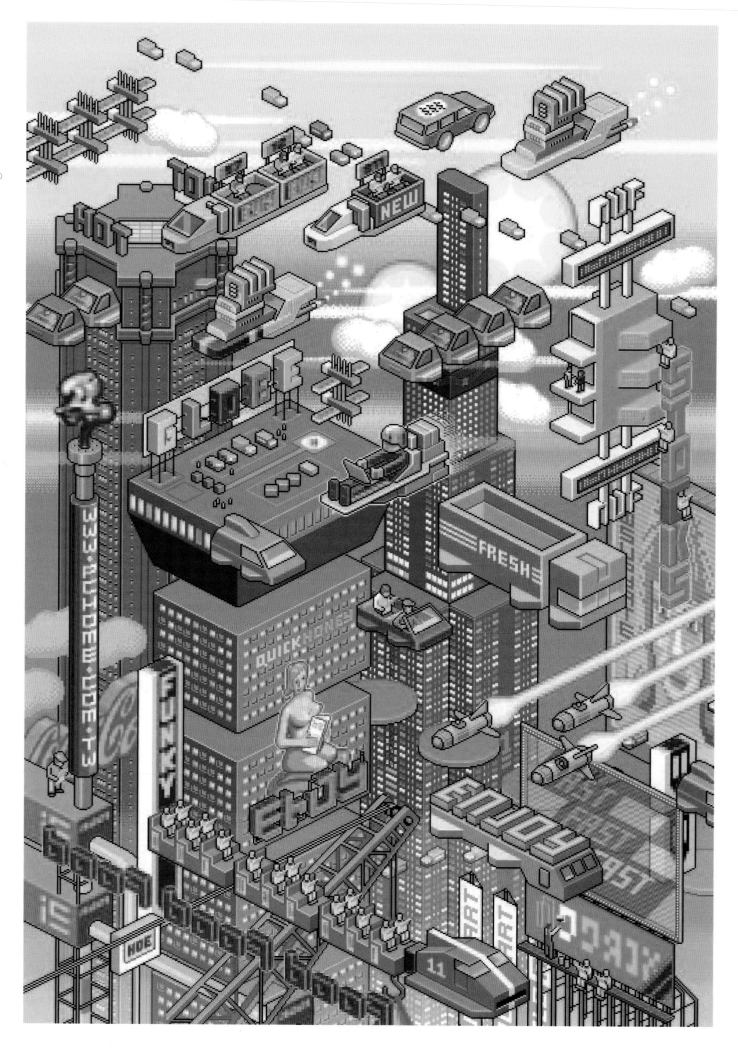

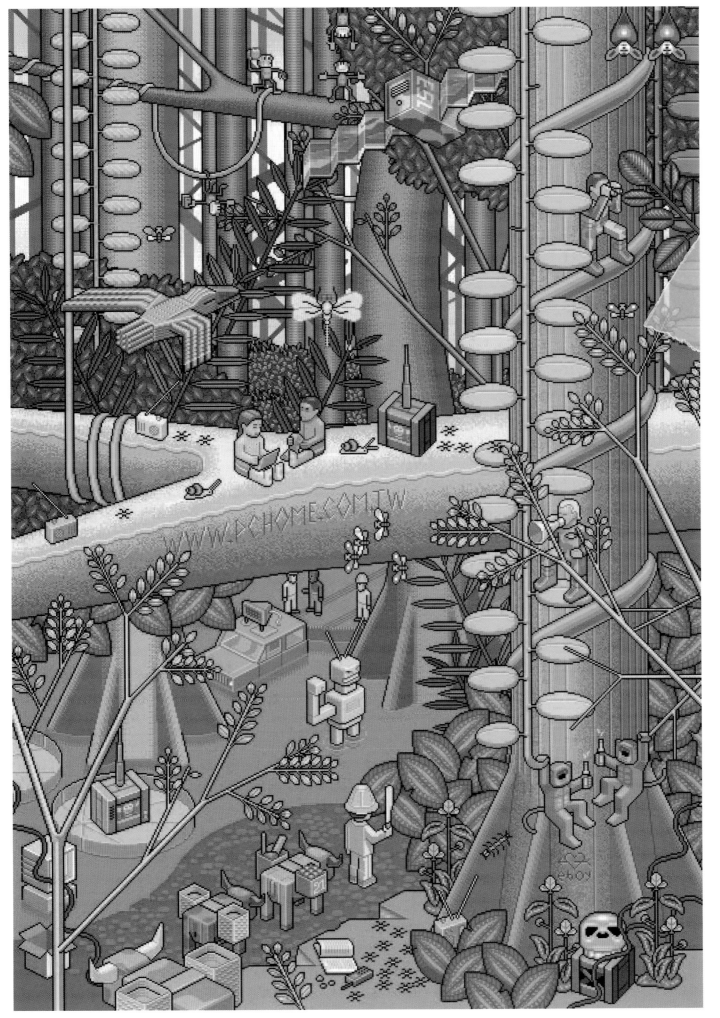

LAURENT FÉTIS

info@laurentfétis.com

What is your nationality & astrological sign? French. I don't believe in astrology. What schools have you attended? Architecture then design school. What is the first thing you do in the morning? Have a cofee. What do you love the most? My girlfriend. What does a habit mean to you? Drawing. Why are you creative? I don't know. Where is your energy inspired from? The waiting of something.

What would you say is your contribution to this world? Tourist. What is illustration to you? Hobby. How do you want to be remembered? In a good way. Explain one of your most difficult drawing experiences? Drawing Versaille's gardens is pretty difficult. If you weren't an illustrator, what would you be? I'm not illustrator. What is your dream job? Mine.

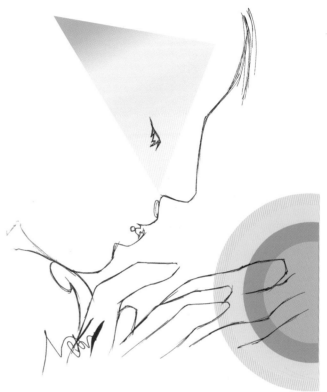

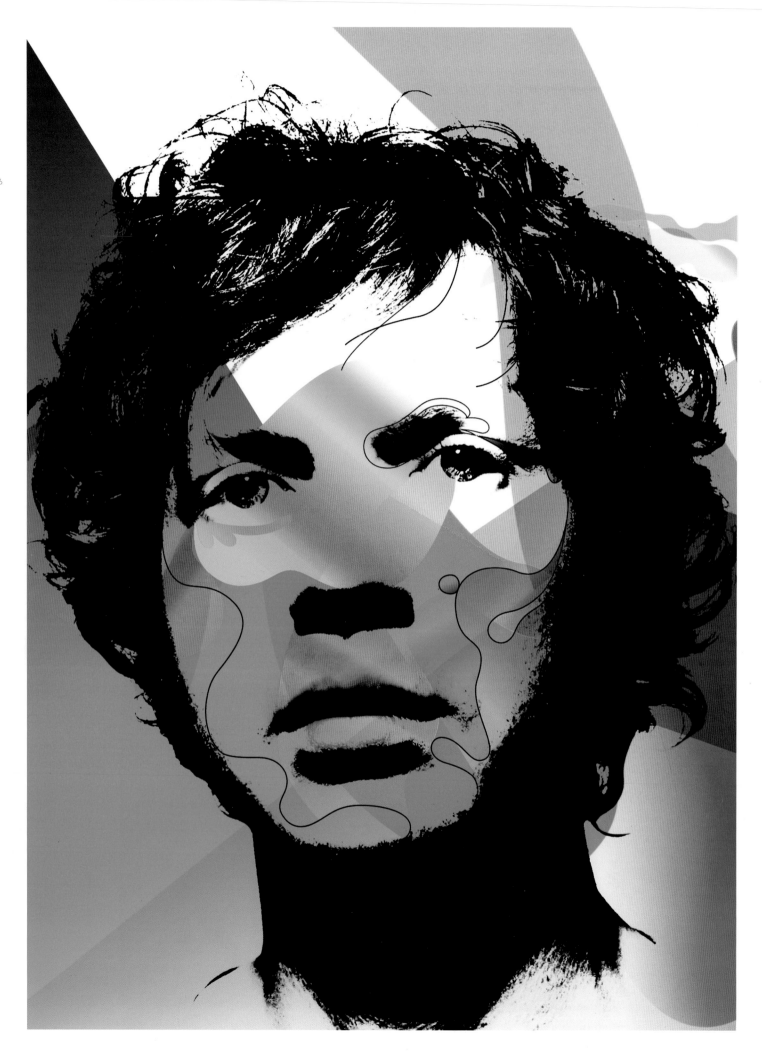

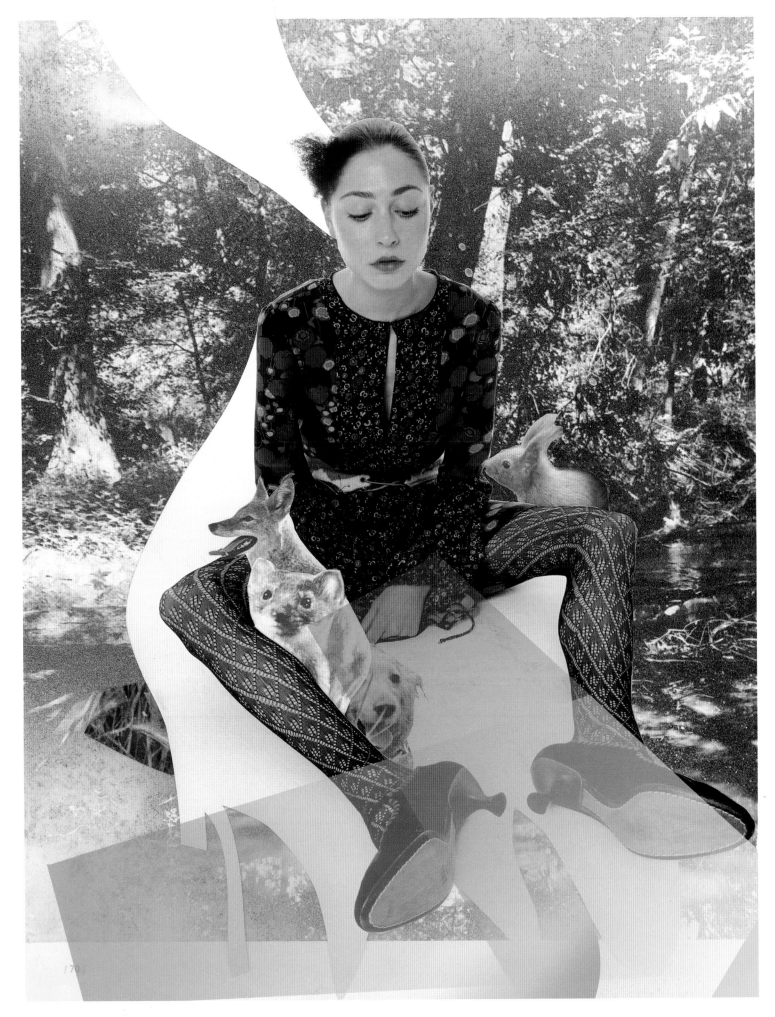

170

JEFFREY FULVIMARI

jfulvimar@hvc.rr.com

What is your nationality & astrological sign? American / Leo, but I do not follow astrology at all. **What schools have you attended?** I did my art school foundation program for two years at The Cleveland Institute of Art, in Ohio, then transferred to The Cooper Union in New York City, where I received my bachelor's degree in Painting and Sculpture. **What is the first thing you do in the morning?** Not very proud of it, but I smoke a cigarette and have a cup of coffee. I draw just about every night, at least one drawing before I go to sleep. I push myself even when I am not inspired. They used to say in art school, 'Never a day without a line'. I pray also every morning, or try to, and have what is called "quiet time" with God and read devotionals. **What do you love the most?** A lot of things, but God first. Then I love my family and friends and my animals. I have two cats and two dogs. I also love living in the country after living in the city for so long. **What does a habit mean to you?** Habit in this part of the world is mostly a negative word. I guess my worst habit is smoking. I also always think I procrastinate, but am often told that I am very productive. But it never feels that way, no matter how much I do. **Why are you creative?** I never really asked why. I am not sure. I think everyone is creative, I just think mankind is creative by nature. It's whether or not they see what they do as creativity. I see people's creativity all the time, whether it be the way they arrange their furniture or dress themselves. I see many old men, say on the street in NY, and the way they dress is so creative, but they would probably never think of it that way. **Where is your energy inspired from?** I work a lot at night, and overnight, and a friend of mine recently said that when I do that I am plugging into some sort of dream state that gets somehow channeled into my work. But I wouldn't recommend it to anyone, since it makes you lethargic and tired in the daytime and a little out of sync with the rest of the world. But I have been like this my whole life, so I guess I don't know what it is to be 'in sync', and besides is anyone ever really 'in synch' with the 'rest of the world'? But that's the energy part of the question, and I see energy and inspiration as very separate. My inspiration comes from my family, who is my real audience. I started drawing girls really early, since my first subject matter was really my two older sisters, who I am very close to. Also, my mom's side of the family were all women, and I used to see them doing crafts and creative projects like ceramics, flower arranging, copper jewelry making, etc. I got most of my of inspiration from them, and still do to this day. **What would you say is your contribution to this world?** I like to think that I am a part of a small group of people who aim to bring some positivity into the small part of the 'world' or industry that we touch. I guess it's more than one discipline, but I feel akin to anyone who is trying not to be overly critical in their work, and also not too sappy or sentimental, but positive and hopeful. It was the stuff that I responded to most when I was a working class kid growing up, and that is the sort of work I have always aspired to. **What is illustration to you?** I guess this answer applies also to the one above. I chose illustration because it's really a humble discipline. I used to think that I wanted to be big and famous, and really chased after that at one time in my life. I either wanted to be a really famous artist – as in 'fine artist', or an actor or singer – a 'celebrity', whatever. But really, over time, deep down I always shied away from it and found to my great surprise that I wasn't really cut out for the spotlight. I have a lot of friends who thrive on that sort of thing, and I saw what a nightmare it can be, so over time I came to terms with the fact that I never really wanted it. I did spend time following those goals and had some small successful experiences in many areas (enough good to satisfy my curiosity, and enough bad to confirm my doubts), before finally settling on illustration. I guess subconsciously I chose illustration because it allows a person to funnel all their talents into something that is rewarding and enjoyable, without running the risk of getting out of control or making the person super famous, like say for instance photography or rock music. Illustration is a supportive role, you are always performing a service or collaborating with another person's vision, whether it be an author or an art director or a designer, so in the end it's not you out there where the arrows are flying. Illustration is also a commercial discipline, and having grown up relatively poor, I am not ashamed of that at all. In fine art, there is a great conflict between art and commerce, and

whether they admit it or not, there is always a piece of a fine artist's life that involves making a living and making money. I know it's never been a choice in my life. This is a job and I have bills to pay, and I am glad that I can do something I enjoy and other people enjoy it, too and that is that. I am always grateful that it allows me to pay my bills, and I see it as a blessing, not as a curse. **How do you want to be remembered?** Oh, I guess to my family and people I know I hope it's a pleasant memory. But to the world at large I guess I value my anonymity enough to say that I don't really aspire to 'be remembered'. I just hope that people like my work while I am doing it, and it makes them smile or feel good at the time. But becoming a mono-lithic presence is not really my focus. Besides, I am still relatively young...(that's a joke). **Explain one of your most difficult drawing experiences?** Oh, well hmmmmm... . I guess it involves the commercial aspect. It is always difficult when people do not see what you do as a service, and that you are doing it to make a living. So the worst jobs I have are when you have a client who could pay well, but doesn't, and in the end you end up feeling taken advantage of. Doesn't always happen, but I am saying this to younger people embarking on an illustration career to dispel any myths of fortune. It's a tough job, and it takes a long time to get people to see its worth. People are always luring you in with the promise of 'exposure'. But what happens in illustration is that sometimes, since your style is more or less like a fingerprint, other clients might not hire you because they identify you too much with the product that you did the 'expo-sure' job for. This is something that I wish someone would have shared with me in the beginning, and most of us have to learn it the hard way. This is where it is a good idea to have several related styles and not get too identified with a single way of drawing. It's a fine line to walk, because you do have to have a signature style, and whatever you do has to be immedi-ately recognizable as yours. But then again, you have to offer a diverse portfolio. I can't really pin down a specific instance of a difficult experience, but I can offer that scenario. Again, I am only saying this to readers of this book that might have hopes of making it as an illustrator, and it's advice that I really could have used when I was young. And on the creative side, the best art directors are those who can bring the best out in you without too much direct interference. The worst are those who are drawing through you and who may be fostering some frustrated ambition as an illustrator or something. So young illustrators be prepared for that, too. It's not unmanageable, and I actually have gotten better at dealing with it, but it is there and has to be faced. I have had a lot of great art directors in my life however, and have learned so much from them all. But occasionally you have the type who will actually come over to your studio and put a pen in your hand, then grab it and move it for you (I have actually had that happen to me once). **If you weren't an illustrator, what would you be?** Hmmmm... . Tough question. It's sort of like, if you didn't have brown eyes what color would you have. I honestly have been doing this since I was two years old, so it's not such an easy answer. I could see being a moss gardener (I love moss), or maybe a relief worker in an underdeveloped nation. That would probably be the most rewarding job, and something that would take more guts than I probably have. But I guess if I am to answer this question honestly, I would have to say that. **What is your dream job?** I guess it would be helming a full-length animated film. I think so much has died with Walt Disney. When he was alive, there was so much life in the medium. Now I think its all so sterile and has really lost it's charm. If you look at 'Sleeping Beauty' or 'Snow White', those are real worlds of enchantment that were drawn under his direction and to the utmost detail. Perhaps he ruled with a whip or whatever, but the final product was so lovingly and sensitively delivered. When a child sees something like that, they feel so loved by the world and cared for. Their imaginations are inspired and the craft is passed on that way. This sort of attention to craft and skill conveys a warmth that is really not around anymore, and what I feel from most illustated films is 'marketing', unfortunately. You also see this sort of greatness in the work of Osamu Tezuka and Max Fleisher. So you see, my ambitions don't really lie in fashion at all... .

Olivia
is mad,
mad mad...

... for plaid.
plaid, plaid.

we like
to
match
sometimes

Sophia invented cool, or at least she
She thinks she did.

Lana's head is
in the
Stars.

THOMAS GAVIN

thomasgavin@btopenworld.com

What is your nationality & astrological sign? English and Scorpio rising. **What schools have you attended?** Central St. Martins (B.A. Hons. Graphic Design). Barnet College (Foundation Art & Design). **What is the first thing you do in the morning?** Click my back, back into place. **What do you love the most?** My family and other animals. **What does a habit mean to you?** A habit to me is something we inherit and repeat over and over without ever really noticing it, until someone comments on how endearing or annoying it is. **Why are you creative?** Because I was created by two very imaginative and talented people, Frances and Pat Gavin. **Where is your energy inspired from?** All sorts of things. Sports, dance, film, music, animals. Pretty much any natural or artificial form that isn't rigid and looks or sounds great.

What would you say is your contribution to this world? To communicate visually, through my work, a fun, humorous and graphic expression of urban culture. **What is illustration to you?** Illustration to me is about forging artistic views and sensibilities together with a knowledge and awareness of what's happening in the marketplace today and creating an easily accessible visual language that's pleasing to the eye. **How do you want to be remembered?** A strong force in the industry of image makers. Like father, like son. **Explain one of your most difficult drawing experiences?** Trying to capture the simple and perfect lines of Pompom's polar bear sculpture at the Musée D'Orsay, Paris. **If you weren't an illustrator, what would you be?** Painter, full-time. **What is your dream job?** Professional surfer.

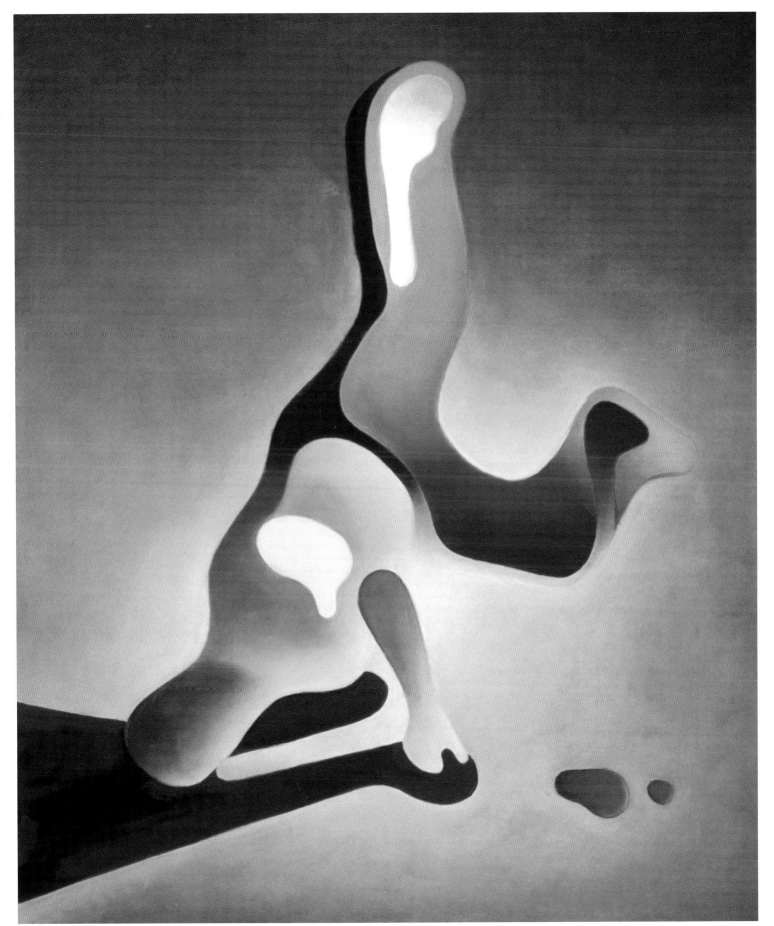

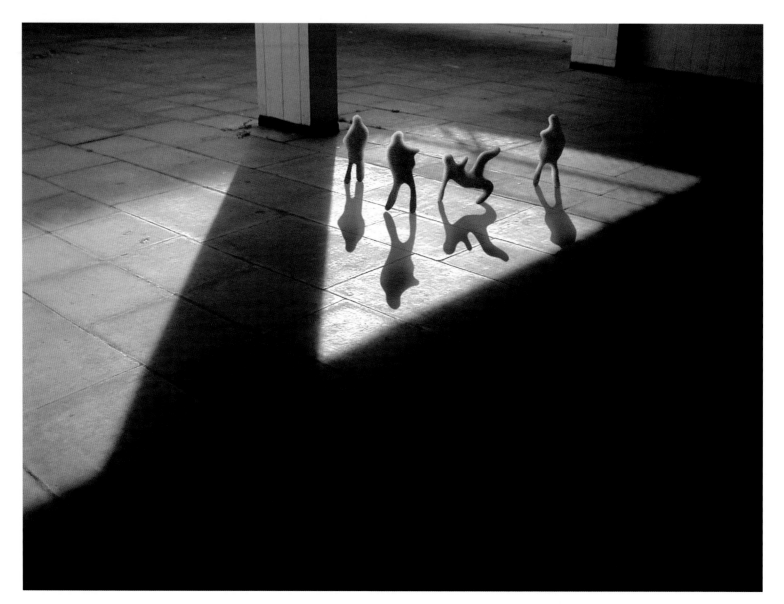

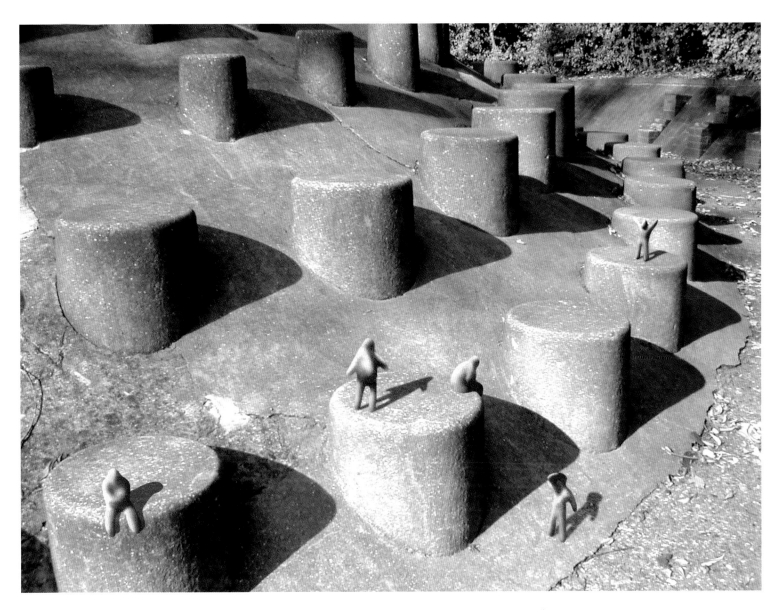

MICHAEL GILLETTE

m.gillette@sbcglobal.net

What is your nationality & astrological sign? Welsh. Cosmic jive wise, I'm on the cusp of cancer and Leo, Lancer? Cleo? **What schools have you attended?** Kingston College of Genteel Crafts (London). Skool o' hard knocks (international). **What is the first thing you do in the morning?** Kiss wife, kiss cat, kiss kettle, kiss off E-mail. Sometimes I add a shower to this equation, in which case I rinse and repeat. **What do you love the most?** My wife and family. All else is tinsel. **What does a HABIT mean to you?** Hmm, the only thing I know about habits is they are a bugger to get rid of, so choose wisely. **Why are you creative?** I'm always in search of that buzz which creating something can bring. It doesn't last long but is pretty euphoric, like licking a toad. And of course the money. That doesn't last long either, but is also pretty euphoric.

Where is your energy inspired from? Music. **What would you say is your contribution to this world?** Blimey, a little early in the day for that. A steady stream of ephemeral hoop-de-ha. Half-a-hill o' beans? **What is illustration to you?** It's the coal in the engine. It keeps the train rolling down the tracks. **How do you want to be remembered?** Angel One: Wasn't he that loser? St. Peter. No way, man. He was dead handy with a ukulele. **Explain one of your most difficult drawing experiences?** Well, aside from tedious commercial wrangling, it's when that buzz I mentioned earlier is nowhere to be found and one has to redouble the efforts to find it. **If you weren't an illustrator, what would you be?** Miserable, or a radio D.J. Depends on what fate dealt. **What is your dream job?** Highly-acclaimed and successful lay about.

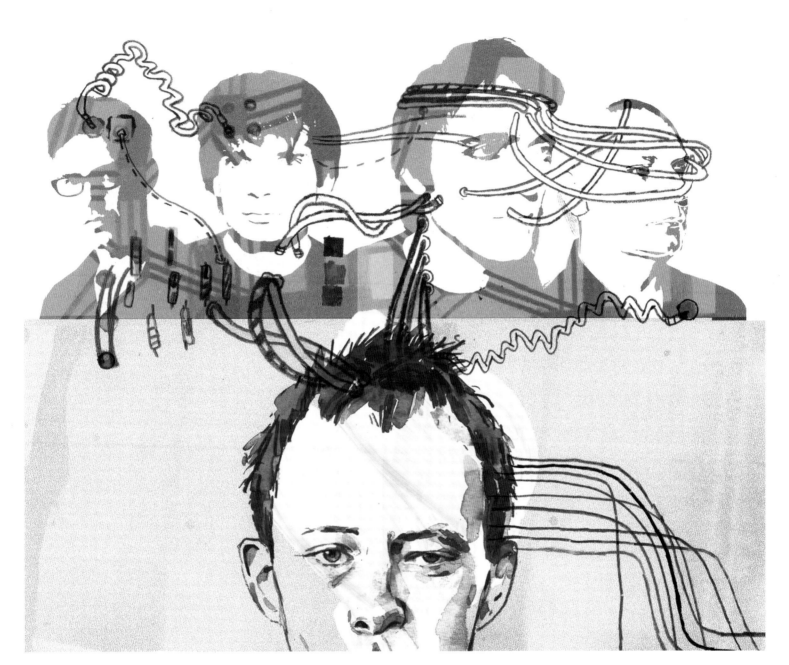

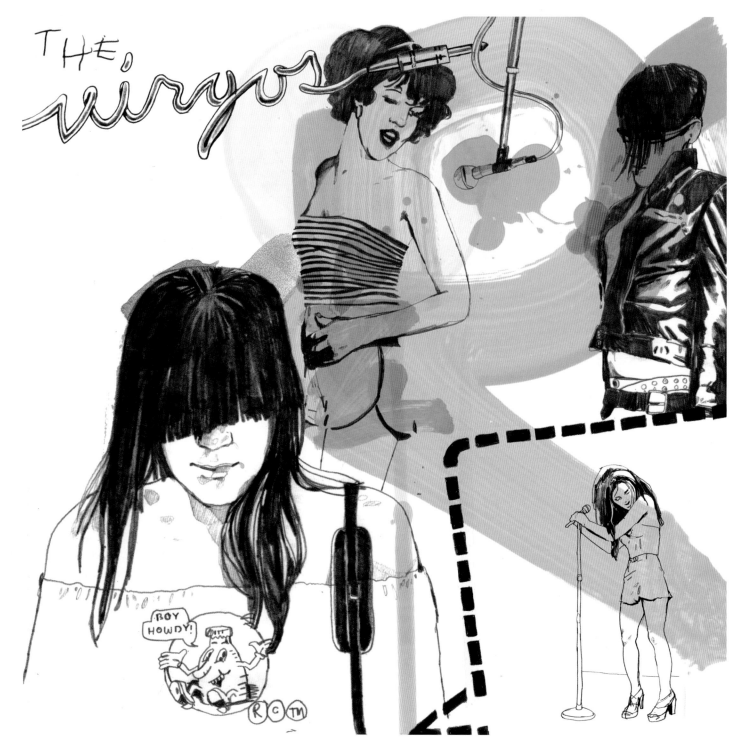

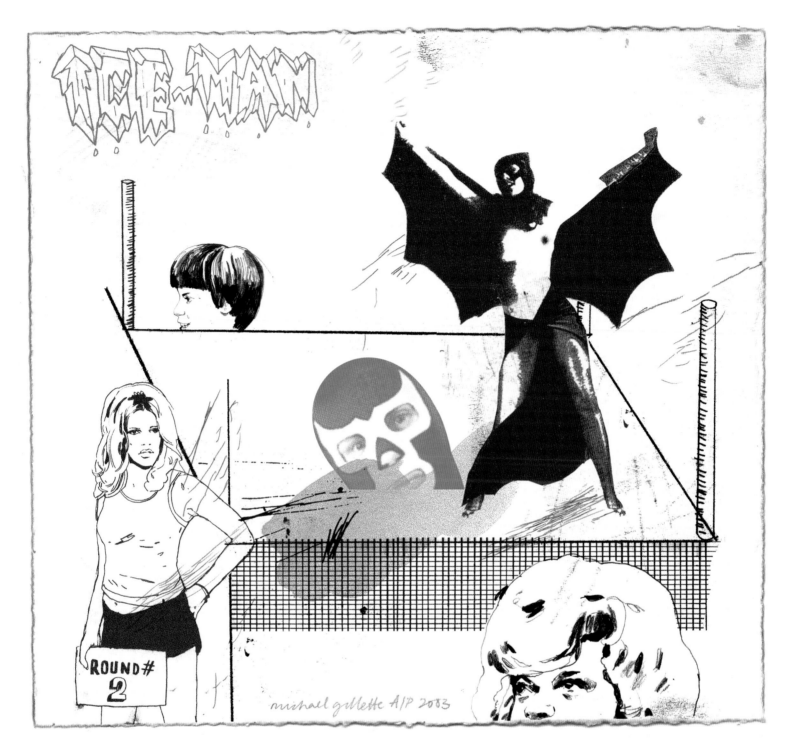

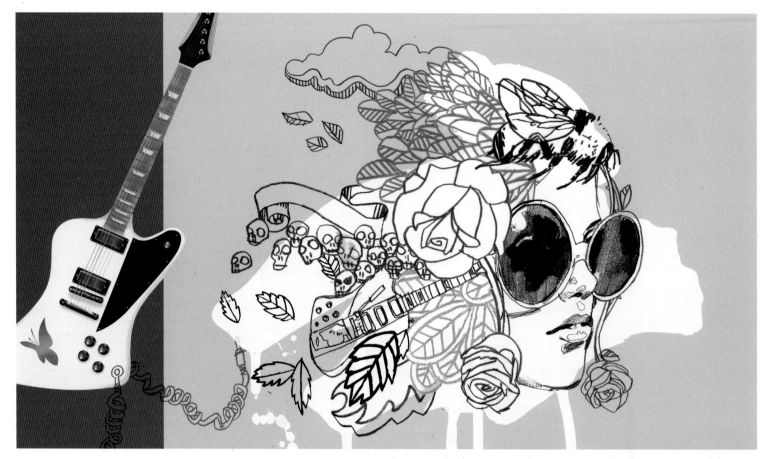

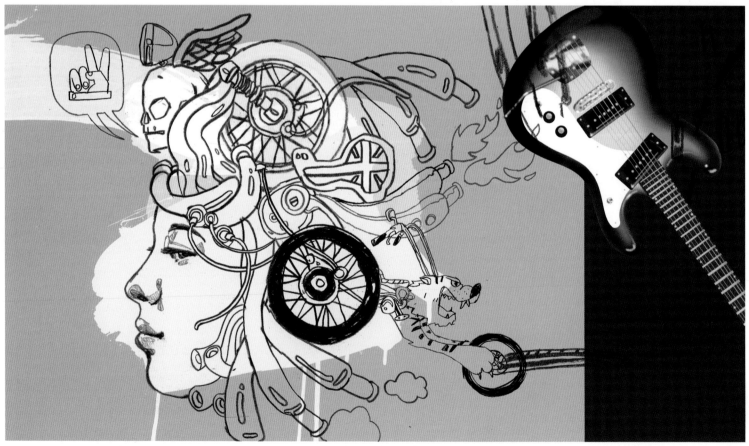

BAN CRIMINALLY LOGGED TIMBER

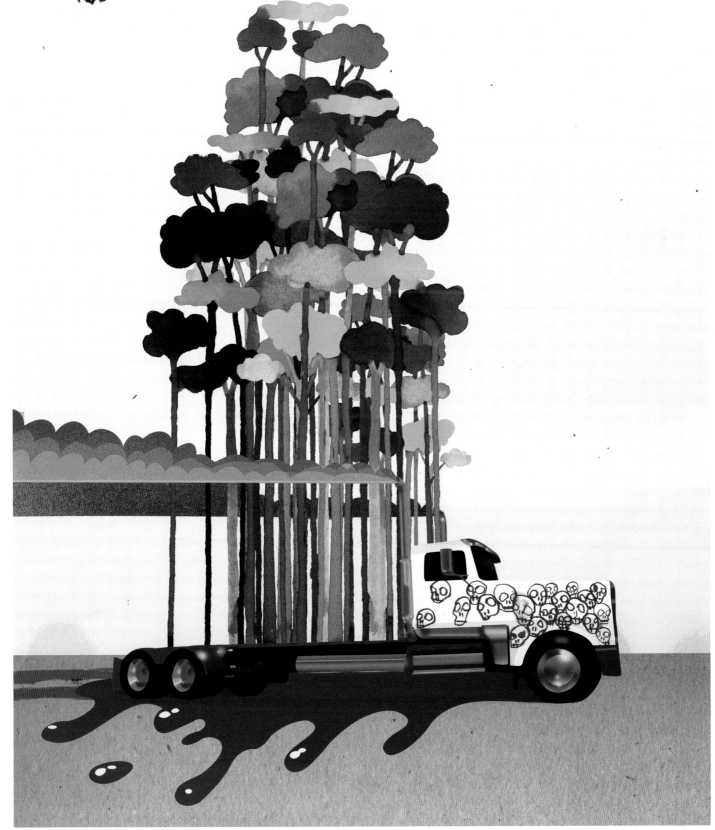

NICK HIGGINS

nick.higgins@virgin.net

What is your nationality & astrological sign? British / Ignatz. **What schools have you attended?** Freaky first school, ordinary second. Manchester University for a nerdy degree. Sir John Cass to learn drawing. Central St.Martins for the rest. **What is the first thing you do in the morning?** Look at the sky. **What do you love the most?** Encyclopaedia Britannica – everything in it. **What does a habit mean to you?** You find yourself in the middle of it but don't remember starting. Now, is it a good thing to be in the middle of? **Why are you creative?** Making images and making things is a way of explaining things to myself. If you can't pick it up, at least you can draw it. Make something for yourself out of it. **Where is your energy inspired from?** Accidents of nature.

What would you say is your contribution to this world? Decorated surfaces. **What is illustration to you?** Explaining things without using words. **How do you want to be remembered?** With a huge public monument in many cities around the world. **Explain one of your most difficult drawing experiences?** The more flawless the subject, the less satisfied I have ever been with the drawing. I have drawn hundreds of horses, all of them very sad beasts. I would find it very hard to draw a bicycle as well as I would want to. **If you weren't an illustrator, what would you be?** I would be writng a musical based on the life of Emiliano Zapata. **What is your dream job?** Illustrated guide at the Emiliano Zapata Museum.

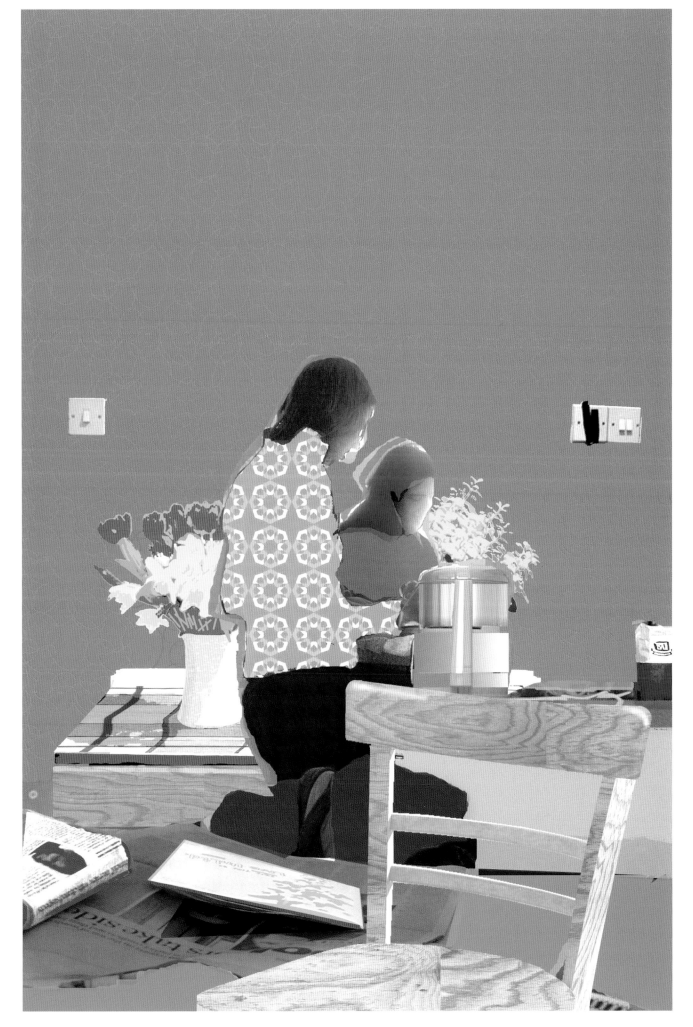

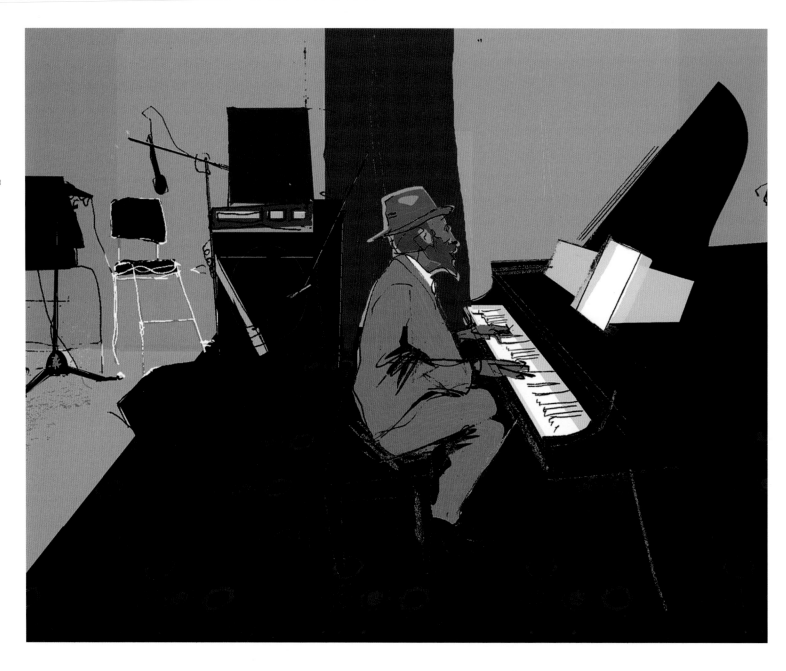

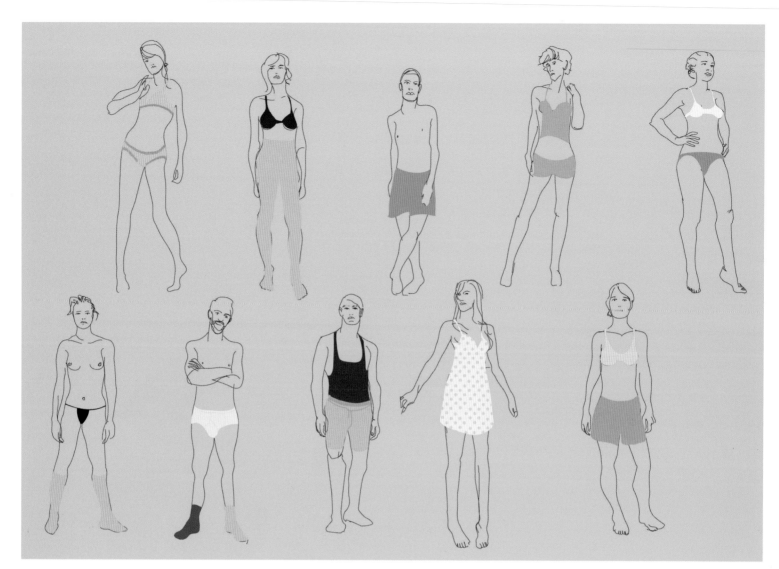

FAIYAZ JAFRI

faiyaz@bam-b.com

What is your nationality & astrological sign? Dutch / Virgo. What schools have you attended? Technical University of Delft at the faculty of Industrial Design Engineering. What is the first thing you do in the morning? Smoke a cigarette. What do you love the most? That I don't have to get dressed when I go to work. What does a habit mean to you? Repetition. Why are you creative? I was born like that.

Where is your energy inspired from? Short-term obsessive fixation. What would you say is your contribution to this world? Bam-b. What is illustration to you? Story-telling. How do you want to be remembered? I don't need to be remembered. I want my work to be remembered. If you weren't an illustrator, what would you be? Unemployed.

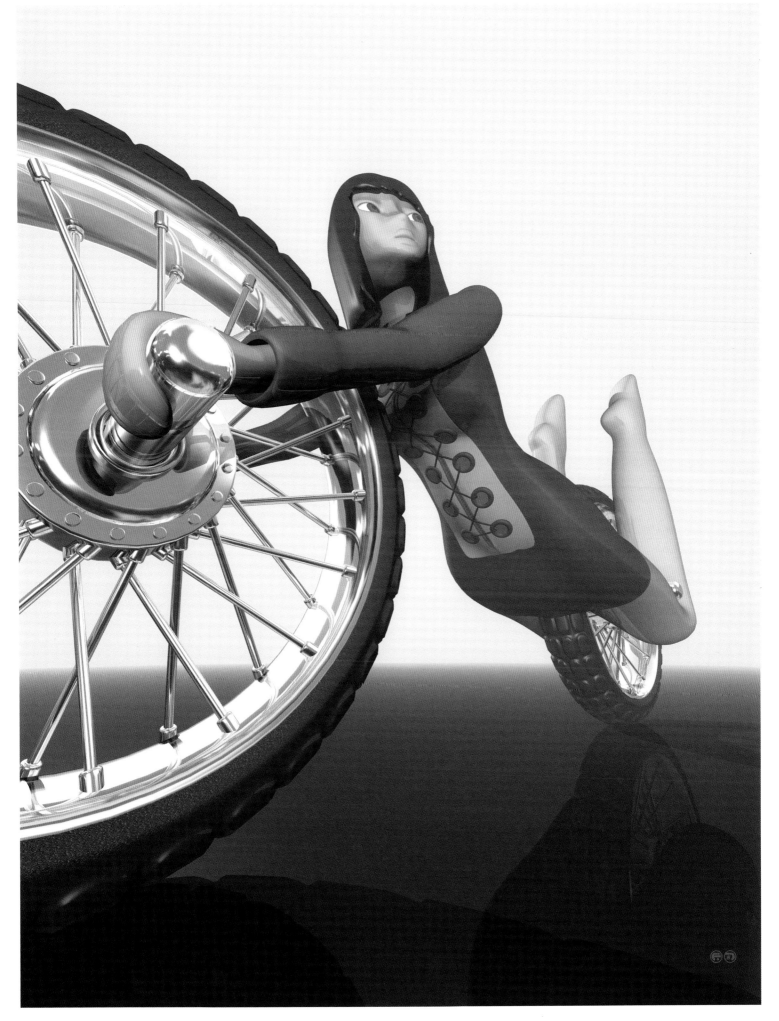

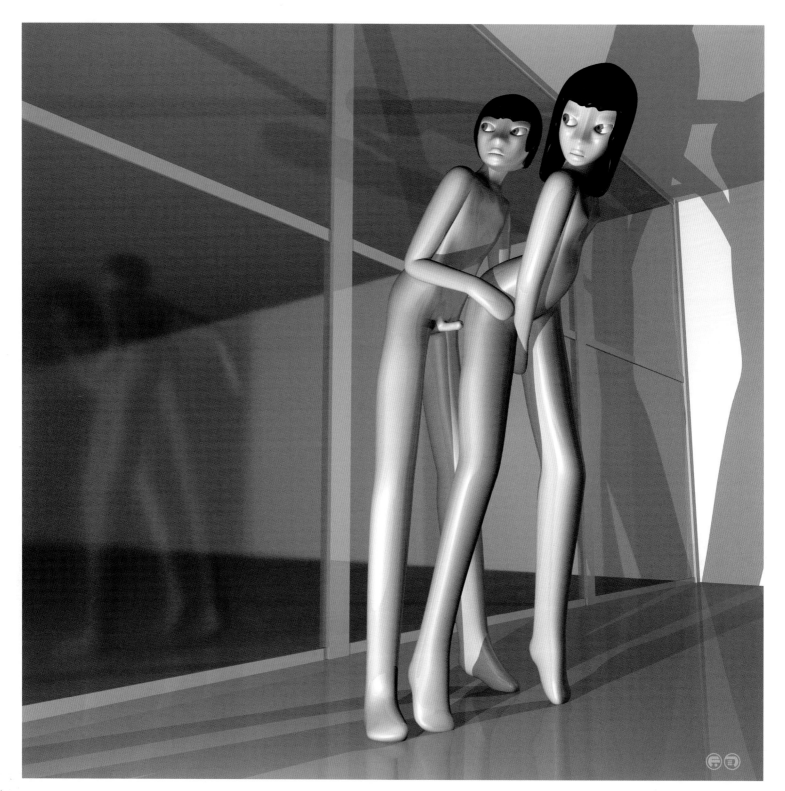

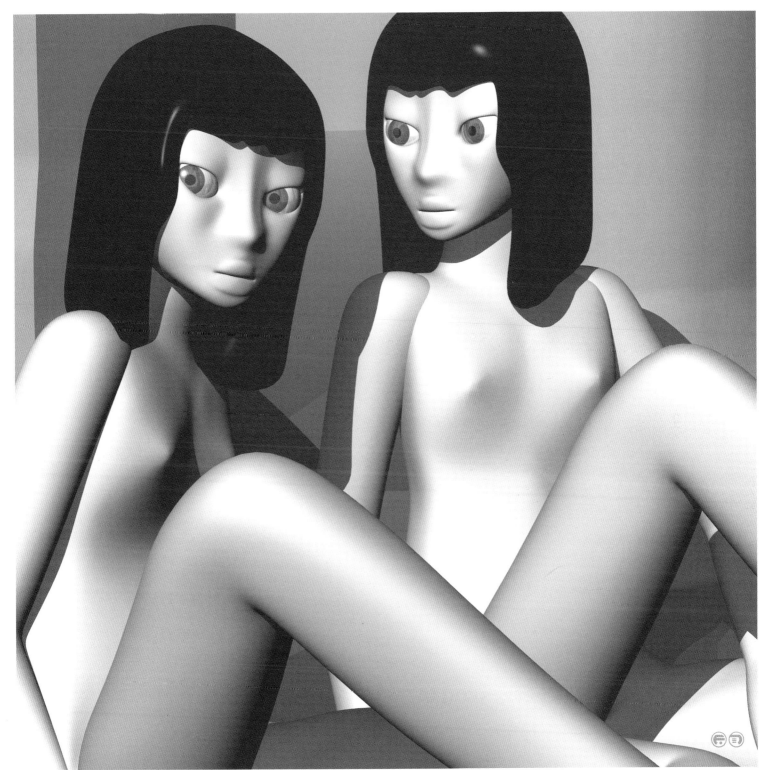

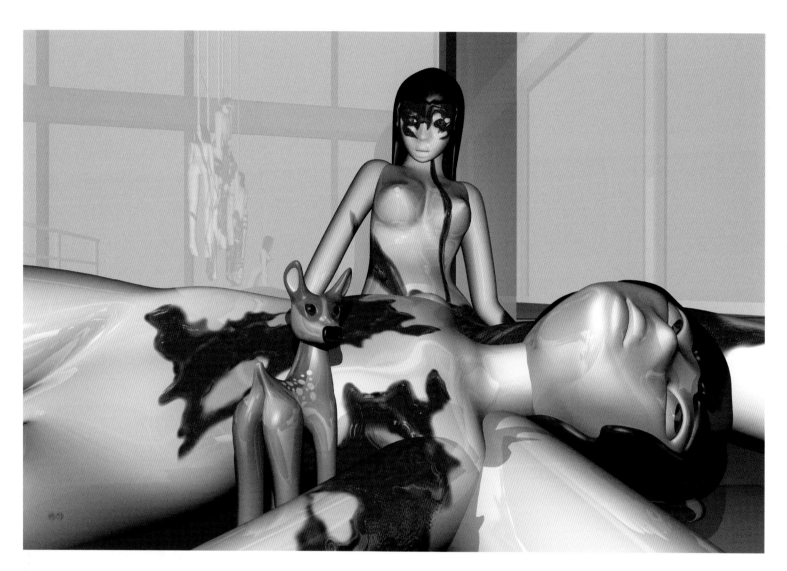

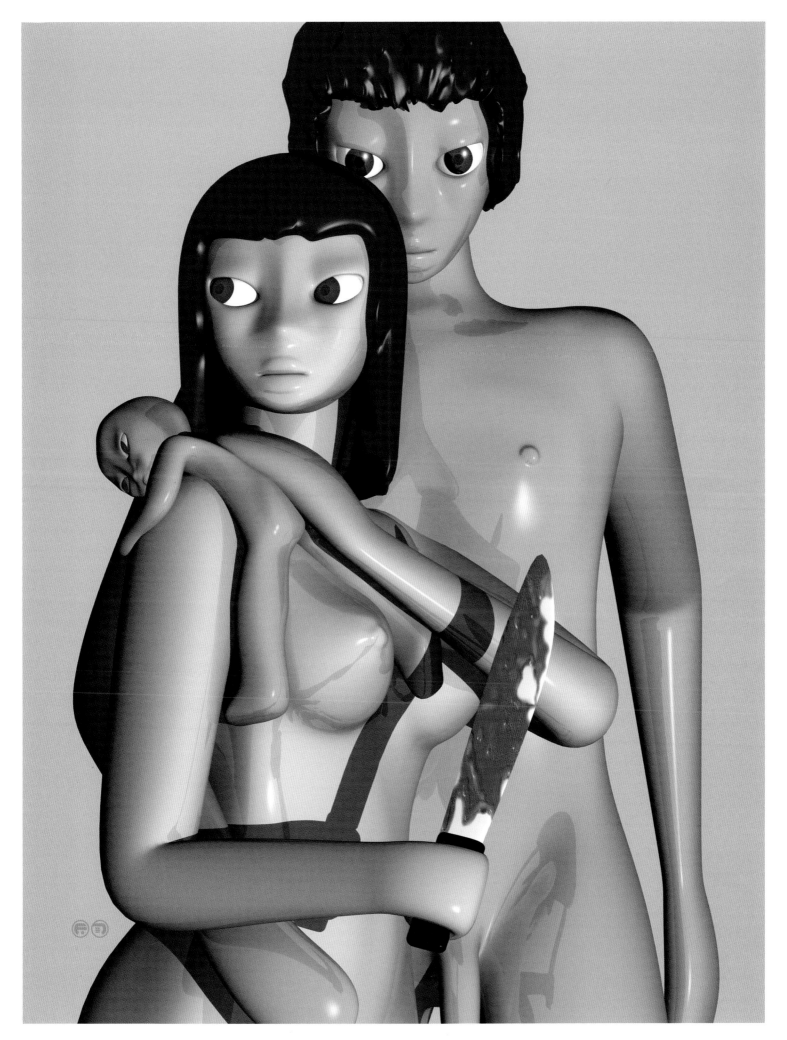

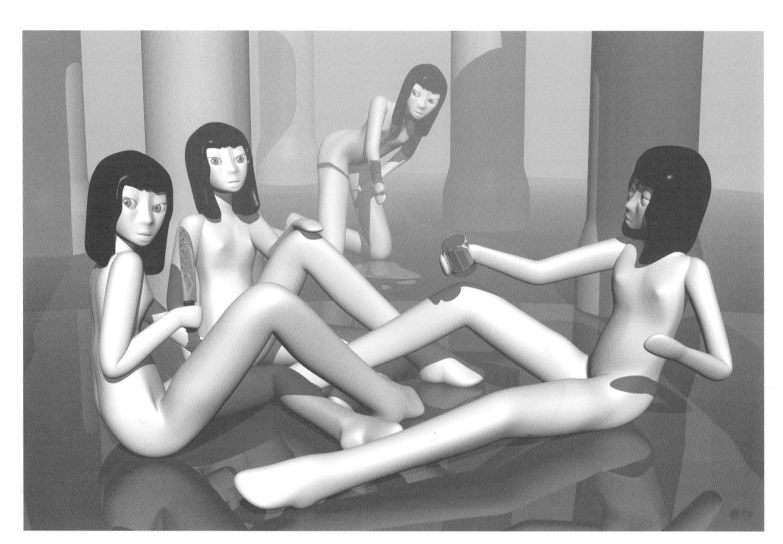

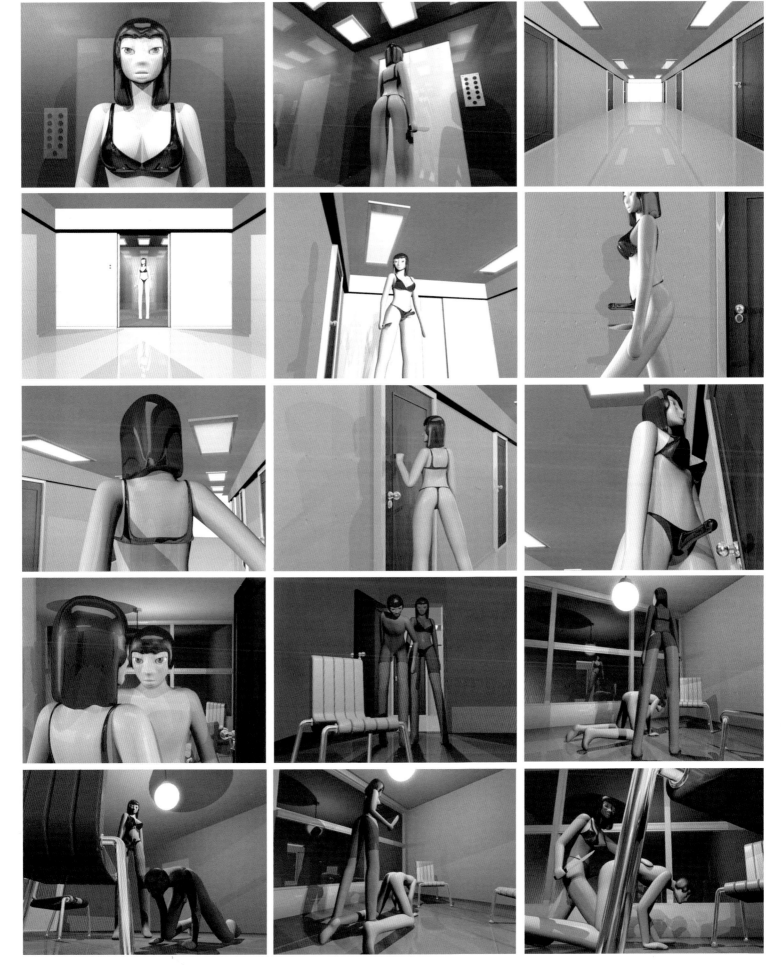

TAKAHIRO KIMURA

kim@faceful.org

What is your nationality & astrological sign? Japan / Cancer. What schools have you attended? The personal school with a genius fashion illustrator. What is the first thing you do in the morning? Meditation for 20 minutes. What do you love the most? All the things except me. What does a habit mean to you? I do not know. Why are you creative? Mission. Where is your energy inspired from? Sleep, food and the sun. What would you say is your contribution to this world? Discharging positive energy generated in my creation. What is illustration to you? Bread of life. How do you want to be remembered? I want to give a shock, but want not to be remembered. Explain one of your most difficult drawing experiences? I have not thought that it was difficult. I do not do a difficult thing. If you weren't an illustrator, what would you be? I do not know. What is your dream job? Live painting at Carnegie Hall.

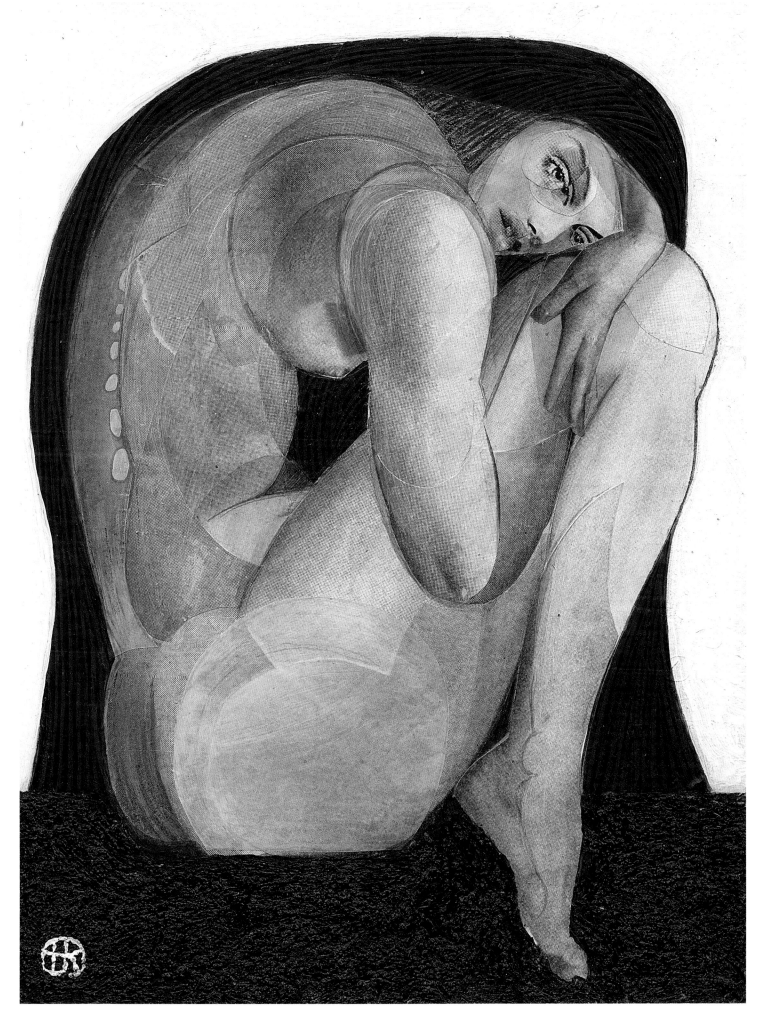

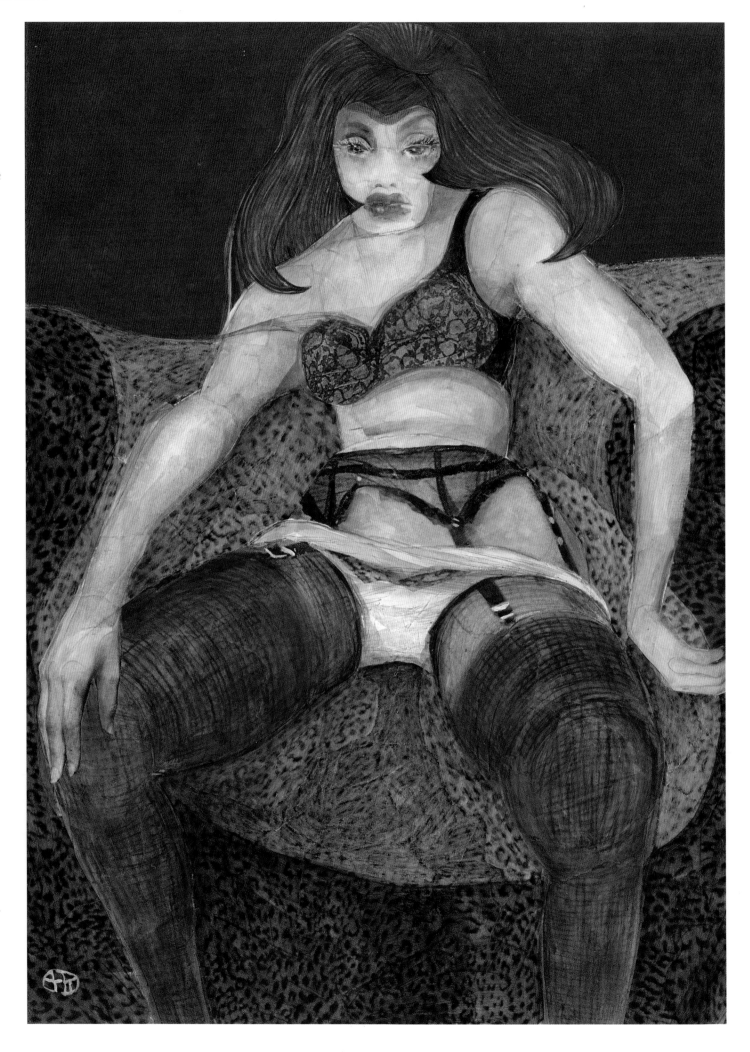

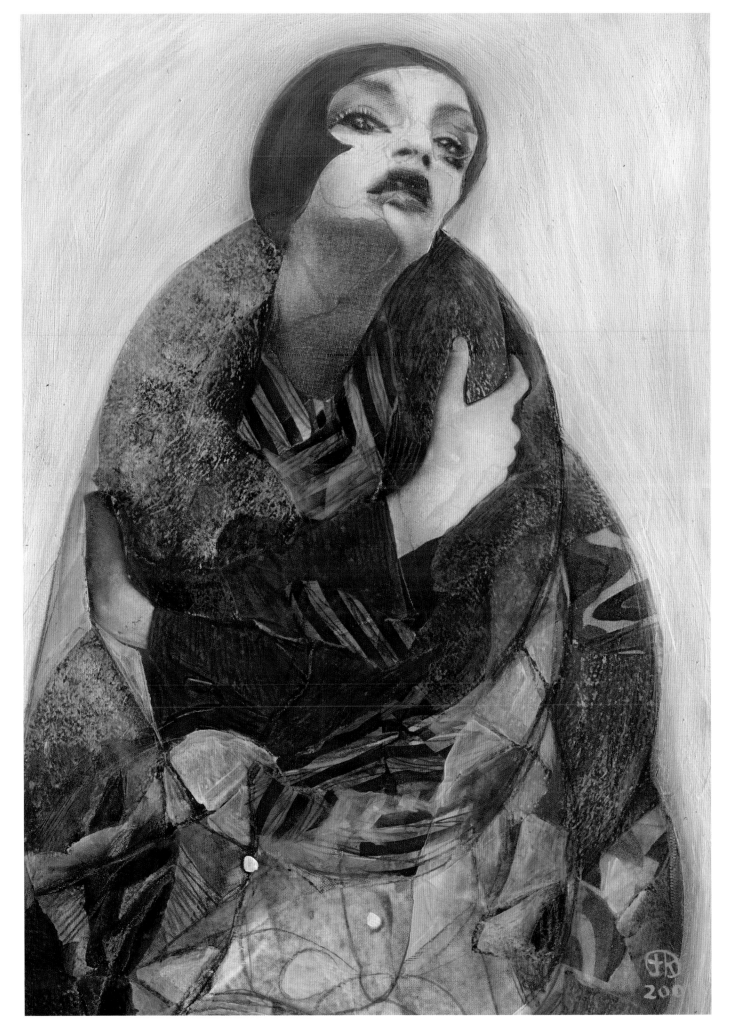

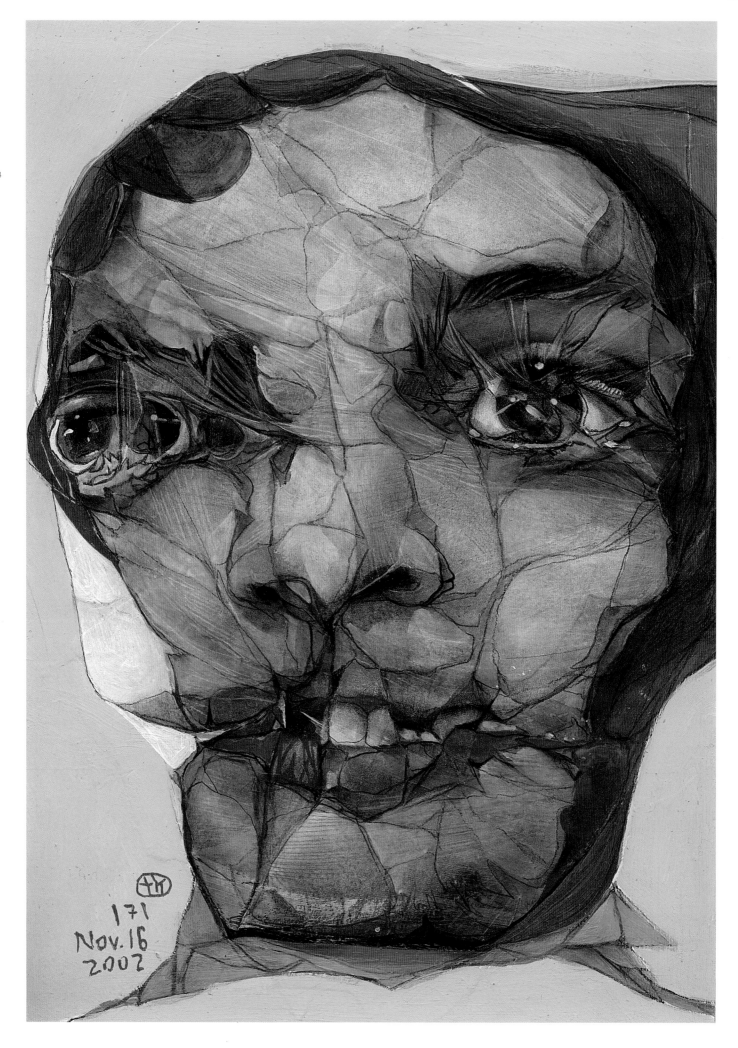

171
Nov. 16
2002

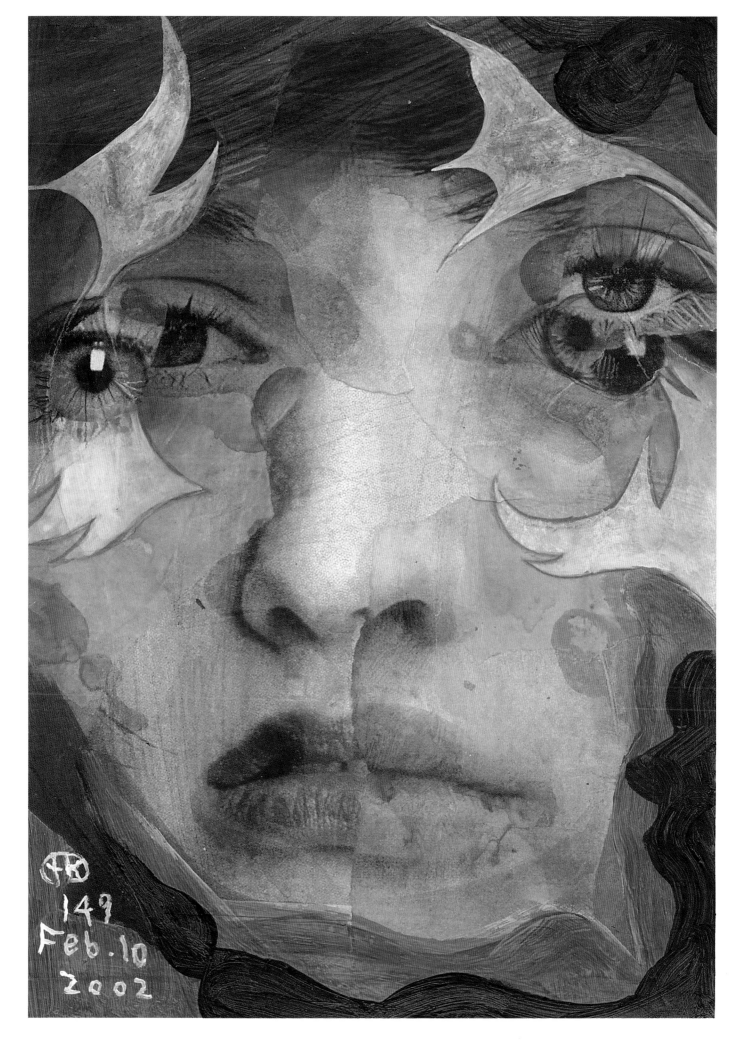

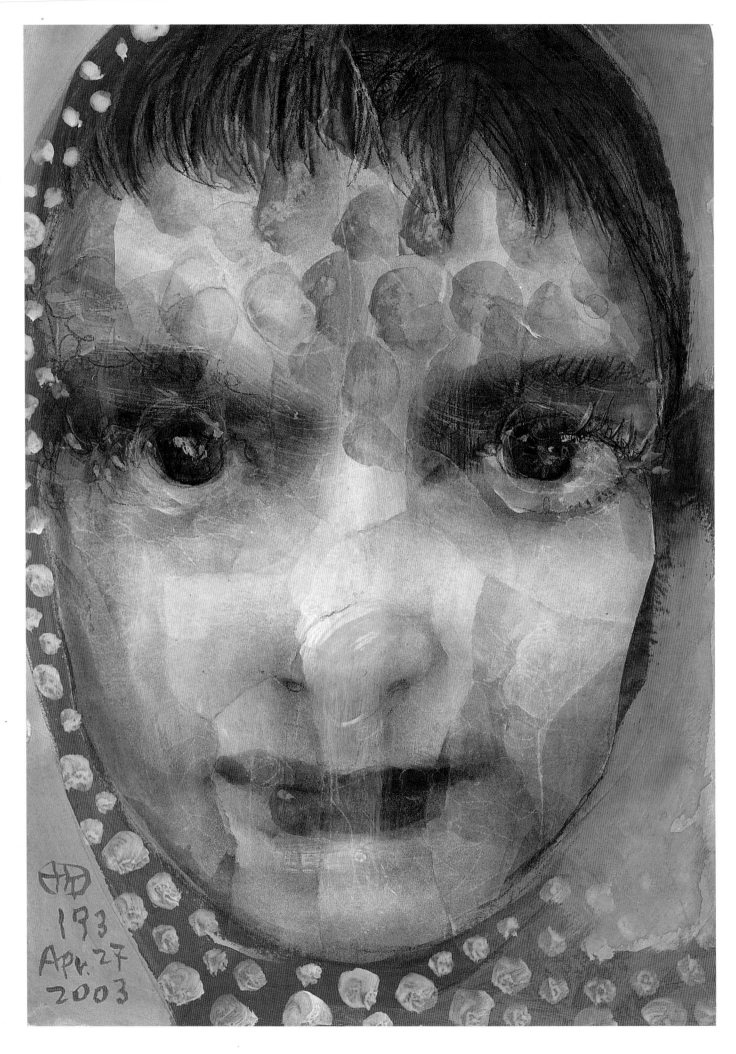

146

173
Apr. 27
2003

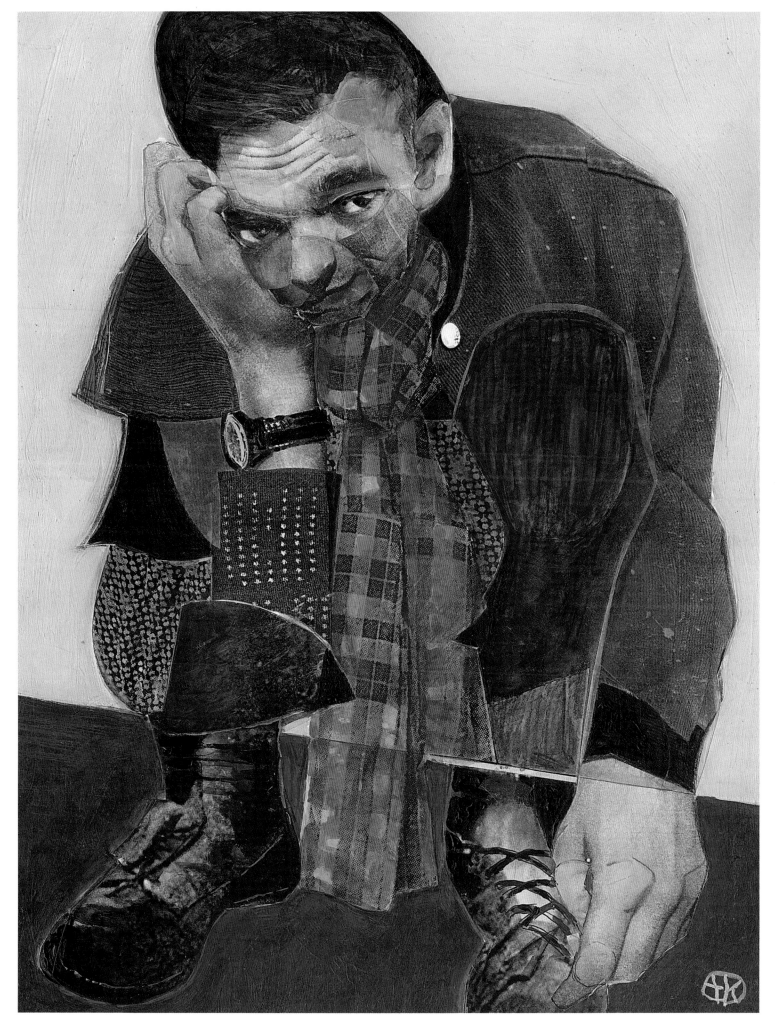

KINSEYVISUAL

dave@kinseyvisual.com

What is your nationality & astrological sign? American / Aquarius. **What schools have you attended?** The school of life: Trial, Chance and Error major. Also, AIP and AIA,'90-'93. **What is the first thing you do in the morning?** Kiss the love of my life. Gaze at the white walls that fall around me in thought to prepare my day. Drink coffee. I'm addicted, finally. **What do you love the most?** JJBNN. Artistic and creative imagery. Knowing there are new roads I have not yet been down. **What does a habit mean to you?** An inability to 'unlearn'. **Why are you creative?** It's part of my natural instinct, nothing more. **Where is your energy inspired from?** Seeing others express themselves through different mediums. My environment. **What would you say is your contribution to this world?** The ability to make someone obtain a feeling through something that I have created.

What is illustration to you? A recording of emotions through human movements. Something a computer will never be able to interpret. **How do you want to be remembered?** As an innovator without application boundaries. Transcending 'scenes'. I would rather my work be remembered than me. **Explain one of your most difficult drawing experiences?** When my 8th grade Geometry teacher tore up a drawing I spent the entire class time working on. She used me as an example of what happens when you waste her time. **If you weren't an illustrator, what would you be?** I might dabble in design, fine art and running a creative agency called Blk/Mrkt. What else interests me? I've thought about architecture, music, photography, directing. **What is your dream job?** The one I have.

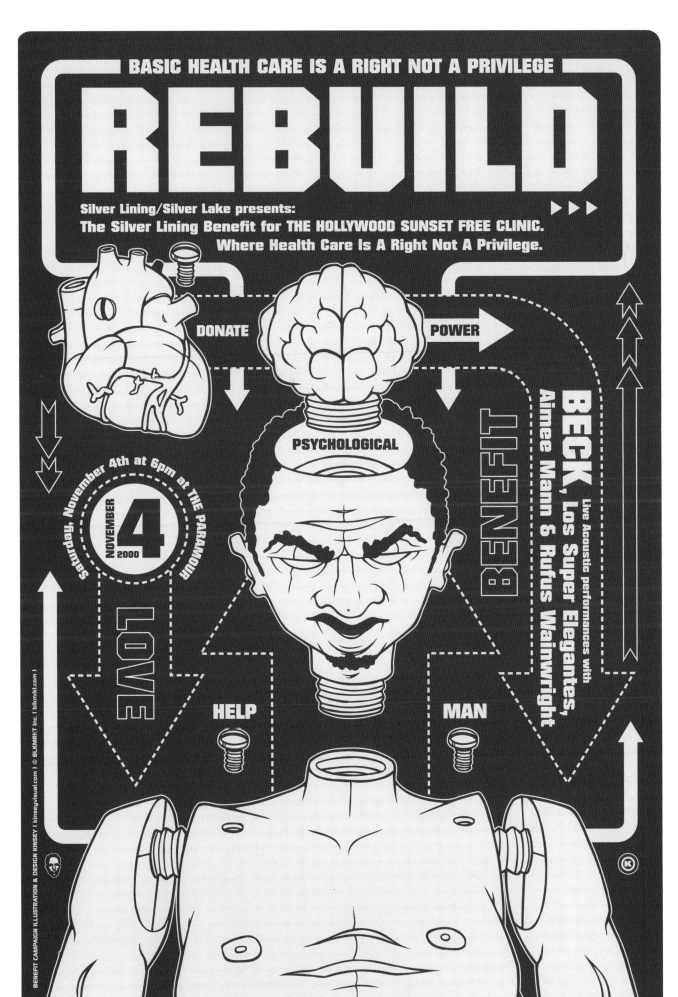

TATSURO KIUCHI

kiuchi@mejirushi.com

What is your nationality & astrological sign? Japanese / Aquarius. **What schools have you attended?** International Christian University; Tokyo Art Center; College of Design, Pasadena. **What is the first thing you do in the morning?** Go to the bathroom. **What do you love the most?** Skin-diving in the coral reef. **What does a habit mean to you?** Doesn't mean anything. You don't need to use your brain when it comes to habit. **Why are you creative?** Basically, because it is fun. **Where is your energy inspired from?** Other people's creative work.

What would you say is your contribution to this world? Can't think of anything, yet. **What is illustration to you?** It is one of my few means to say I am alive. **How do you want to be remembered?** I don't have to be remembered if I am no longer alive. **Explain one of your most difficult drawing experiences?** I forgot. I feel like every drawings are difficult, but forget how difficult when it is over. **If you weren't an illustrator, what would you be?** A fisherman **What is your dream job?** Murals for important landmarks anywhere in the world.

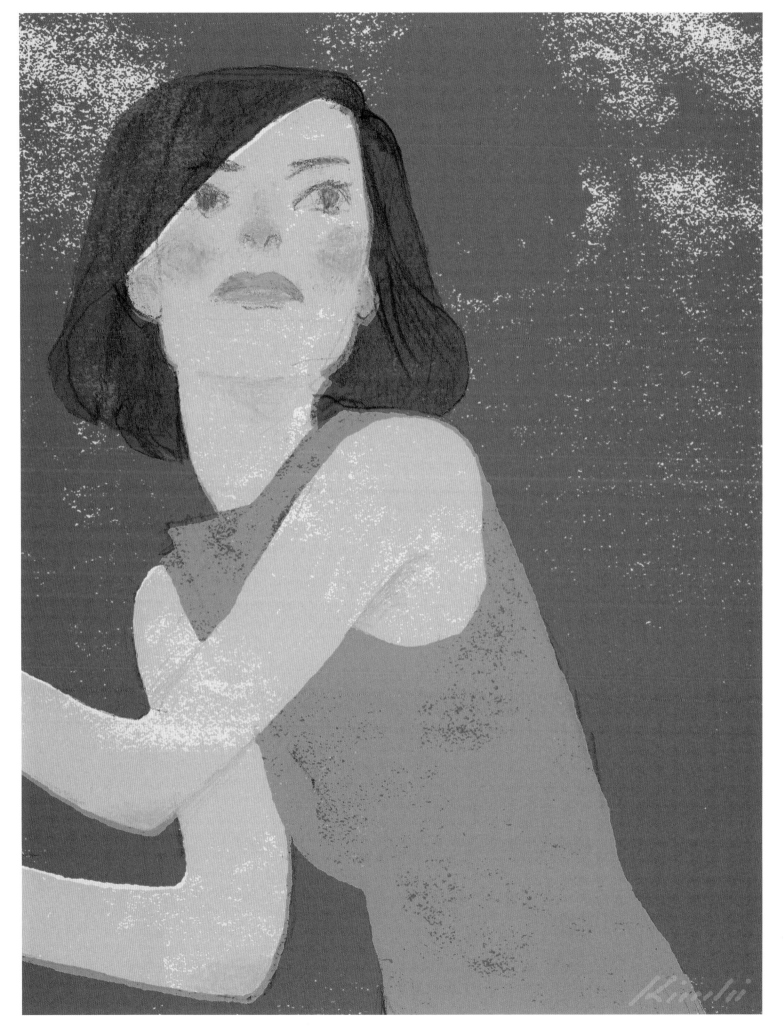

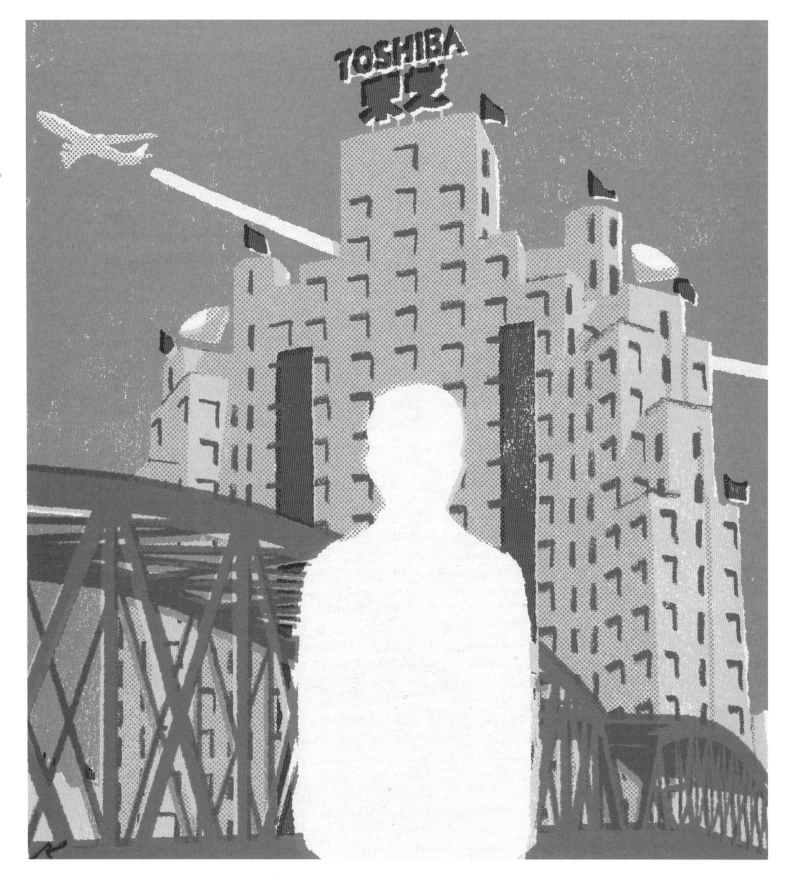

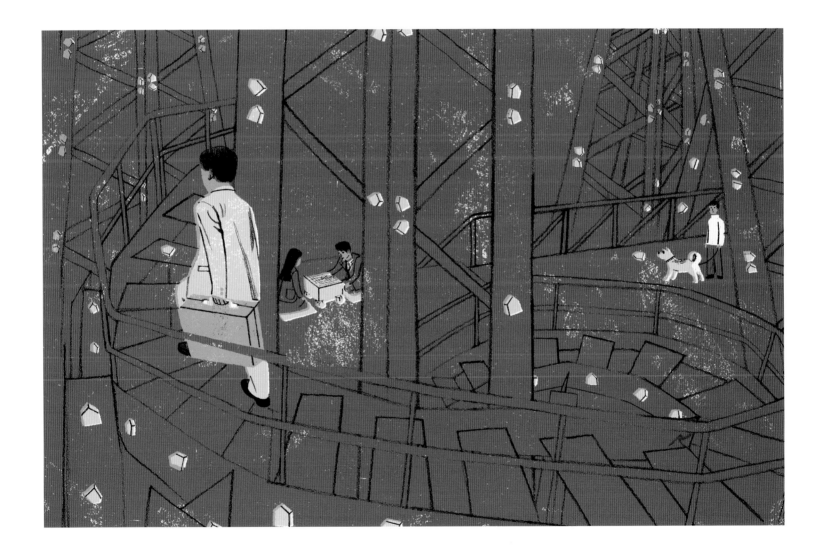

SEIJIRO KUBO

kubo@btf.co.jp

What is your nationality & astrological sign? Japan / Aquarius. What schools have you attended? Nippon Designer Gakuin in Shibuya, Tokyo. What is the first thing you do in the morning? Running (when the weather is nice). What do you love the most? Myself. What does a habit mean to you? My tendency to be easily depressed by tiny things. Why are you creative? Because I want to show my work to people (people I work with, and my friends). Where is your energy inspired from? It comes out of my complex.

What would you say is your contribution to this world? Well, it's something I've never thought about. What is illustration to you? The place where I can express myself the best. How do you want to be remembered? A person who is fun to be with, but is mean a little bit. Explain one of your most difficult drawing experiences? I am not good at drawing in front of many people. If you weren't an illustrator, what would you be? I don't know. What is your dream job? Working on a picture book or something that remains.

Enjoy 100%, QIWQ

We only have now.
So now is the time to play, laugh, enjoy.
Give it 100%.

Enjoy 100%. aiwa

We only have now.
So now is the time to play, laugh, enjoy.
Give it 100%.

Enjoy 100%, aiwa

We only have now.
So now is the time to play, laugh, enjoy.
Give it 100%.

8-9-10 ! *Jitterin' Jinn*

TIM MARRS

tim.marrs@virgin.net

What is your nationality & astrological sign? British / Cancerian. **What schools have you attended?** I'm thinking you mean art schools, right? Well firstly BA Hons in Graphic Design / Illustration at Humberside University 91'-94' and then an M.A. in Communication Design / Illustration at Central Saint Martins College of Art 96'-99'. **What is the first thing you do in the morning?** Wake up! Then think, 'Life's good,' scratch my arse, then make a cup of tea and toast for the girlfriend after I've washed my hands of course. **What do you love the most?** Going to the seaside with Shelley. **What does a habit mean to you?** I think bad habits are a part of my make up! As an illustrator it can often mean me being lazy and re-using imagery or not trying to push a particular brief as far as I can. As for good, keeping up using my sketch books. **Why are you creative?** I owe a lot I think to my grandparents. They from a young age encouraged me to express myself creatively and always showed endless enthusiasm and passion throughout my early years. They also had what seemed like endless amounts of paper/ old school pads grandad was a Science teacher so I never really stopped drawing when I was there. I will always remember holidays with them as a youngster, and how we used to put scrap books together, including post cards, maps, guides and drawings–either by me or my grandad–all recording our trips out. This always stuck with me and I guess my attitude towards my sketch books is quite similar to this. Bless 'im'. **Where is your energy inspired from?** Beleif and faith in myself and my work. **What would you say is your contribution to this world?** hand made-looking, Mac-based images that rock...? **What is illustration to you?** A great way of life...when you're busy. **How do you want to be remembered?** Kept smiling through out. **Explain one of your most difficult drawing experiences?** The transition from A-level art to Art Foundation diploma. They pushed me so hard from the start to express myself through mark-making, using different media and making you think and question your work with thoughts on composition, dynamics and expression. I guess the usual art college experience, but something that has always stayed with me. A shock to the system, then, especialy when previously used to drawing stagnant still-lifes of fruit and sheep skulls...nice. **If you weren't an illustrator, what would you be?** A bored, below-average graphic designer, perhaps? Never could get excited about type unless it was hand-rendered! **What is your dream job?** A spitfire pilot...Oh, now, er... Bookcovers for any George P. Pelecanos novel, or CD covers.

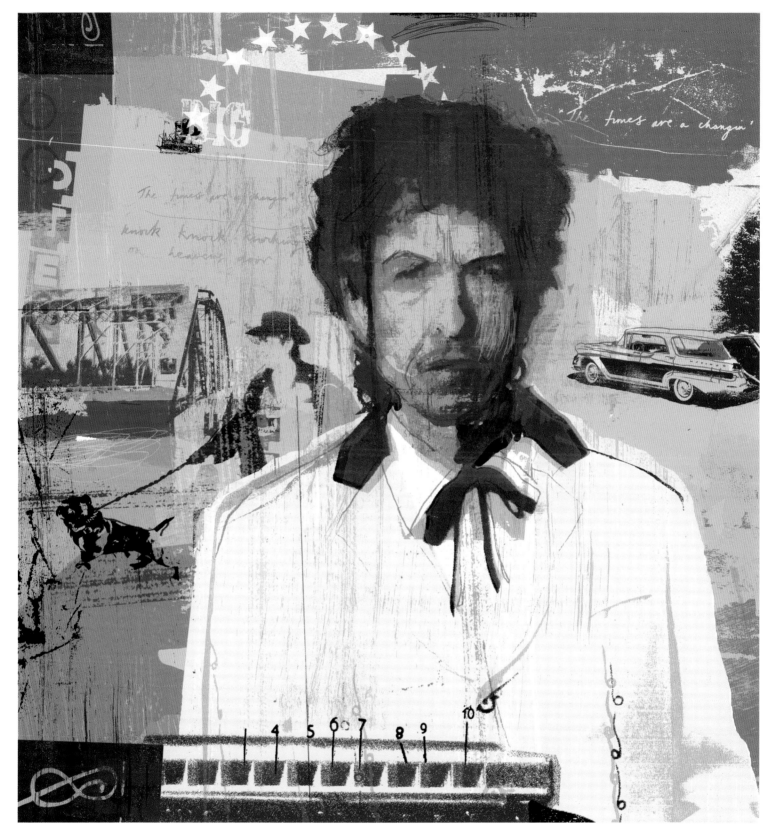

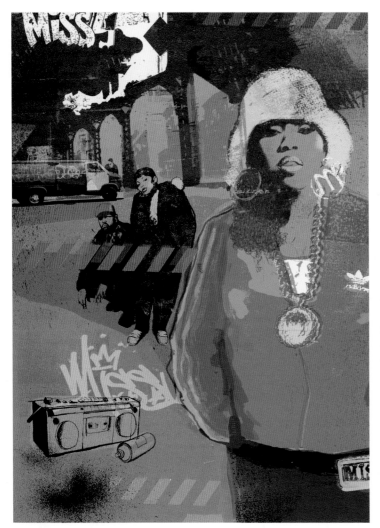

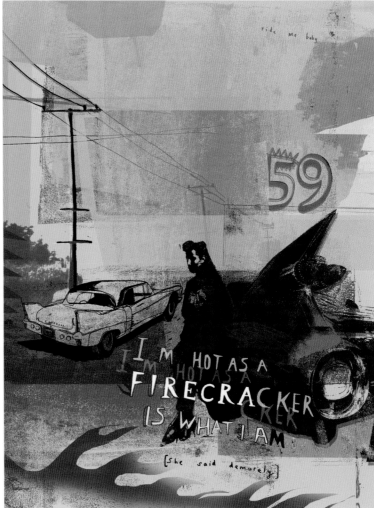

ME COMPANY

paul@mecompany.com

What is your nationality & astrological sign? Jess: British and Sagittarius. Rossmina: Spanish and Tarus. Paul: British and Gemini. Bekka: Russian and Capricorn. Roy: Israeli and Sagittarius. **What schools have you attended?** Rossmina: Universidad de Vigo; Universidad de Bellas Artes, Bilbao; Wimbledon School of Art; LCP London Institute. **What is the first thing you do in the morning?** Paul: Get up. Bekka: Turn over. **What do you love the most?** Charlie: Howling at trains. Rossmina: RGB and marzipan. Jess: Everything under a null. Paul: Endorphin and CMYK. Bekka: Charlie. Charlotte: Strawberry Mivvys. Roy: BMW 600. **What does a habit mean to you?** Rossmina: It's a kind of mouse but with longer ears? Paul: That's rabbit. **Why are you creative?** Bekka: I am destructive and creative. I am a dichotomy! Paul: Genetics. **Where is your energy inspired from?** All-Krupps. Jess: Tetley. Paul: Fear. **What would you say is your contribution to this world?** Jess: Oil in the machine. Charlie: Puppies (unknown number) **What is illustration to you?** Roy: What other people do. **How do you want to be remembered?** Paul: In colour. Jess: In 3-D. **Explain one of your most difficult drawing experiences?** Paul: During a power cut. **If you weren't an illustrator, what would you be?** Charlie: A dog (sniffer optional). Paul: That's what you are. **What is your dream job?** Rossmina: Ser Presidente de Platano Republique dans le baski-land. Jess: Nanotechnologist. Paul: A waterfront conservationist in the Orkney Isles.

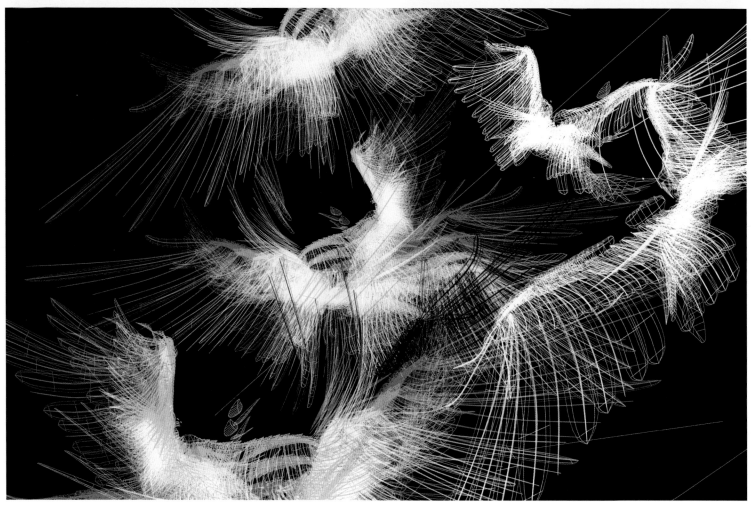

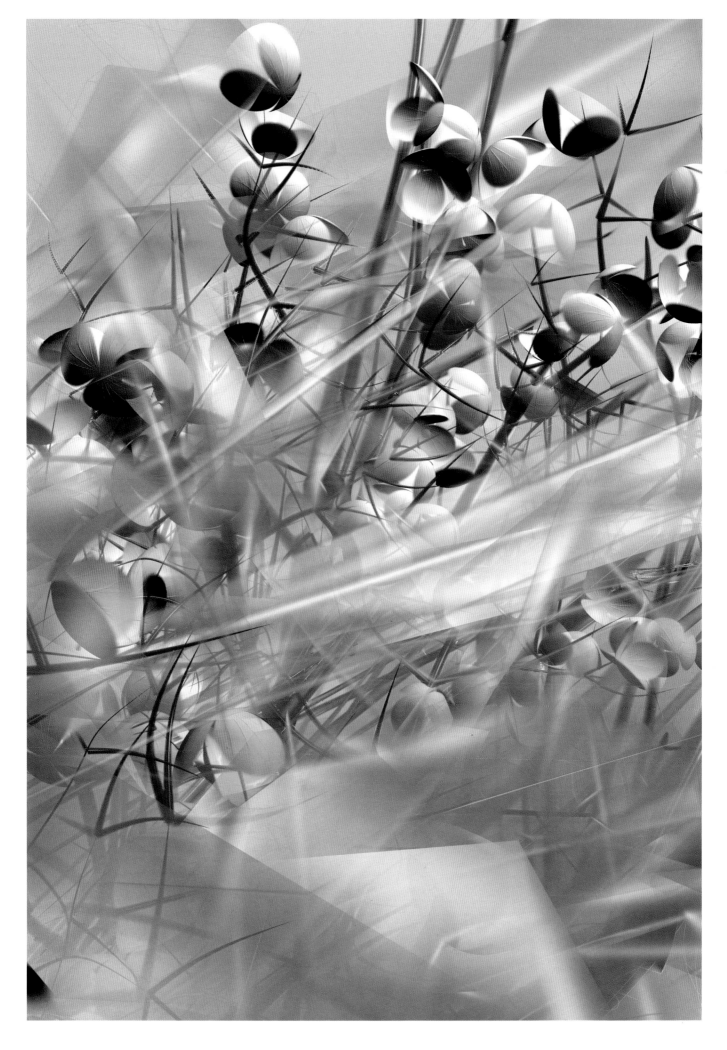

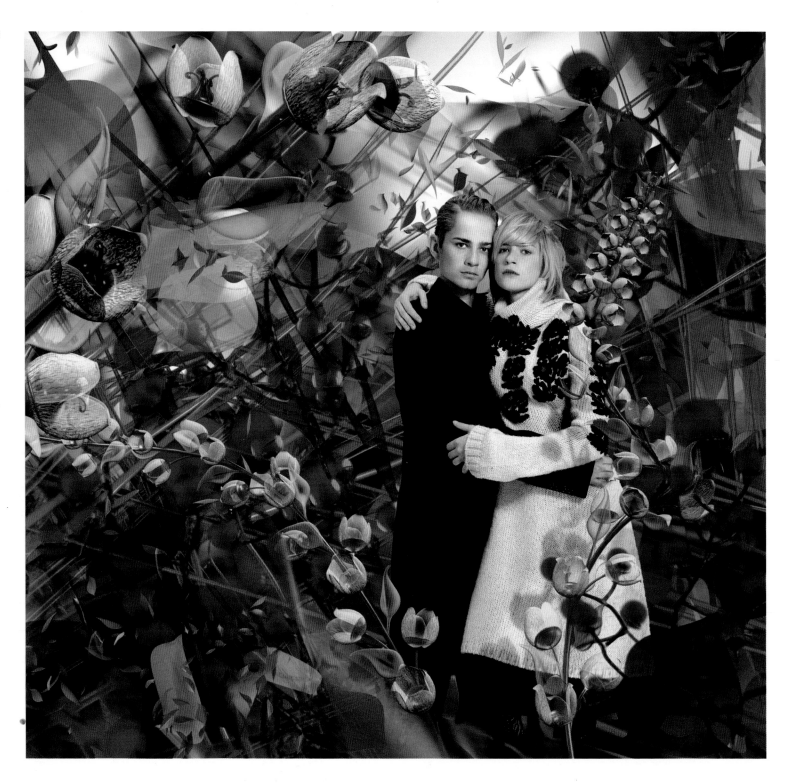

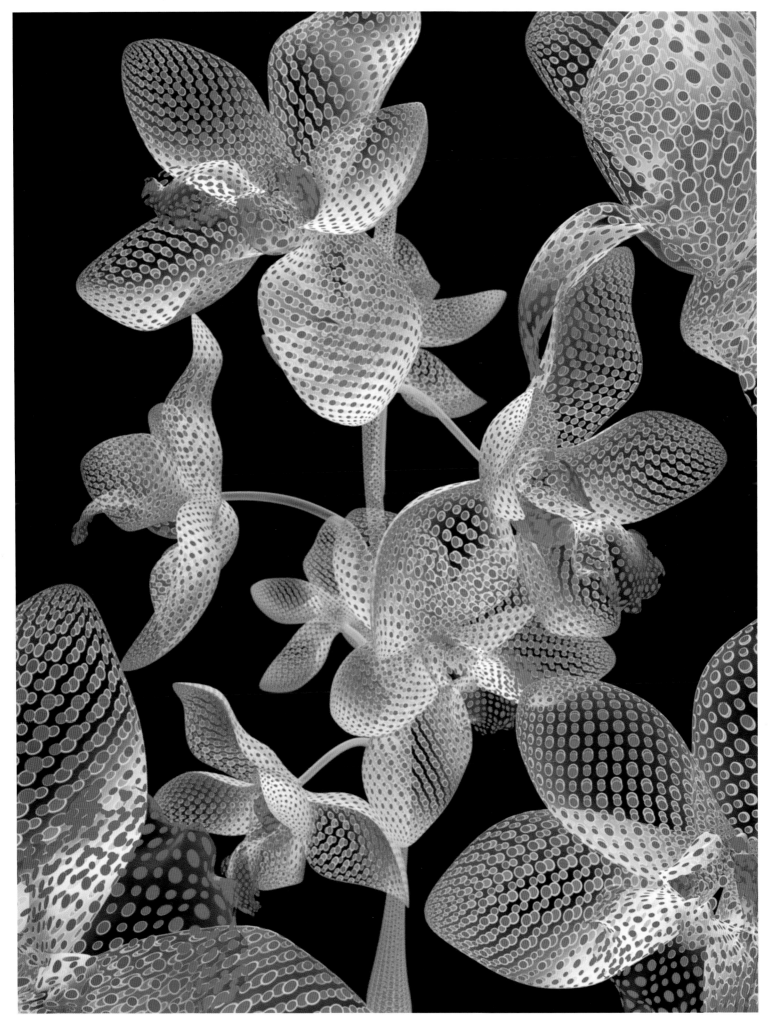

MONSIEUR Z

misterz@noos.fr

What is your nationality & astrological sign? I'm a French Capricorn. What schools have you attended? I went from Estienne, a Graphic Arts School in Paris. What is the first thing you do in the morning? Kiss my wife. What do you love the most? Making nothing, watching the sea and listening to jazz music. What does a habit mean to you? To be a lucky man, to have passion. However, if it's difficult for who lives around you. Why are you creative? I don't know. Maybe because I don't find or I would like to change all around me. Where is your energy inspired from? Love. What would you say is your contribution to this world? Like an illustrator? I don't know, but I try to take my bicycle instead my care. What is illustration to you? My vision of another world. How do you want to be remembered? I dont know. I prefer that people get pleasure to see my art work, than knowlege who I am. Explain one of your most difficult drawing experiences? Making sketches with my left hand beacuse my other hand was broken. If you weren't an illustrator, what would you be? Musician, or architect, or both. What is your dream job? My next work, I ofen dream about what I have to do.

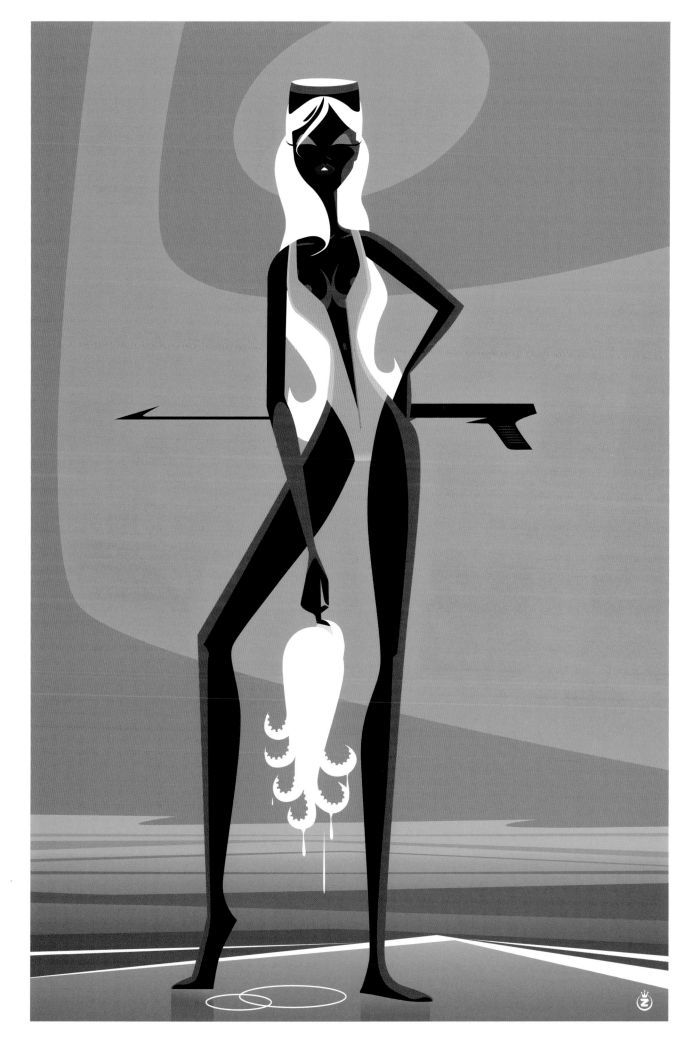
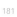

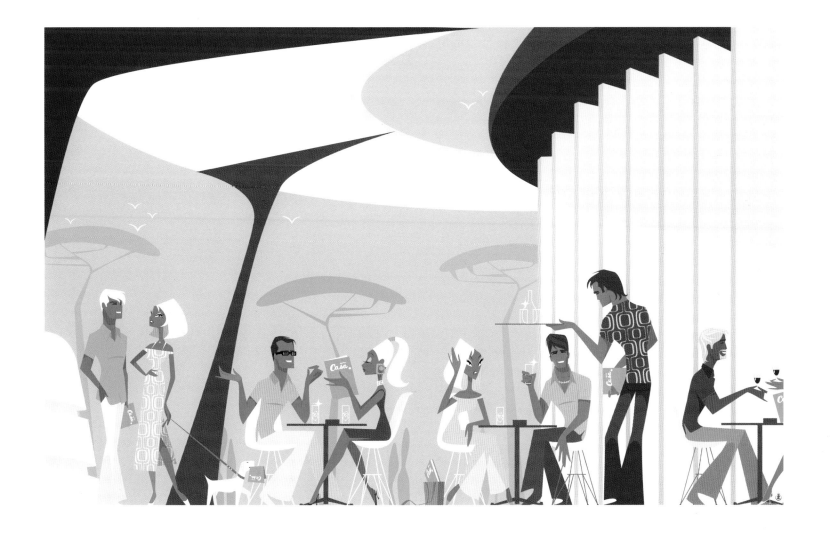

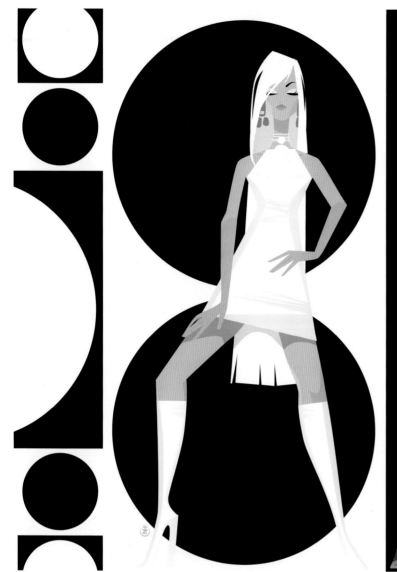
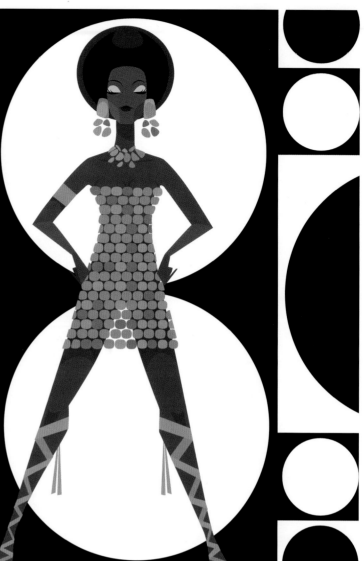

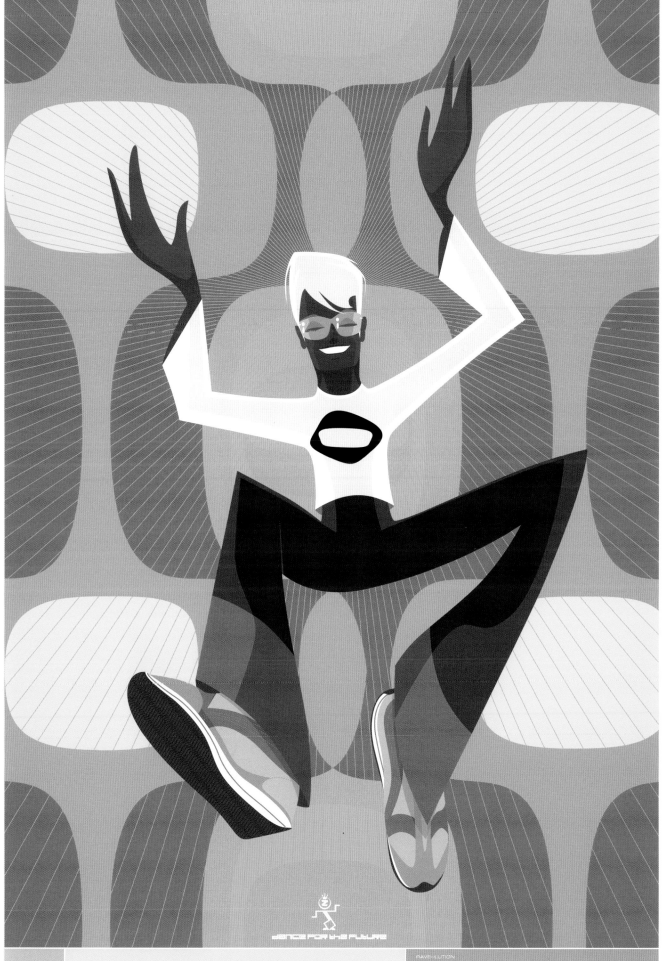

DANCE FOR THE FUTURE

DANCE FOR THE FUTURE

RAVE-LUTION

SHINKO OKUHARA

ok@shinko.cc

What is your nationality & astrological sign? Japan / Fishes. **What schools have you attended?** The Yokohara Junior College of Arts. The Setsu Mode Seminar. **What is the first thing you do in the morning?** What does breakfast eat? **What do you love the most?** Art works. **What does a habit mean to you?** Hold a private exhibition 1.2 times per year. **Why are you creative?** I trust of my destiny. **Where is your energy inspired from?** From everyday small Impressions. **What would you say is your contribution to this world?** If my work is seen and I have you impressed, I will think that it is fortunate. **What is illustration to you?** It's a work. But sometimes, life work. **How do you want to be remembered?** What do you want to be remember to audience? Or What strikes me before now? **Explain one of your most difficult drawing experiences?** A nice stationer's. **If you weren't an illustrator, what would you be?** Although it seldom occurs, is it having drawn 100 people's illustrations in three days? **What is your dream job?** CD jacket of bjork ???

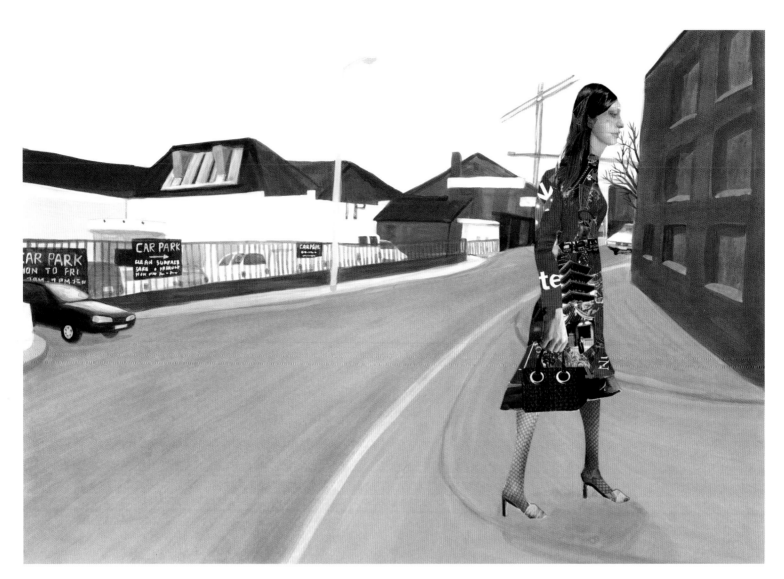

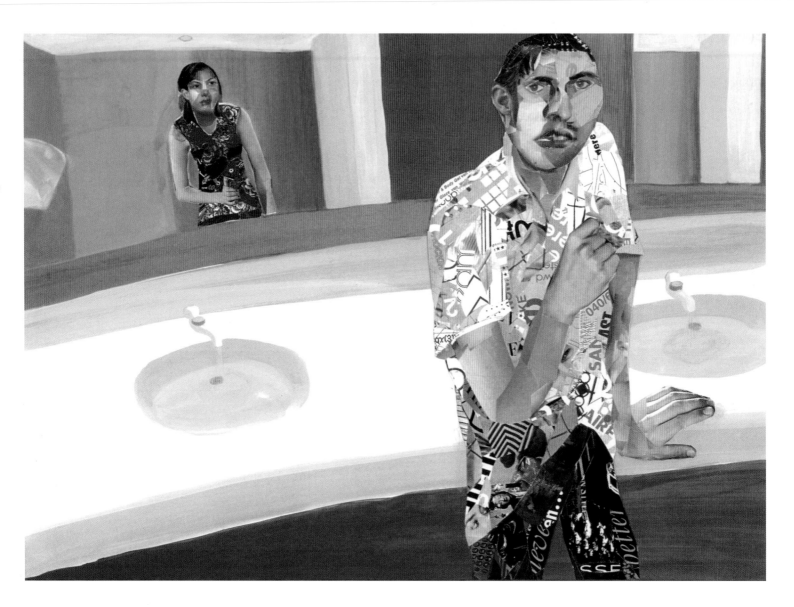

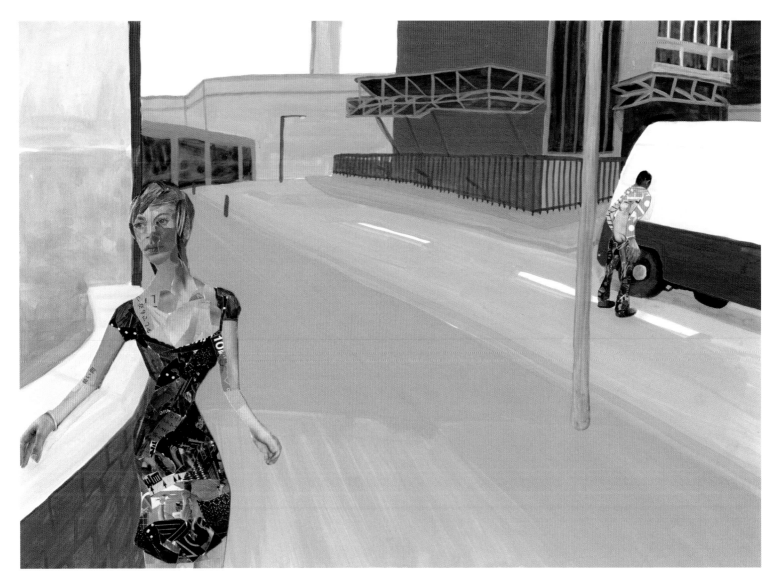

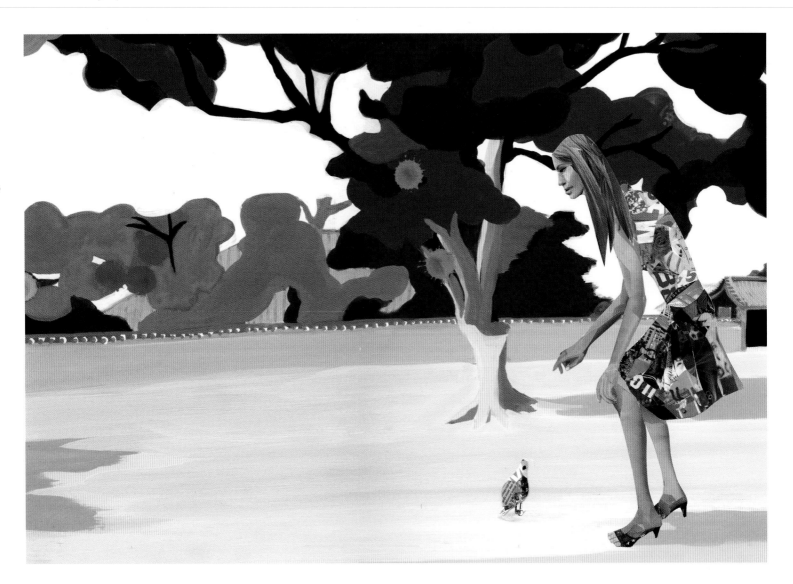

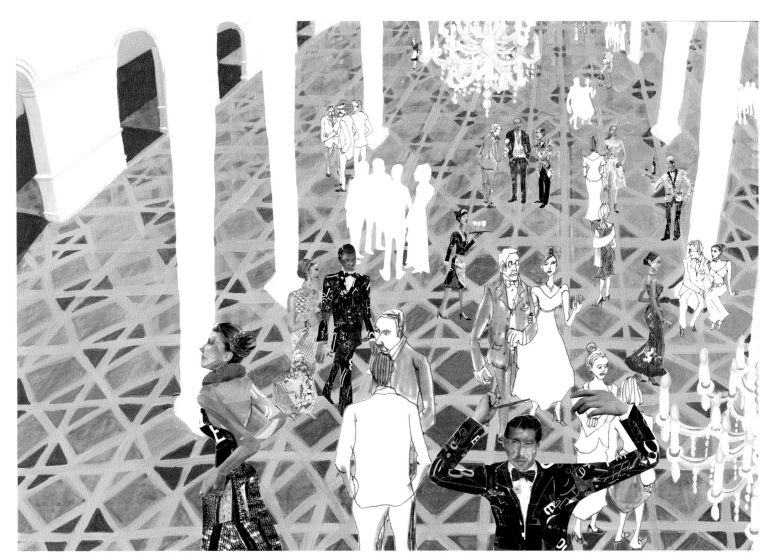

MARTIN O'NEILL

oneill@dircon.co.uk

What is your nationality & astrological sign? North West London / Irish. Scorpion. **What schools have you attended?** Harlesden, Chelsea, Leeds. **What is the first thing you do in the morning?** Think about what I'm doing in the evening. **What do you love the most?** JP, my family, collecting junk, travelling and going down to the pub for a nice, cold Guinness. **What does a habit mean to you?** Bad - Arriving late. Good - Pulling it off in the end. **Why are you creative?** I think all people from all walks of life seek to be acknowledged in some way. This is my way. **Where is your energy inspired from?** My physical inspiration is born from a passion for finding and collecting everyday objects, photos and paper. My mental inspiration is drawn from talking and listening to everyone and anyone who has something to say. Collecting stories and experiences. Laughing.

What would you say is your contribution to this world? I'd like to think that I create beautiful things from what is often disregarded and thrown away. **What is illustration to you?** Illustration is a very rewarding way of getting a quick fix for your artistic endeavours. **How do you want to be remembered?** For the Craic! **Explain one of your most difficult drawing experiences?** I once had to draw a large German bus driver dancing naked in the Blackforest in Bavaria. That was difficult. **If you weren't an illustrator, what would you be?** I would make collages from sound or taste. A musician or a chef. **What is your dream job?** A commission to travel to the most interesting destinations around the globe for a few years, freely documenting my experiences through my work. Finally, creating a beautifully printed tome of a book with the launch in Cork in Ireland. That would be something.

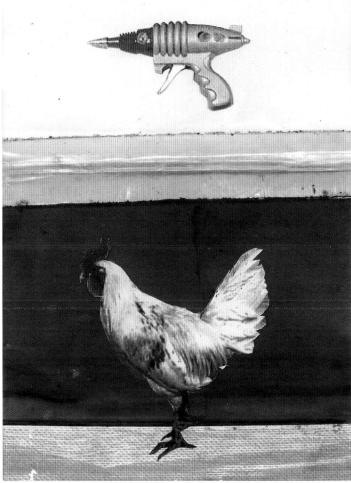

Yours faithfully :

REGGIE PEDRO

mudfoot8@hotmail.com

What is your nationality & astrological sign? My Nationality would be described as a British born Nigerian. My astrological sign is Pisces. **What schools have you attended?** I Graduated from the Royal College of Art in 1997 with an MA in illustration and before that I attended the University of West England with a Fine Art BA hons graduating in 1995, before that I left Rokeby school Stratford East London in 1983 after being kicked in the nosebridge by some 3rd form nutter who had just left Borstall. **What is the first thing you do in the morning?** The first thing I do in the morning is tell the butler to bring me my newspaper and slippers (mans living a proper bling lifstyle now yanaahmean). **What do you love the most?** Mudfoot which will one day be recognised as a philosophy and a way of life, and a way of thinking and being and doing and seeing and hearing and loving and hating, feeling sex booty ladies freaks etc... **What does a habit mean to you?** I don't really think of life in that way, I think if you love doing something then continue to do it until it either makes you rich or it kills you. Call it what you like habit, obsession, craving. If it makes you rich then you deserve it if it kills you then you deserve it. **Why are you creative?** It's a habit. **Where is your energy inspired from?** I lived under a set of electric pylons on a housing co-op in East London for over 7 years I've consumed enough energy to light up the Queens bedroom. **What would you say is your contribution to this world?** Need I say...mudfoot. (refer to Q.4). I also give to charities. **What is illustration to you?** Ilustration is not what I would typically consider my work to be, I think illustration in it's essence is a combination of graphic and fine art (put simply). I think a pure Illustrator would be.able to answer this question better than me. **How do you want to be remembered?** For doing what I do I suppose and hopefully for offering some sort of visual satisfaction to folk, but not just as an artist who depicts urban life I'm sick of that clich_. I'm gonna be working on a series of paintings around the theme of unicorns and waterfalls soon anyway cos' urban is just too 1980's. **Explain one of your most difficult drawing experiences?** The most difficult drawing expereince I have ever had was when I was doing the Gomez album cover 'Bring it on' 1998, I think I spent day and night working on this piece in my bedroom at the time which only measured about 2'x 2' (the painting that is)trying to get the structure of the painting to look right the mood and composition to feel right.etc. I almost lost my mind working on that small piece of artwork, the most difficult part of the picture was drawing that boy in the background I think I must have drawn and redrawn it over a hundred times to get it to look the way it does. I think most people probably look at it and think it was just a quick sketch but there are layers of paint underneath that drawing which ended up as a line drawing of economy. The crazy thing was that once the deadline came, and I had to submit the piece I still thought I hadn't resolved it, The designers at Blue Source took a look at it and thought it was perfect I'd been working on it for so long that I completely lost any kind of sense of judgement about what I was doing. It was only after I'd got away from it and later seen it on the album cover that I realised how good it looked. I'd regard that piece as being the best piece I did for that series of record covers. That piece again would be seen as just an urban depiction, but there was so much frustration and agonising that went into getting it right that I would have to dispute that sort of categorisation, it's portrayed wthin an urban setting. But theres other stuff going on in that picture that almost put me in a mental institute. NO LIE. **If you weren't an illustrator, what would you be?** I don't know if my work is seen as Illustration like I said, but if I wasn't doing what I do I'd be into motors. And that really is an honest answer I used to be into cars when I was a boy. **What is your dream job?** My dream job would be to do a portrait of Floella Benjamin in oil pastels.

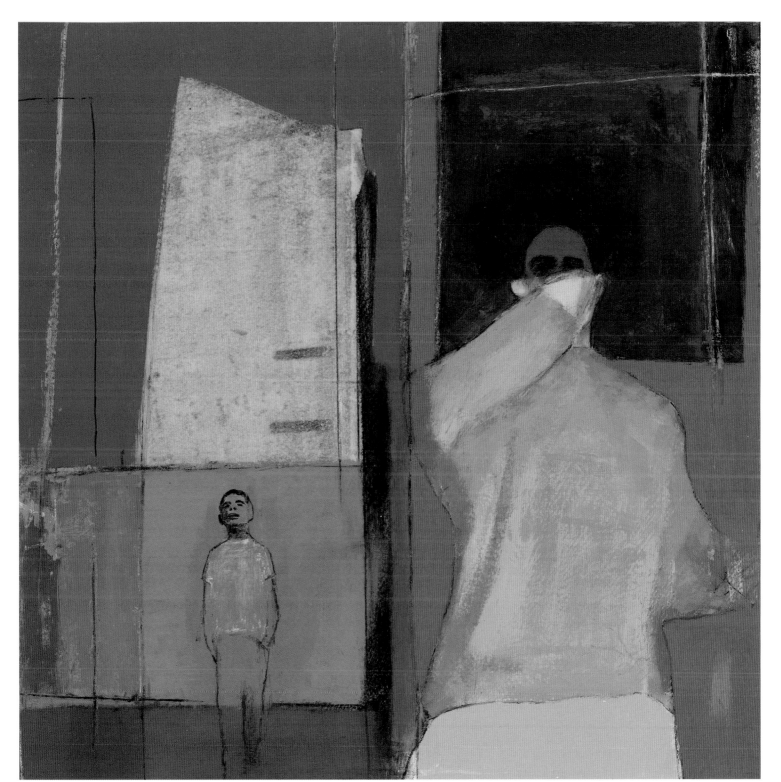

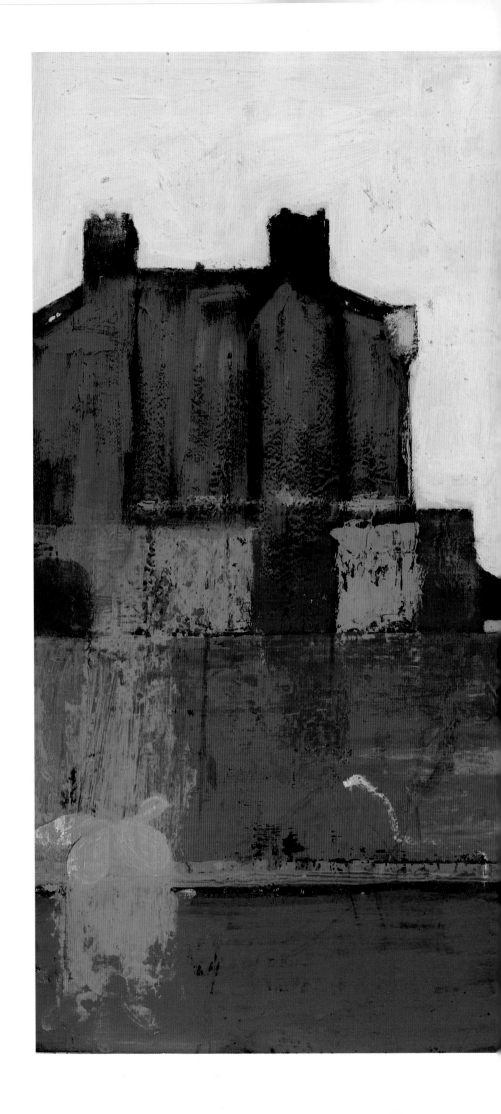

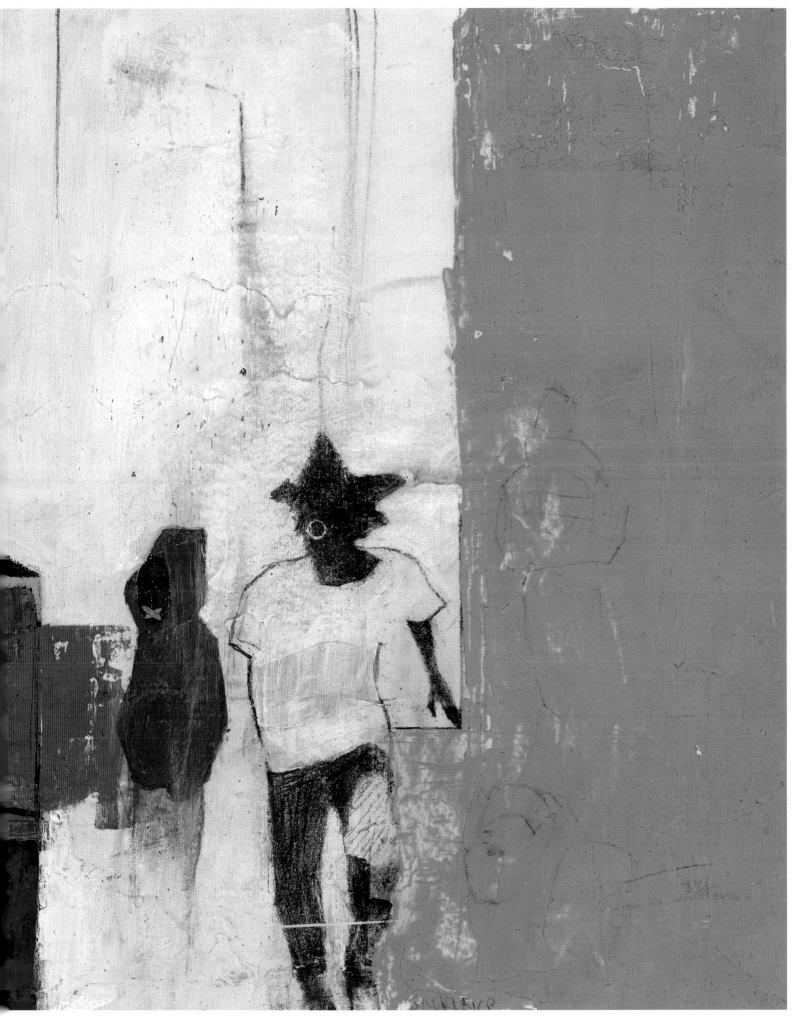

STINA PERSSON

204

stina@stinapersson.com

What is your nationality & astrological sign? Swedish, but the last 11 years I lived in Japan, Italy and New York. I'm a Gemini. **What schools have you attended?** Istituto Europeo di Arti Operative in Perugia, Italy. Polimoda (a division of F.I.T) in Florence, Italy. Pratt Institute, New York, USA. **What is the first thing you do in the morning?** Jump out of bed, I'm a morning person and I love coffee and breakfast. **What do you love the most?** My husband. And my family and friends. **What does a habit mean to you?** My life is constantly changing with different jobs, different cities and now soon another person in my life (I'm 8 months pregnant). So I treasure the normal, everyday things I guess you could call 'habits'.

Why are you creative? It makes me happy to make things. **Where is your energy inspired from?** My surroundings. People I love around me. **What would you say is your contribution to this world?** Scribbles. **What is illustration to you?** More scribbles. Paints. Dots. Stains. Brushstrokes. **How do you want to be remembered?** I'm not dead, yet. **Explain one of your most difficult drawing experiences?** I'm clumsy and have a tendency to spill ink all over the place. **If you weren't an illustrator, what would you be?** I would still be working with design, shapes, colour and form. Hmm... .But I'm not sure how. **What is your dream job?** Working together with all the talented friends I have.

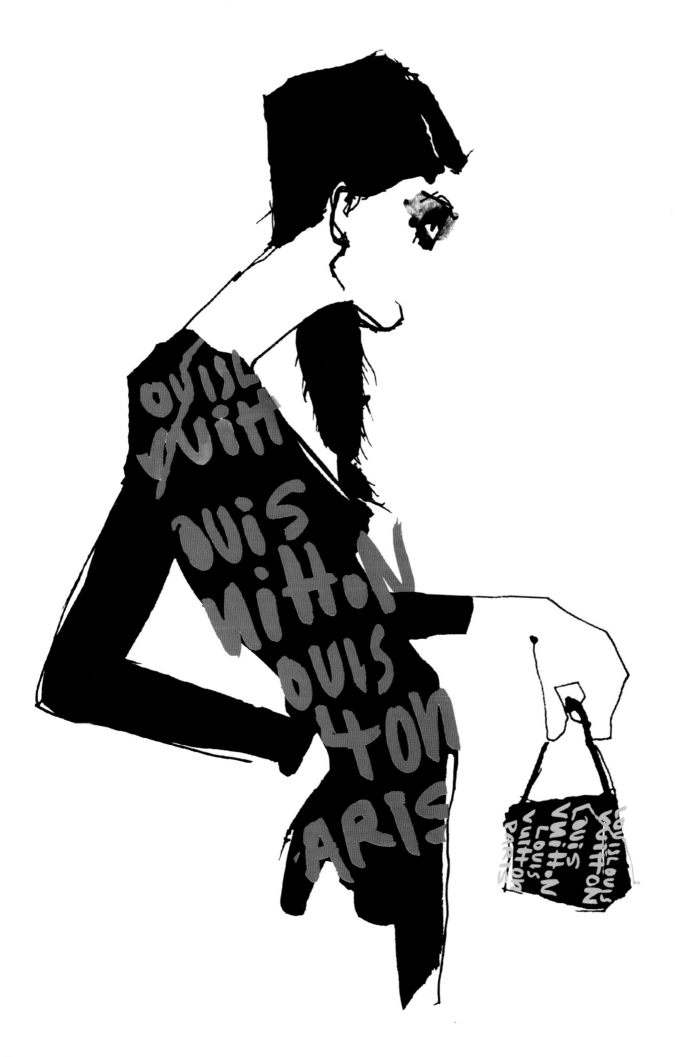

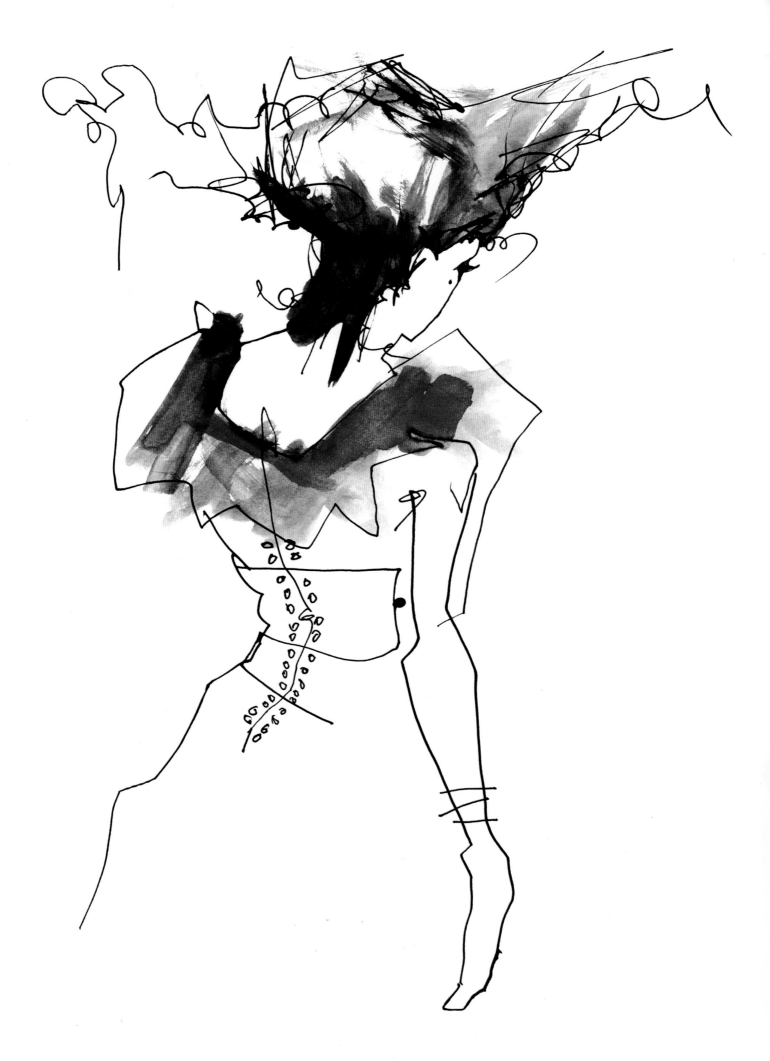

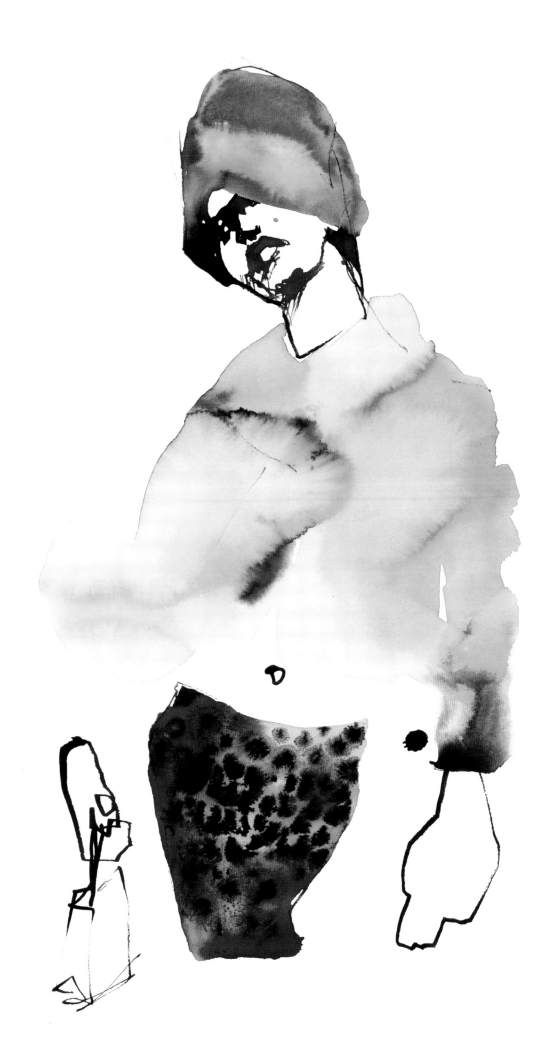

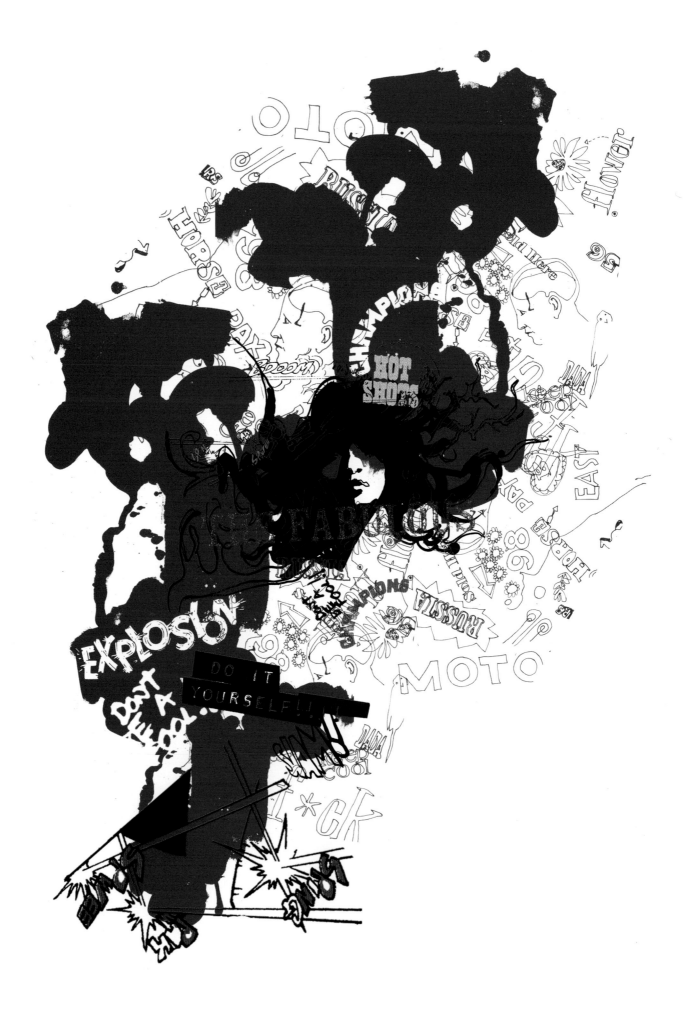

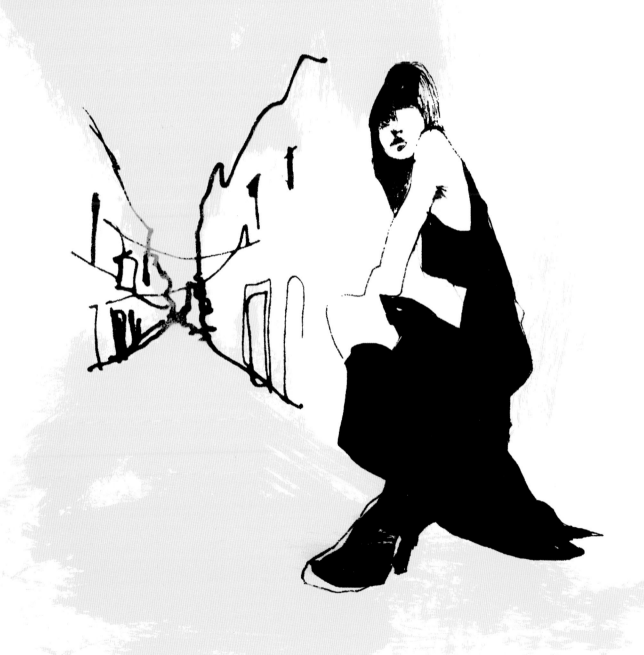

ADAM POINTER

adampointer@yahoo.co.uk

210

What is your nationality & astrological sign? I'm English and a star crossed Capricorn / Aquarius hybrid. **What schools have you attended?** Lincoln School of Art & Design, BCUC Buckinghamshire Chiltern's University College. **What is the first thing you do in the morning?** Get up, put some music on. **What do you love the most?** Fresh air, my girlfriend, rock and roll **What does a habit mean to you?** I guess something you feel compelled to do on a regular basis without really knowing why. **Why are you creative?** I just like to draw pictures. **Where is your energy inspired from?** Simple things, the sun and air, people I've seen and places I've been. **What would you say is your contribution to this world?** Well I've started recycling and last week I rescued an insect from drowning in a swimming pool. **What is illustration to you?** Modern art. **How do you want to be remembered?** As a good guy. **Explain one of your most difficult drawing experiences?** Probably the hed kandi 12" series, as it was one illustration stretching across six covers and each cover had to work in its own right; I put the music on 24/7 to get a feel for the project and probably won't listen to another house record ever. **If you weren't an illustrator, what would you be?** I really don't know. I can't imagine not being an illustrator. **What is your dream job?** Something that required me to travel to new places and see new things.

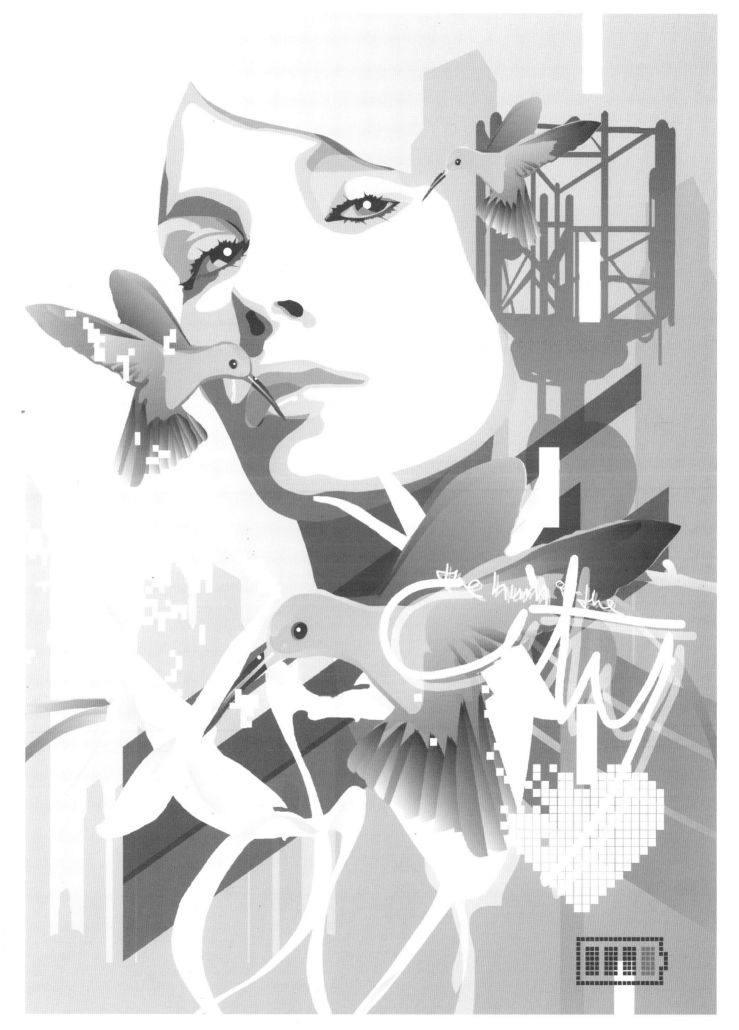

ANDREW RAE

a@andrewrae.org.uk

What is your nationality & astrological sign? British of Scottish descent. Aquarius. **What schools have you attended?** I studied Illustration BA(hons) at The University of Brighton, and now I teach at Camberwell College. **What is the first thing you do in the morning?** I tend to greet the day by letting out a deafening primal scream. **What do you love the most?** I love it when I'm walking somewhere and then I seem to step outside of myself and have a moment where I'm aware of the world around me. I'm also pretty keen on sandwiches. **What does a habit mean to you?** An addiction, I guess. **Why are you creative?** I think it started with misconceived ideas of my own genius at a young age, but now I guess it's a kind of compulsion. Producing a piece of work that I'm proud of gives me a lot of pleasure for a few minutes until I'm thinking of the next thing to do. **Where is your energy inspired from?** My inspiration is all around me, everyday. I have loads of ideas all the time, but I have to put them through rigorous testing in my frontal lobes and as scrawlings on whatever is close at hand before I do anything. I prefer when ideas form naturally of their own accord, rather than having to squeeze them out of my head. I go through periods of excitement and energy and then of sloth, but they both seem to be equally important. **What would you say is your contribution to this world?** Sometimes I think that I should be doing something real that has more of an effect on the world. But then I consider how much joy images, music, animation, films, etc. give me and it does feel worthwhile. It beats data entry, or fork lift truck driving or modelling ice-skating trousers or all the other weird things I've done. **What is illustration to you?** Illustration is just a term really. I've been described as an illustrator, a designer, an art director, but then when I step out onto the street I become a pedestrian, so I think these terms are interchangeable really. I suppose it's a way of saying I work in a specific way, but apply that to other people's problems a bit like a hired-gun or bandito. Or maybe that's just trying to glamourize it.

How do you want to be remembered? I don't think I'm doing this to be remembered, particularly. Most work is pretty throw-away these days, but if people want to remember me I hope that I don't make them sick to their stomach. With a bit of luck, I'll be around for a while yet, so remembering won't be necessary. You can hear my screaming in the mornings for a while yet, unless my girlfriend puts a stop to it. **Explain one of your most difficult drawing experiences?** The hardest thing is when I'm doing a job and my heart isn't in it. I try to avoid doing that. I did a job aimed at young mothers a while back for a large supermarket chain. The creatives at the agency wanted me to do something edgy and I just knew clients weren't going to go for it. But I had to get the work past them before it could work it's way up the hierarchy to the client. I was probably the wrong guy for the job, really, but I did them the way I thought they should be and then had to change them to make them more edgy and nearly lost the job because of it. Then I had to change them back to something more like the way they started-all ASAP, of course. I'm not that proud of the final images, but they did the job and I've done better work since then so I don't dwell on it. **If you weren't an illustrator, what would you be?** I always wanted to be a musician, but I wasn't that good at it–although I still like to fiddle around on a keyboard or sampler from time to time. Other than that, I could be a teacher, a stunt man, mountaineer, or maybe one of those guys with a 'Golf Sale' sign standing on Oxford street. **What is your dream job?** My dream job would be making my own animated series. I've been art directing on one called 'Monkey Dust' for Talk back productions, recently, which was great and I learnt a lot about the process. Mostly that there aren't any rules about how to do it right. I'm working on some stuff at the moment, but it's all top-secret and hidden away in my underground lair. Ha, ha, ha, ha! (I always like to finish with an evil cackle).

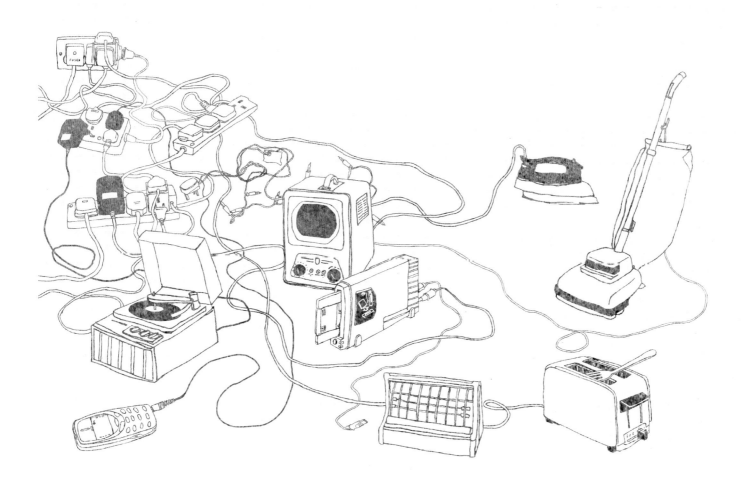

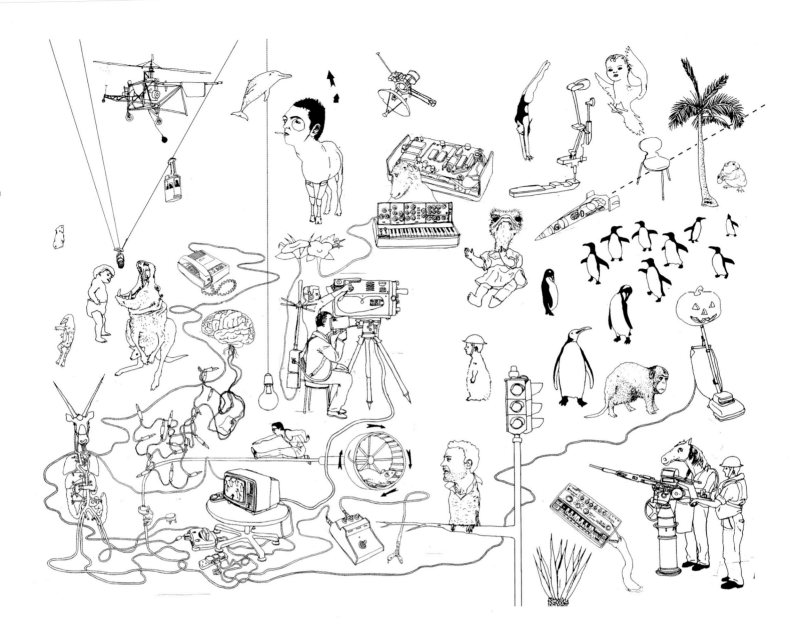

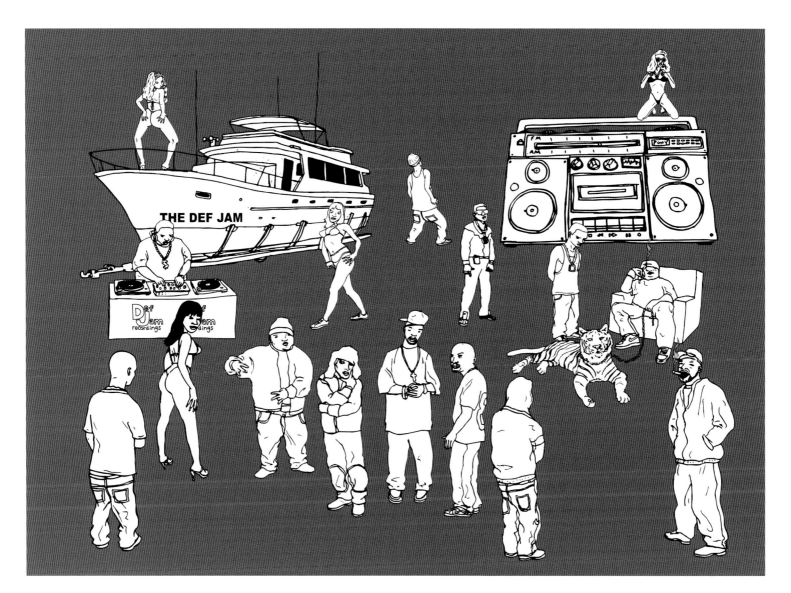

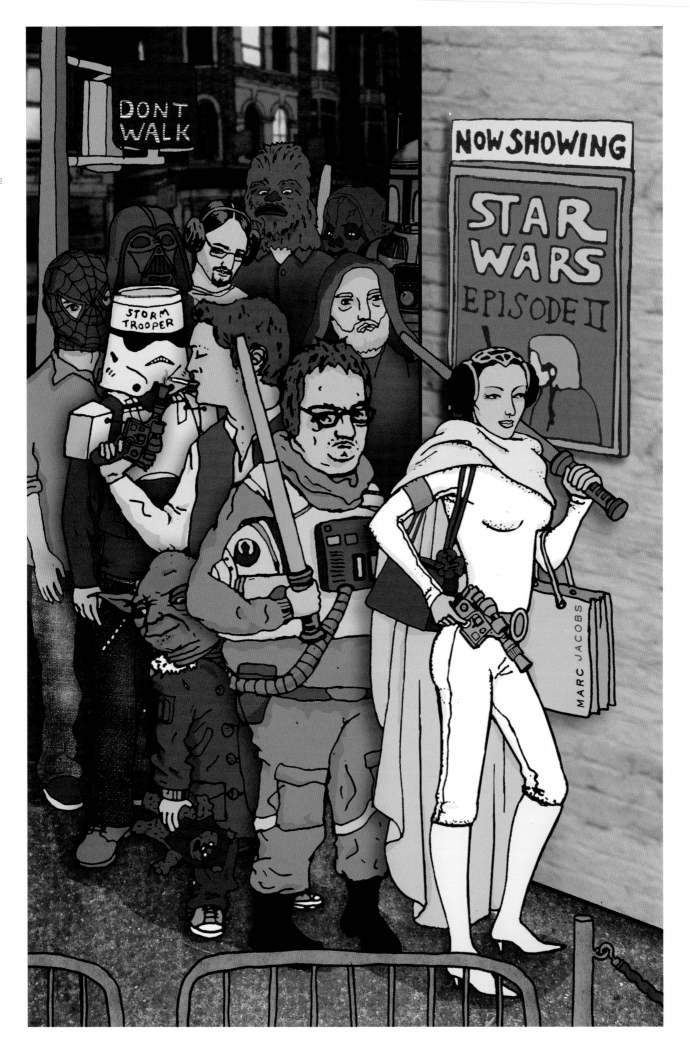

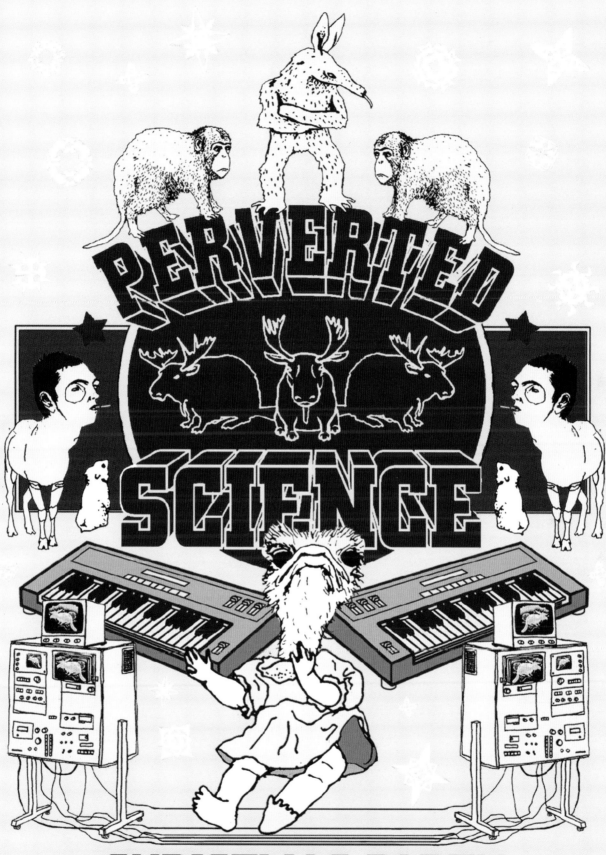

CHRISTMAS PARTY

SHONAGH RAE

shonagh@shonaghrae.com

What is your nationality & astrological sign? British / Cancerian. What schools have you attended? Gravel Hill primary, Hardwick middle, King Edwards secondary, Ipswich. College, Central St. Martin's and Royal College of Art. What is the first thing you do in the morning? Drink coffee. What do you love the most? Elephants, marzipan, my tent, jeans, grey/green, thistles. What does a habit mean to you? Good and bad. Why are you creative? Human nature. Where is your energy inspired from? Deadlines. What would you say is your contribution to this world? My ego isn't that big. What is illustration to you? It's a job I feely lucky to be able to do and enjoy. How do you want to be remembered? Positively. Explain one of your most difficult drawing experiences? Being asked to draw a figure from memory in front of 20 students. If you weren't an illustrator, what would you be? Something that was both creative and physical. A trapeze artist, perhaps. What is your dream job? My dream illustration job would be a set of postage stamps.

RAINEE HOU

raineedog@yahoo.com.tw

What is your nationality & astrological sign? Taiwanese, Sagittarius. **What schools have you attended?** Interior Space Design at Shih Chien University. **What is the first thing you do in the morning?** Think about what can I wear today. **What do you love the most?** My daughter. **What does a habit mean to you?** Picking my nose. I've done that for 26 years. **Why are you creative?** I hate repetition. **Where is your energy inspired from?** Sleeping well.

What would you say is your contribution to this world? Some smiles. Maybe. **What is illustration to you?** Good stories. **How do you want to be remembered?** The faces I painted. **Explain one of your most difficult drawing experiences?** Modern Chinese painting. Chinese paintings require a lot of study. **If you weren't an illustrator, what would you be?** A mother (and a housewife?) **What is your dream job?** An illustrator(I am almost in my dream), or an architect(that's too hard).

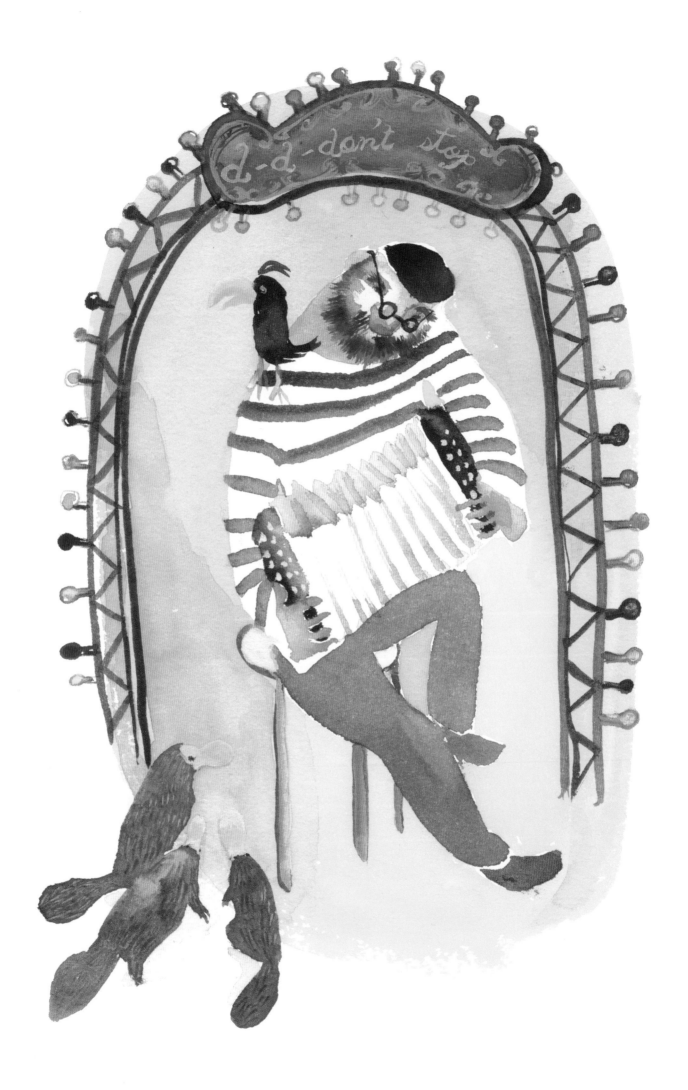

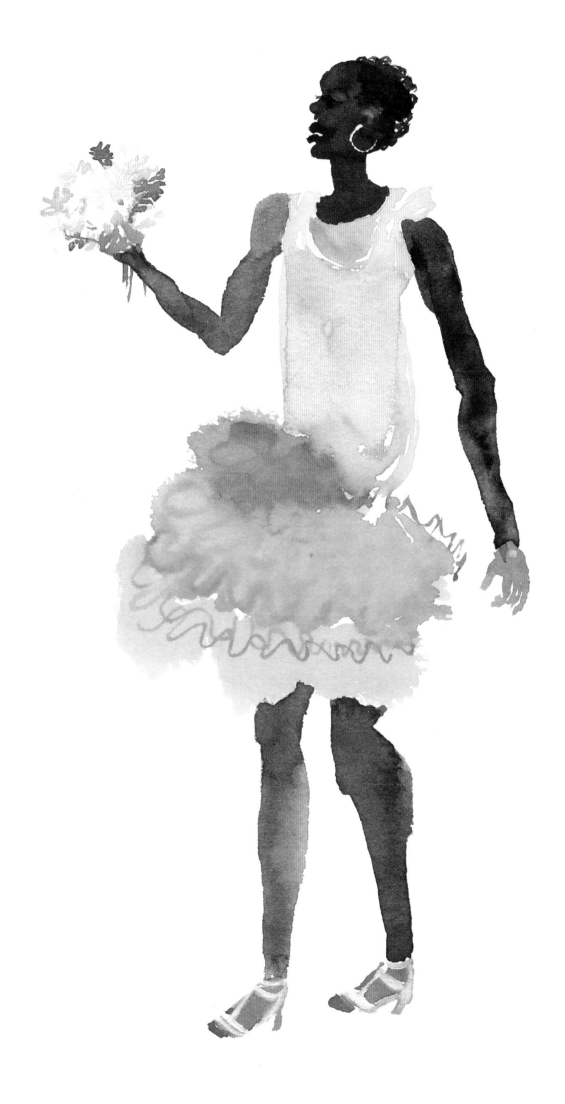

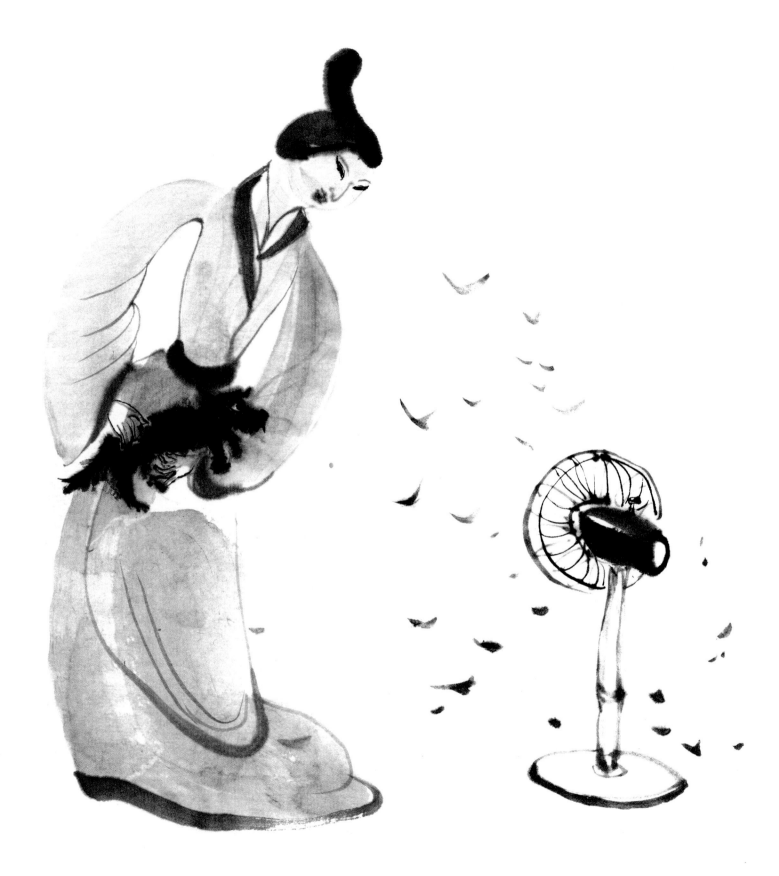

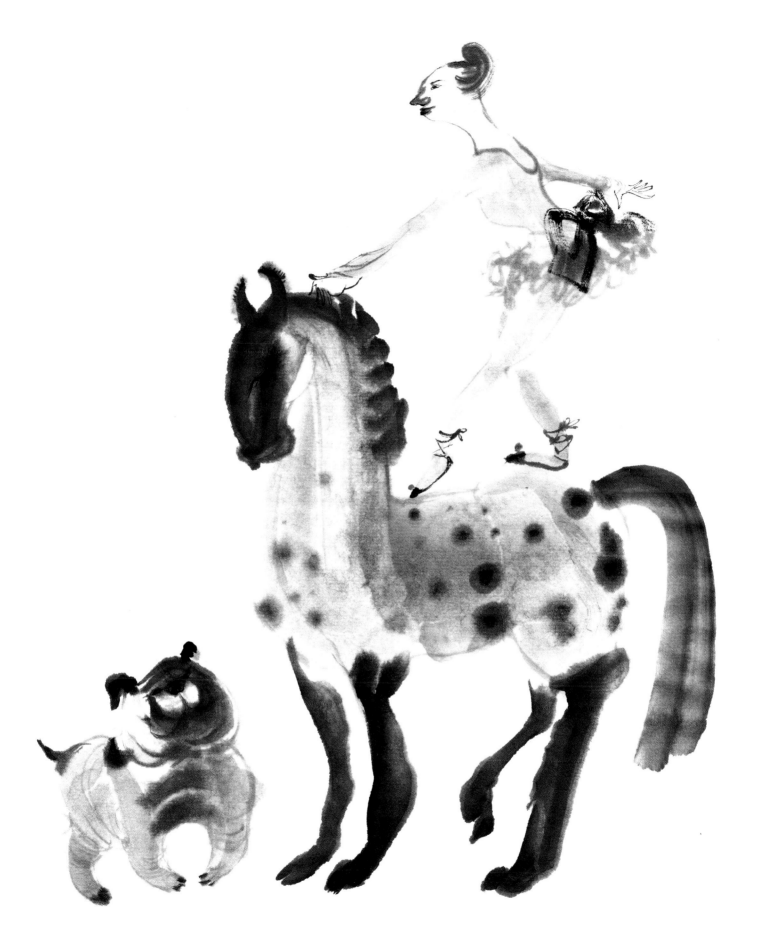

PAUL REILLY

reilly.p@virgin.net

What is your nationality & astrological sign? British / Taurus. **What schools have you attended?** Duncan of Jordanstone, College of Art and The Royal College of Art. **What is the first thing you do in the morning?** Open my eyes, my mind & my blinds. **What do you love the most?** Cheese, art galleries, good books, cola, TV & loud music. **What does a habit mean to you?** It's something that's far too pleasurable to give up, but that will probably kill you in the end. **Why are you creative?** It's the only thing I'm good at. **Where is your energy inspired from?** The everyday-ordinary and the extraordinary.

What would you say is your contribution to this world? Not enough yet! **What is illustration to you?** Looking at the world from a really Reilly point of view. **How do you want to be remembered?** With a wink and a smile. **Explain one of your most difficult drawing experiences?** The transition from pen and ink to puck and stylus. **If you weren't an illustrator, what would you be?** A gardener. **What is your dream job?** I'm still dreaming, but a nice art director's job wouldn't be too amiss.

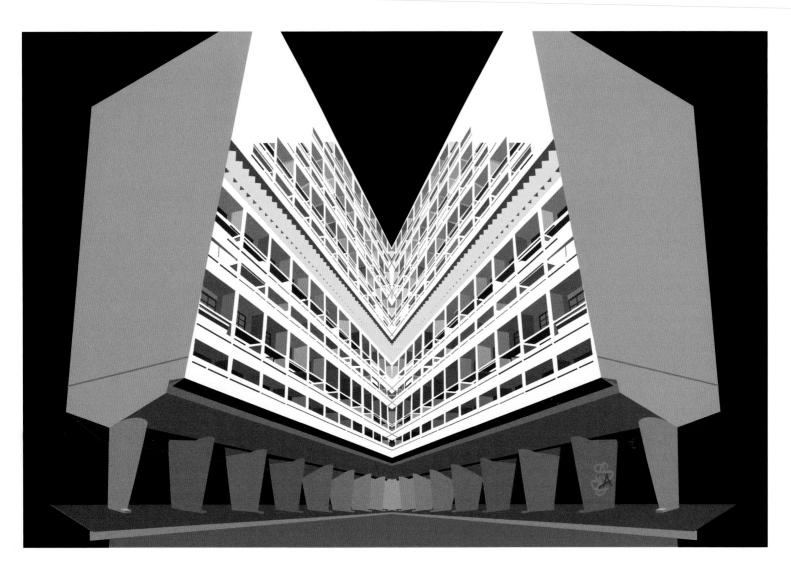

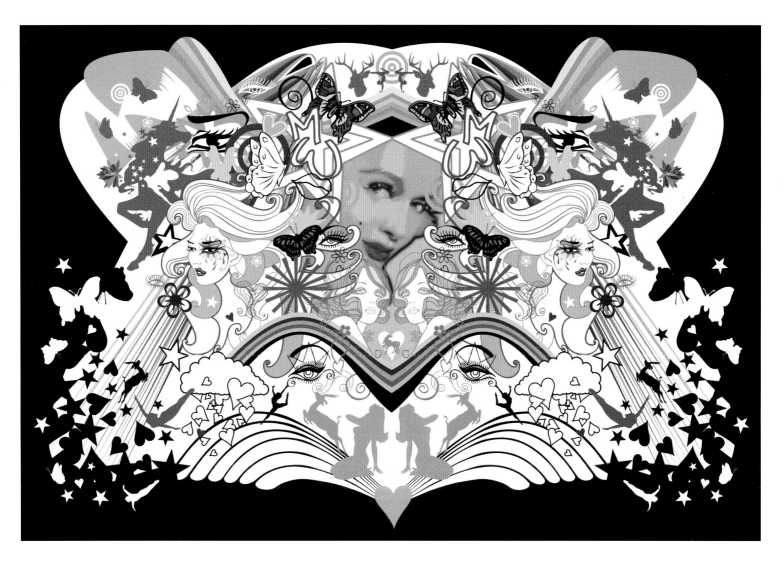

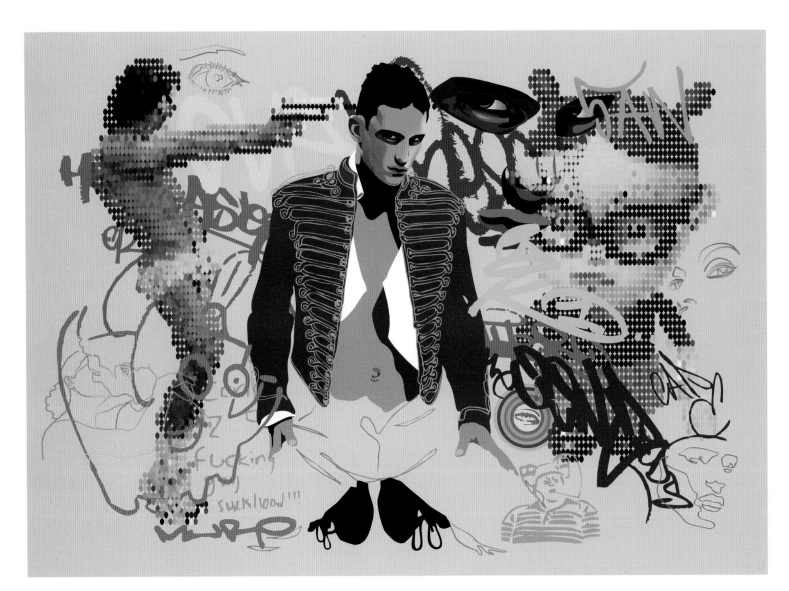

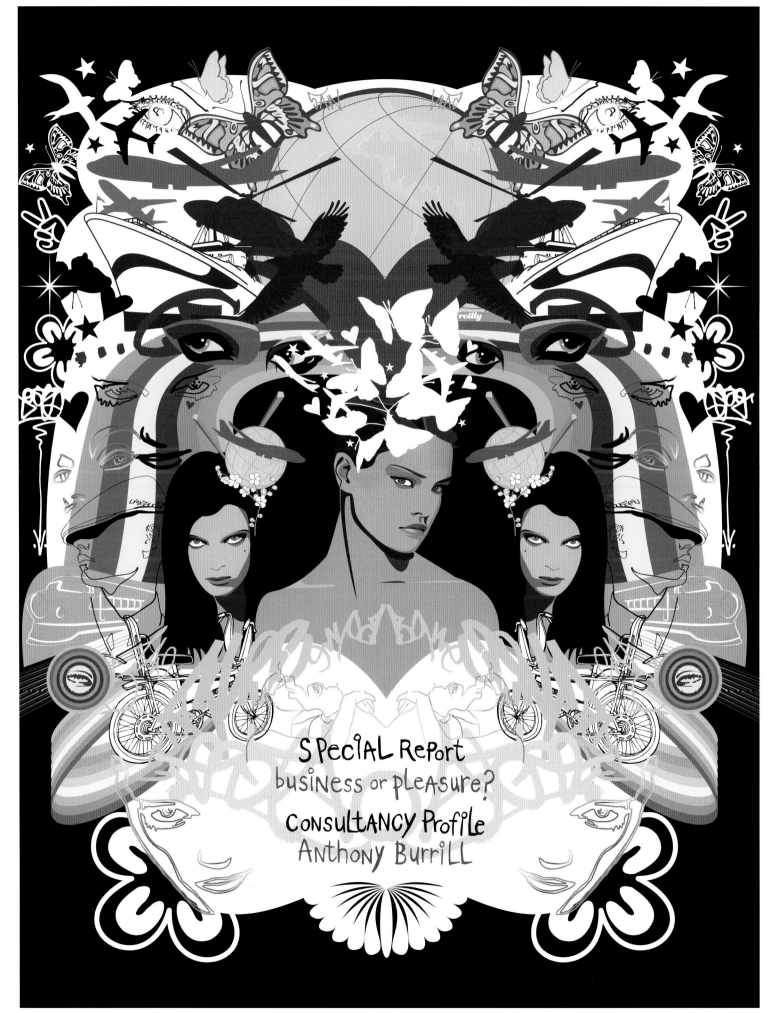

SPECIAL REPORT
business or PLEASURE?
CONSULTANCY Profile
Anthony Burrill

SHIV

shiv@devilgirl.co.uk

What is your nationality & astrological sign? Half-English, half-Irish (Shiv is short for Siobhan). Leo. **What schools have you attended?** Danesfield. Notre Dame Senior School for girls. St. George's College. West Surrey College of Art and Design. Camberwell College of Art. **What is the first thing you do in the morning?** Check where I am. **What do you love the most?** Love. **What does a habit mean to you?** Something I excel in. **Why are you creative?** Who isn't in thee own special little way. **Where is your energy inspired from?** Anything and anyone I come into contact with, or is in my direct line of vision. **What would you say is your contribution to this world?** That would depend on who you asked, I think everybody will take or see something different in everyone. **What is illustration to you?** Escapism. **How do you want to be remembered?** For my dazzling wit and sparkling répartié. **Explain one of your most difficult drawing experiences?** When the life–drawing model quite obviously had her period. **If you weren't an illustrator, what would you be?** International playgirl. **What is your dream job?** International playgirl.

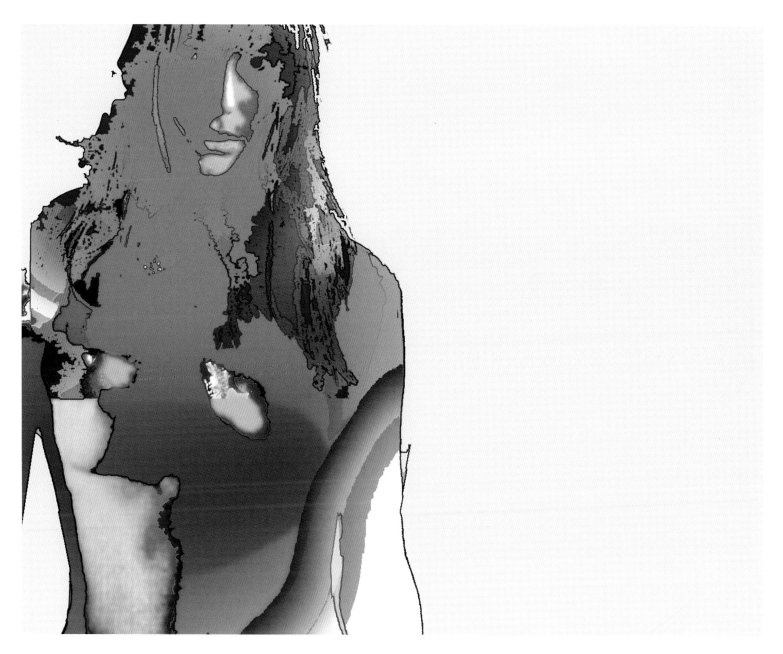

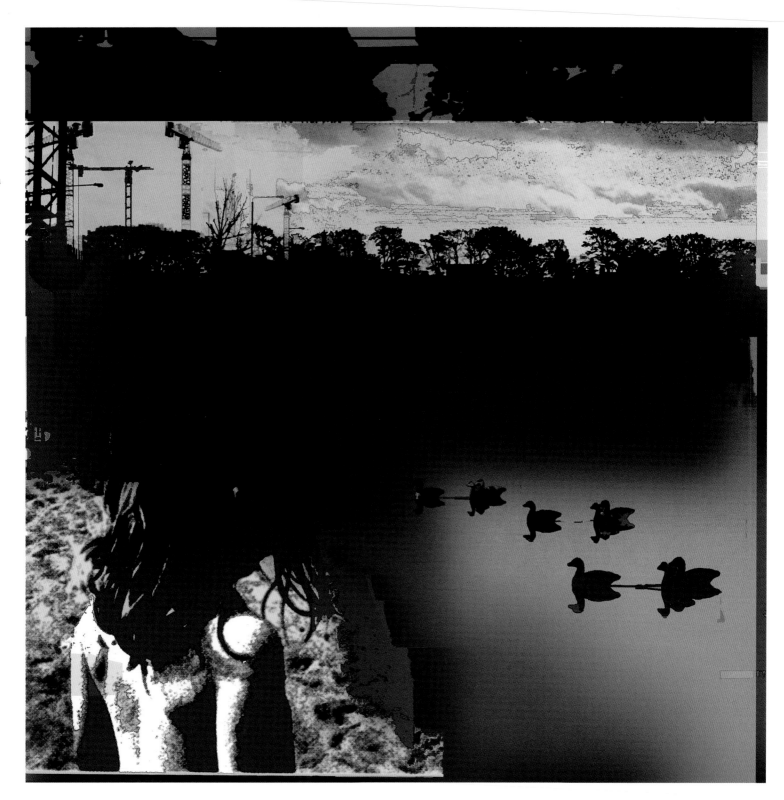

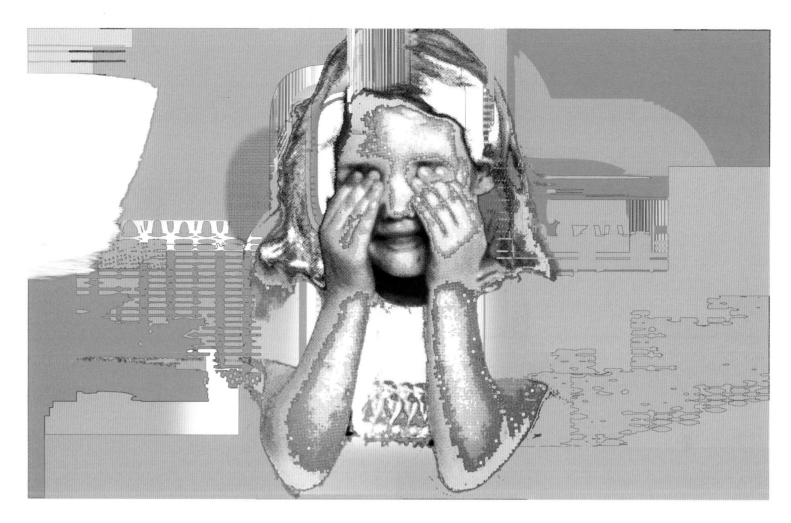

JAMES STARR

What is your nationality & astrological sign? UK citizen. Starsign Libra on the cusp of Scorpio. **What schools have you attended?** Millfield school, then Chelsea College of Art, then Kingston University. **What is the first thing you do in the morning?** Wake up, figure out where I am, a few coffees, look at last night's work, check emails, locate diary, shower, make a few phone calls in no particular order. **What do you love the most?** Seafood, surf, exotic travel when possible, road movies, table football, London, lockins in country pubs. In fact, lockins anywhere. Dawn and dusk, good music, working creatively, the process of screen printing and somebody who shall remain anon. **What does a habit mean to you?** I guess creativity is a habit that is tough to break. **Why are you creative?** It's my way of interacting with the world, leaving a mark, communicating a memory or making concrete an experience. But still have never been able to answer that question properly. **Where is your energy inspired from?** The sun, the surrounding habitat. **What would you say is your contribution to this world?** Chaos and calm, in roughly equal amounts, I have been described as a weapon of mass confusion. **What is illustration to you?** Sometimes it is a supporting act for the graphic design industry. For me, it is much more than that. **How do you want to be remembered?** As somebody who was not selfish. **Explain one of your most difficult drawing experiences?** Not sure. Maybe wealthy treasure hunter, Formula-one driver, maybe astronaut? **If you weren't an illustrator, what would you be?** Again, wealthy treasure hunter. **What is your dream job?** Drawing on location in Africa, Asia, Arctic Norway and North America has posed many problems.

Come

003729

HIRO SUGIYAMA

ss@elm-art.com

What is your nationality & astrological sign? Japan / Cancer. What schools have you attended? Tokyo Institute of Art and Design. What is the first thing you do in the morning? Stroke my dog. What do you love the most? Positivity. What does a habit mean to you? Ease. Why are you creative? Since there is desire. Where is your energy inspired from? Fine Art. What is illustration to you? Communication. Explain one of your most difficult drawing experiences? Since I had much it too much, I have forgotten. If you weren't an illustrator, what would you be? Dentist.

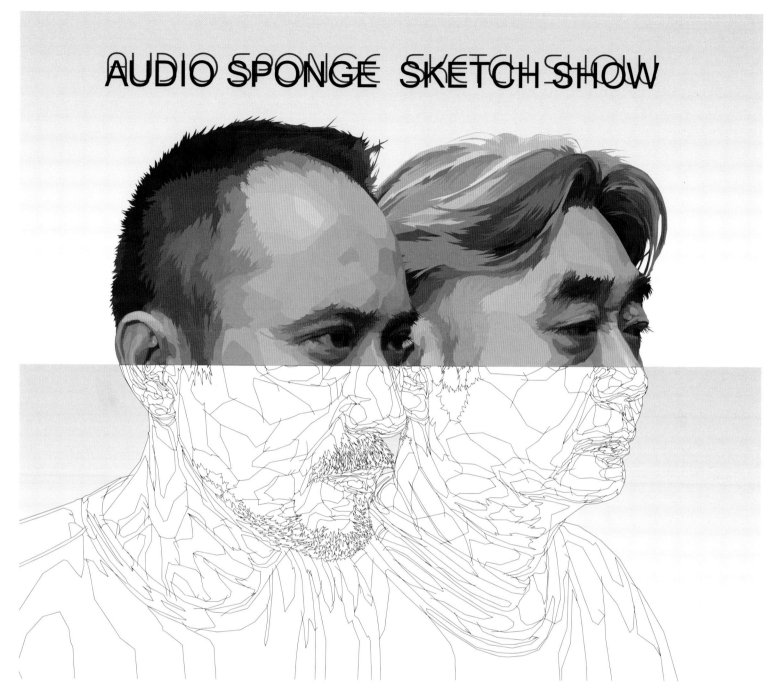

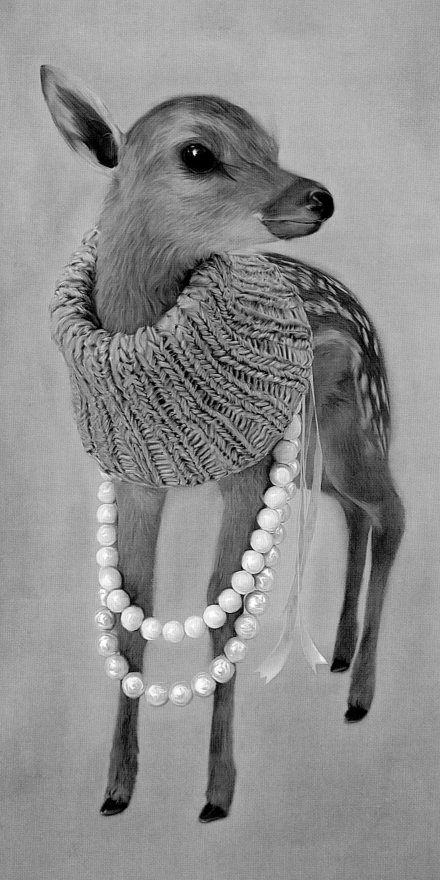

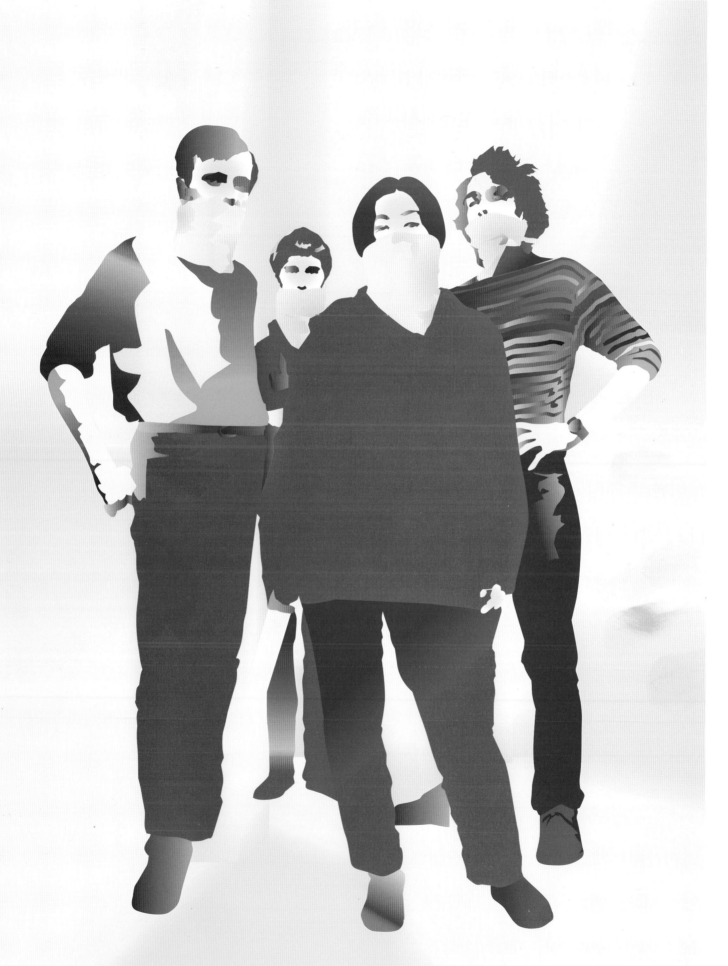

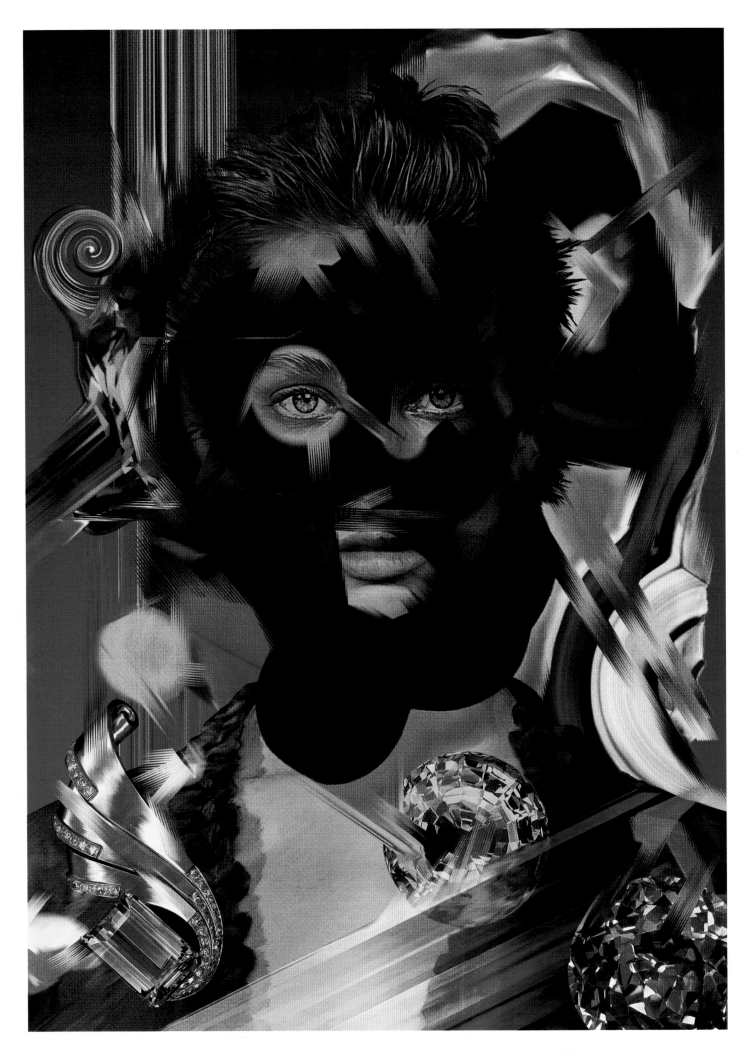

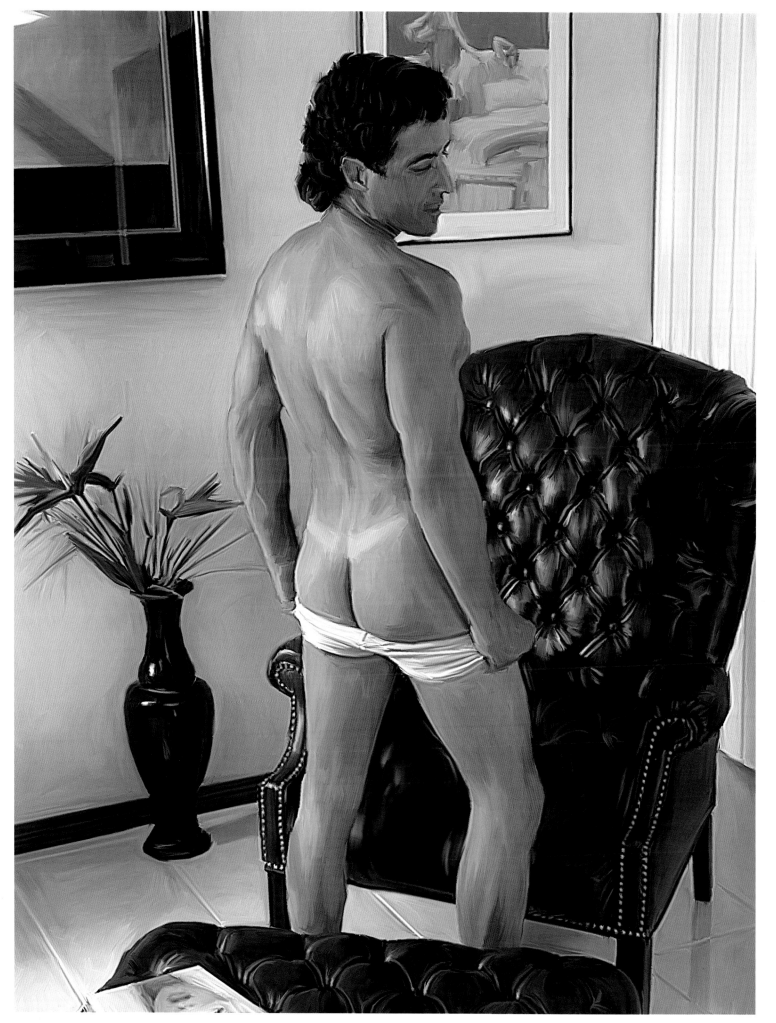

KAM TANG

mail@kamtang.co.uk

What is your nationality & astrological sign? British / Aries. What schools have you attended? Brighton University, Royal College of Art. What is the first thing you do in the morning? Think of the day ahead. What do you love the most? The good-life. What does a habit mean to you? Comfort. Why are you creative? Curiosity. Where is your energy inspired from? Life.

What would you say is your contribution to this world? Me and my actions. What is illustration to you? Drawing. How do you want to be remembered? Boy done good. Explain one of your most difficult drawing experiences? Giving an art director something he doesn't know that he wanted. If you weren't an illustrator, what would you be? Unhappy. What is your dream job? What i do now...but with a bit more pay.

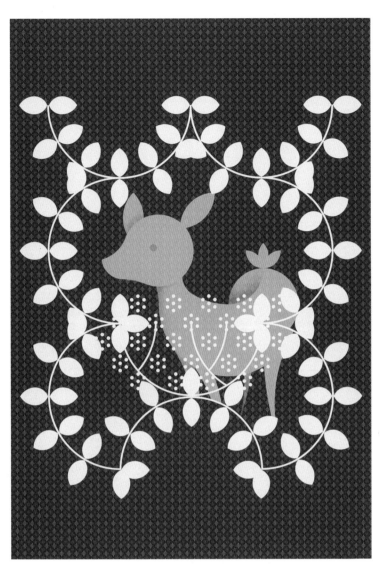

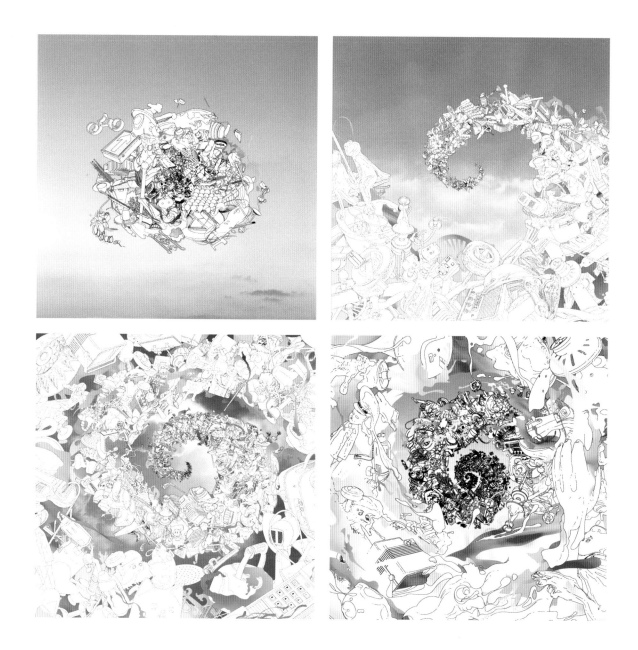

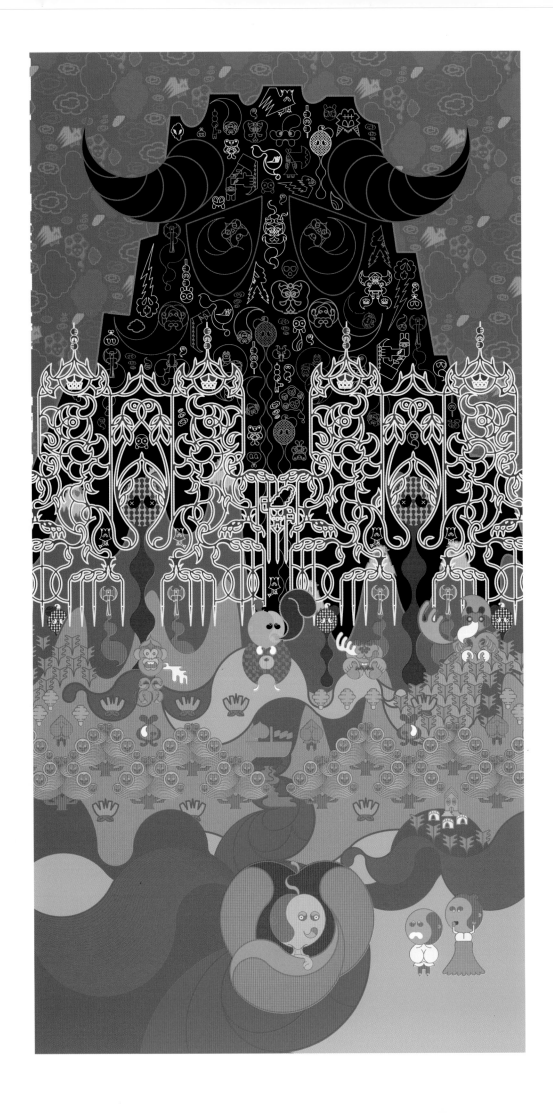

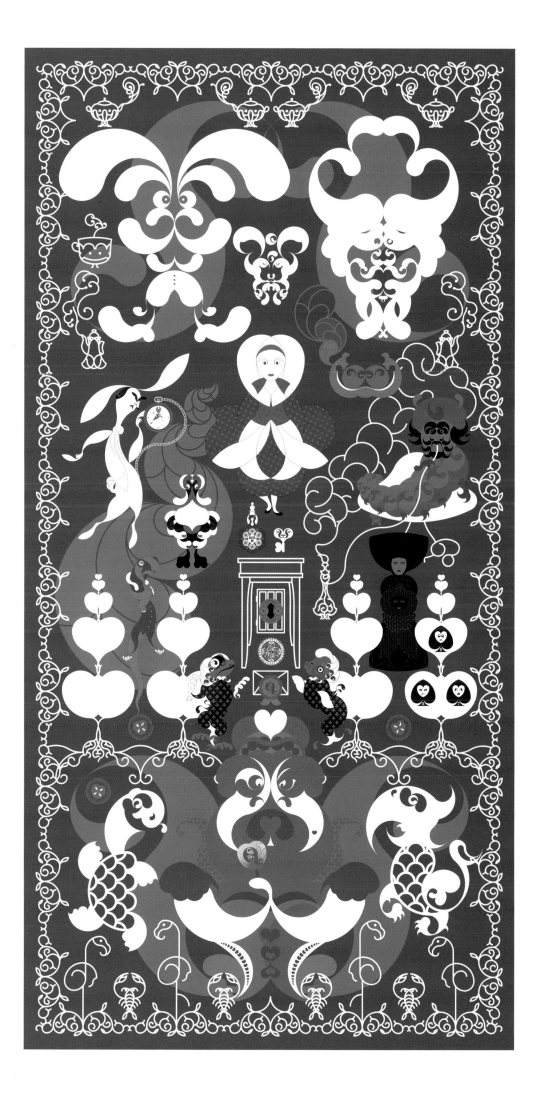

ED TSUWAKI

eden@path.ne.jp

What is your nationality & astrological sign? Japan / Cancer. **What schools have you attended?** Ordinary high school. **What is the first thing you do in the morning?** Turn on my computer. **What do you love the most?** Delicious meals. **What does a habit mean to you?** It tells me the difficulty of making a fresh start in my life to be an ideal person. **Why are you creative?** All my hobbies since I was a kid became my job. I think that hobbies can make people's out look brighten. **Where is your energy inspired from?** Delicious meals, good coffee, beautiful views, beautiful women, good music. **What would you say is your contribution to this world?** I do not know if there is anything I am contributing to this world.

What is illustration to you? At present, illustration is my strongest point. **How do you want to be remembered?** Artist who draws the most beautiful woman in the world. **Explain one of your most difficult drawing experiences?** Always difficult, but in the other word never be in difficult. It means difficulties always face to pleasure. **If you weren't an illustrator, what would you be?** Rock star? **What is your dream job?** I would like to make designs for postage stamps or designing some paper bills is also nice. I am interested in making designs for something people can see in their daily life without consciousness.

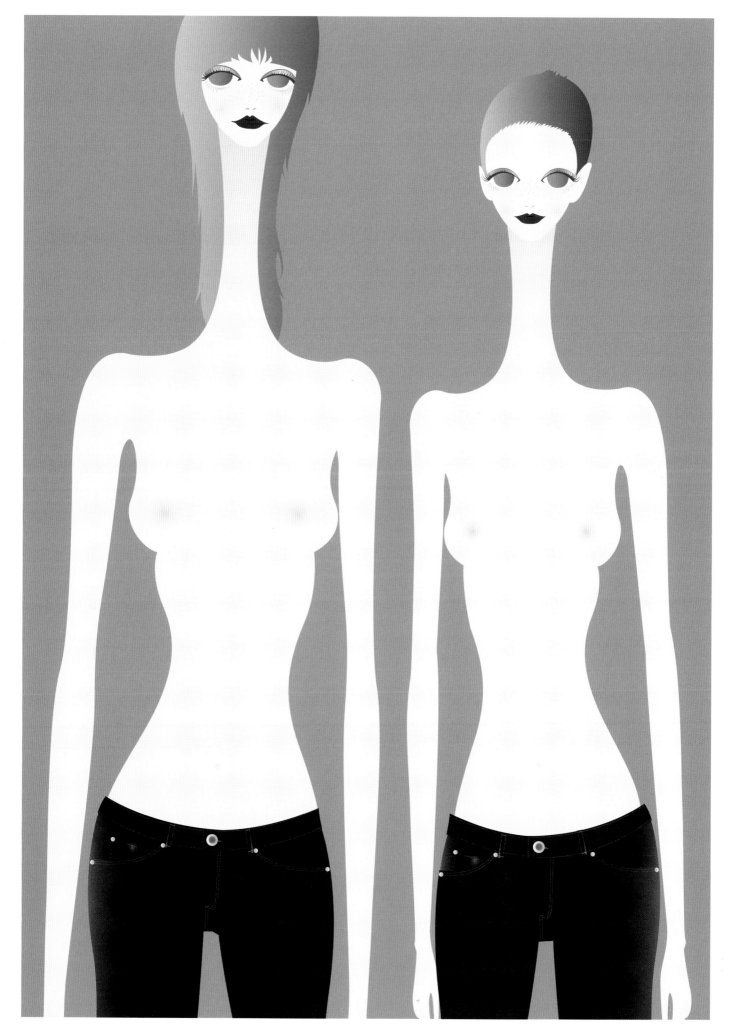

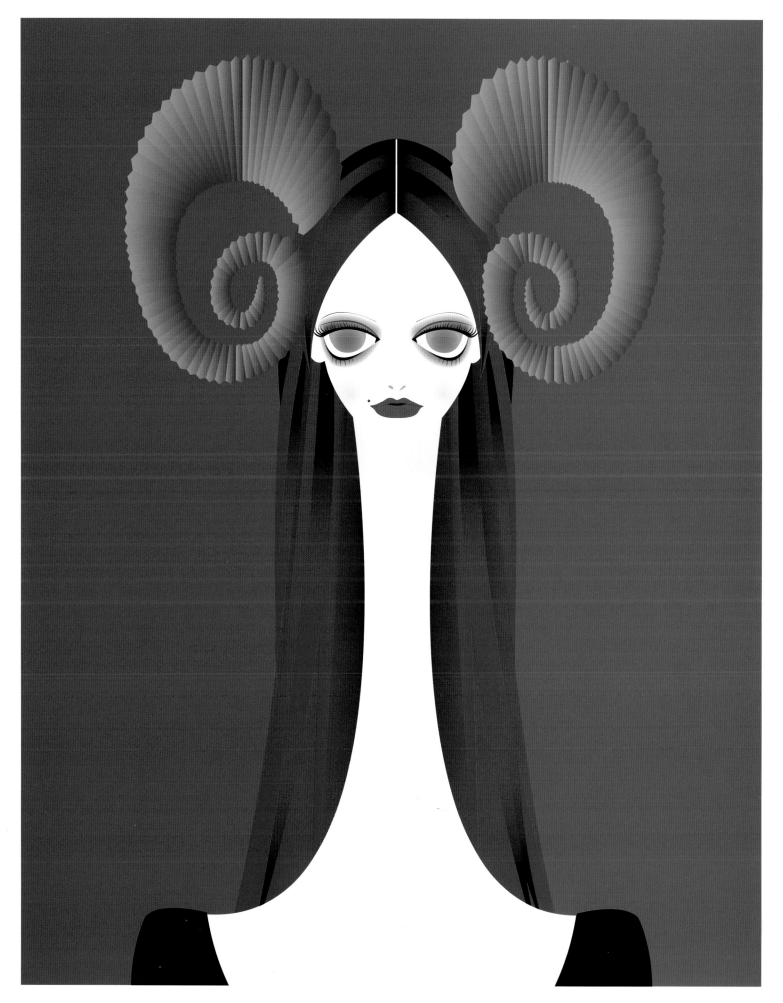

ANDY WARD

gaiward@btconnect.com

What is your nationality & astrological sign? English / Taurus. **What schools have you attended?** The Norwich School of Art and Design. **What is the first thing you do in the morning?** First, I make sure all of my dreams have finished. Then I get dressed, have a coffee and a banana and start drawing. **What do you love the most?** Gaia, tropical fish, git-go, Charlie Parker, cacti, sharp pencils, pasta bean soup, Saul Steinberg, fish markets, Hanna-Barbera, Joe Henderson, aeroplanes, Max Fleischer, underwater cameras, Charles Adams, Yusef Lateef, baby parrots, second-hand skateboards, Blue Note, mellotex paper, being underwater, John Coltrane, Raw Vision, Pablo Picasso, butterfly collections, surprises, getting it right. **What does a habit mean to you?** Get away from that computer. Put that pencil down. Have you eaten today? Why do your eyes look like that? Where's all the coffee gone? Who ate all the sugar? Etc.

Why are you creative? Curiosity, making sense of things, thinking too hard about simple things. Identity. **Where is your energy inspired from?** Living, loving, learning. **What would you say is your contribution to this world?** Baby ward, arriving shortly... Followed by more baby wards... **What is illustration to you?** I think illustration is great, and it should stay that way. **How do you want to be remembered?** Not for that bad thing I did but for that other thing I did that I'm really proud of. People will be talking about it for generations to come. **Explain one of your most difficult drawing experiences?** I find them all difficult. What I'm trying for hasn't happened yet. **If you weren't an illustrator, what would you be?** A piano player. **What is your dream job?** I'd like to be in charge of putting some love back into this world.

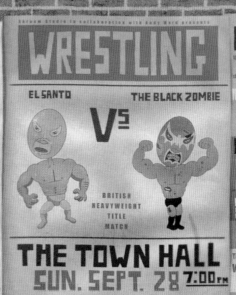

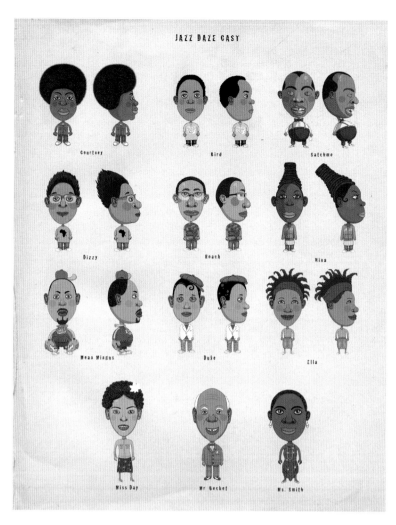

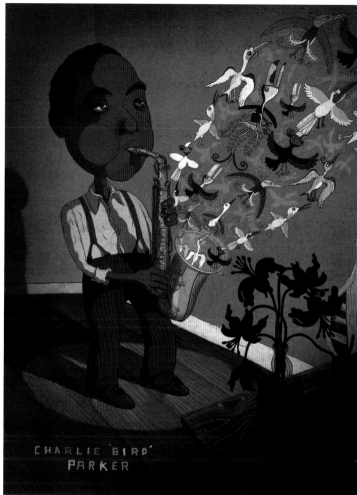

LUKE WILSON

luke_wilson@btopenworld.com

What is your nationality & astrological sign? British / Pisces. **What schools have you attended?** Milton Primary and Junior School. Churchill Secondary School. Weston College. Exeter School of Art and Design. **What is the first thing you do in the morning?** Drink tea (milky with two sugars). **What do you love the most?** Getting paid for drawing pictures. **What does a habit mean to you?** Dipping biscuits in tea. **Why are you creative?** Good genes. **Where is your energy inspired from?** Other people. **What would you say is your contribution to this world?** Positive visual solutions and nice pictures. **What is illustration to you?** An exciting but undervalued media. **How do you want to be remembered?** As a bloke who could draw quite well. **Explain one of your most difficult drawing experiences?** The whole period between leaving college and getting my first commission. **If you weren't an illustrator, what would you be?** Richer. **What is your dream job?** Umm, can't think of anything else I'd rather be doing.

JANET WOOLLEY

janetrwoolley@aol.com

What is your nationality & astrological sign? I am British, my sign is Cancer. **What schools have you attended?** I attended a secondary modern school in Shropshire, England. Shrewsbury School of Art, Brighton College of Art and Design and The Royal College of Art in London. **What is the first thing you do in the morning?** Drink coffee. If I am teaching that day, check that I have any paperwork needed or books and information that I have promised to take in for students. If I am working in my studio (which is in my apartment and very small) I usually have a list of priorities, which roughs to work on first, artwork to finish, phone calls to make or it may be an idea morning when I sit and draw, make designs, take photographs, or brainstorm and sketch out ideas and play around with them. **What do you love the most?** I love my partner, daughter, family and cat. I love to be excited about a new creative venture, an illustration for a client, a picture I'm making for myself or the preparation for it. **What does a habit mean to you?** A habit to me is anything that becomes routinely part of the day whether it is necessary or not. Drinking too much coffee is one, calling people on the telephone whether I need to or not. I am told that I constantly sing and hum songs and that is how I can be found when out and about. **Why are you creative?** I think that it is in certain people's nature to be creative. They have a built-in need to build or create something that previously didn't exist. I feel that I was born to be a creative person. I have always drawn, painted, written stories or made things. **Where is your energy inspired from?** I am inspired by looking at other artists, music, reading and the students that I teach. **What would you say is your contribution to this world?** My daughter who is a gifted songwriter and musician, my pictures, and the talented students that I have encouraged over the years. I try to be a kind and empathetic person with a sense of humour.

What is illustration to you? Illustration is a way of communicating feelings, facts and moods. It may be in some cases the only pictorial art that people come in contact with on a regular basis. It can at times be a way of putting across both perennial feelings and important information or at least attracting people to read the information it accompanies. **How do you want to be remembered?** As a kind, strong and creatively intelligent person that contributed to the arts. Someone that has helped changed the way that people think of illustration. **Explain one of your most difficult drawing experiences?** My least successful drawing experiences usually involve diagrammatic images, one of which was a very large illustration of a science laboratory. The most difficult ones are not always failures. One of these was a picture titled 'In Windows'. This was a very large image undertaken for an 'Urbanite' exhibition in 2003. It portrays the inhabitants of a block of apartments. Each window frames the personalities of the inhabitants, their dramas, hobbies and tragedies. The picture is partly humorous and partly dark in mood. The design and tonal balance of this picture caused me some anxiety. It was also the first large digital piece that I had attempted. **If you weren't an illustrator, what would you be?** I would be a painter. If I had to make a choice away from the arts, I would be involved in the medical profession in some way. **What is your dream job?** My dream job would be one in which I had a great deal of creative input, although I do enjoy working in a team and I do welcome input from others that may have knowledge of the marketing of a the product I may be advertising, or the philosophy involved in a publication. I always enjoy ambitious jobs and ones where I am being used for the creative and aesthetic qualities in my work and my ability to solve problems. I suppose if I'm honest, my dream is to be slightly indulged and used to attract attention with an image of my choosing.

INDEX

Special Thanks to:
John C. Jay for opening my eyes to the world of illustration; Frances Chapple
of Synergy Art Limited for being the nicest agent in the world;
Lawrence Zeegan for a wonderful introduction; all the participating artists
for submitting their work on time; Rudolf and the team at BIS for their
patience and support, Gene for the brilliant book title and creative input,
Trista for the beautiful book design; and a most special thanks to
my wife Ive and our baby Sean for giving my life such joy.

Book Designed by Pao&Paws
Imin Pao, Tzuchan Shen